THE LONG TAKE

THE
LONG
TAKE

art cinema and the wondrous

Lutz Koepnick

 University of Minnesota Press

Minneapolis

London

Portions of chapter 1 were previously published in "Long Takes," in *Berlin School Glossary: An ABC of the New Wave in Germany*, ed. Roger Cook, Lutz Koepnick, Kristin Kopp, and Brad Prager (Bristol, U.K.: Intellect, 2013), 195–204. Reprinted with permission.

Published by the University of Minnesota Press
111 Third Avenue South, Suite 290
Minneapolis, MN 55401-2520
http://www.upress.umn.edu

Library of Congress Cataloging-in-Publication Data
Koepnick, Lutz P. (Lutz Peter), author
Title: The long take : art cinema and the wondrous / Lutz Koepnick.
Description: Minneapolis : University of Minnesota Press, [2017] | Includes bibliographical references and index. |
Identifiers: LCCN 2017001236 (print) | ISBN 978-0-8166-9584-3 (hc) | ISBN 978-0-8166-9588-1 (pb)
Subjects: LCSH: Motion pictures—Aesthetics. | Motion pictures—Production and direction. |
 BISAC: PERFORMING ARTS / Film & Video / Direction & Production. | ART / Film & Video. | PERFORMING ARTS / Film & Video / History & Criticism.
Classification: LCC PN1995 .K6575 2017 (print) | DDC 791.4301—dc23
LC record available at https://lccn.loc.gov/2017001236

CONTENTS

PREFACE AND ACKNOWLEDGMENTS

The book was written over the course of several years, a process often interrupted by other writing commitments, administrative obligations, and various unexpected events. Unlike most of my previous book projects, I had planned to write *The Long Take* in order, starting with the Introduction and finishing with the final chapter's last word. Needless to say, the idealism of drafting a book as if writing could emulate the logic of a long take didn't entirely pan out.

I am deeply grateful to the readers of the University of Minnesota Press for having identified a number of weak spots in the developing argument and the architectural setup of the project early on; to Nora Alter for taking the time to closely read the book late in the game and asking me to rethink various ill-conceived premises; and to my editor, Danielle Kasprzak, for pushing me—luckily—to administer more cuts and edits, reframings and modifications, than I initially had anticipated. In the end, the book's story of coming into being is not really that different from any of the others I have written before—with the exception that none of the chapters published here has been published as such before anywhere else.

I am thankful for opportunities to share my work in progress at professional conventions and during invited lectures at the University of Chicago, the University of Missouri, Rice University, Rutgers University, Vanderbilt University, the University of Virginia, Washington University in St. Louis, the universities of Cologne, Frankfurt, Potsdam, Tübingen, and Zurich, and the Nam June Paik Center in Seoul. The many insightful

comments I received when probing certain aspects of this book as it developed have been of tremendous help to strengthen the final book. A few passages of chapter 1 were published in my essay "Long Takes" in *Berlin School Glossary: An ABC of the New Wave in Germany*, edited by Roger Cook, Lutz Koepnick, Kristin Kopp, and Brad Prager (Bristol, U.K.: Intellect, 2013), and I am thankful to the publisher for allowing me to reprint these materials here. Sophia Clark provided tremendous assistance in tracking down permissions and helping prepare the book for publication.

Given the promiscuous nature of the long take in contemporary moving image culture, *The Long Take* was written with diverse audiences in mind. Readers might be familiar with certain subsets of materials and perspectives. I have tried to contextualize the discussion of individual projects in such a way that their stakes will be clear to readers no matter their disciplinary backgrounds and investments. Each of the chapters makes its case through detailed analyses—paradigmatic close readings—of individual works or constellations of works, reading what often resists reading, and placing as much conceptual pressure on the interplay of formal arrangements, temporal structures, and spatial articulations as each work can bear without defeating the delicacy of its aesthetic particularity. Readers may at times perceive this as a sacrifice of specificity; others may want to fault the author for not positioning individual image makers thoroughly enough in their respective discursive fields. At all times, my effort is not only to take the invitations and promises of each work as seriously as possible but to facilitate the transdisciplinary conversations that today's long takes themselves, as we will see, advocate.

INTRODUCTION

Toward a Wondrous Spectator

The central argument of this book is that contemporary moving image practice often embraces long takes—extended shot durations and prolonged experiences of moving image environments—as a medium to reconstruct spaces for the possibility of wonder. This is not to say that any effort to withhold a cut in films, video installations, and new media art is meant to shower the viewer with wondrous images. On the contrary. Much of what long takes have to offer today are either quiet, contemplative, often in fact emotionally flat and disengaging images, driven by a desire to collapse choreographed movement back into scenes of standstill; or spectacular designs showing off a director's bravura skills in coordinating motion and mise-en-scène, character blocking, and camera mobility. But most of the long takes discussed in this book do at once more and less than this. They come in different shapes and sizes; they exist across different media platforms. They crisscross the gray zone between black box and white cube, invite viewers to investigate possible tensions between the classical cinematic auditorium and today's practices of mobile spectatorship, and thereby urge their critics to develop new concepts of art cinema altogether. They may simply index the passing of ordinary time or open a hole in its fabric for the surreal and fantastic. What they all share, however, is their effort to rub against today's frantic regimes of timeless time, against today's agitated forms of viewership and 24/7 spectatorial self-management. What they share is that they all tap into the durational to make us probe different attentional economies as much as to clear the ground for the promise of the wondrous, the experience of something that

defies expectation but need not be encountered with fear, restless action, or speechless defensiveness.

Long-take cinematography has gained iconic prominence since the mid-1990s in the work of international art-house filmmakers such as Lisandro Alonso, Nuri Bilge Ceylan, Pedro Costa, Hou Hsiao-Hsien, Michael Haneke, Jim Jarmusch, Jia Zhangke, Abbas Kiarostami, Cristian Mungiu, Cristi Puiu, Kelly Reichardt, Gus Van Sant, Angela Schanelec, Aleksandr Sokurov, Béla Tarr, and Tsai Ming-liang. It has become commonplace to think of the work of these directors as deeply preservationist in nature, to subsume their films under the rubrics of slow and contemplative cinema, and to understand their aversion to the cut as a clear nod to the legacy of European postwar auteurs and their historical experiments with extended short durations. Long takes, it is often concluded, are the privileged stuff of cinephiles. They are designed for viewers passionate about the traditions of postwar art cinema and deeply suspicious about how digital technologies threaten the vibrant materiality of the analog experience. Long takes, it is often added, are also the stuff of those fervently trying to roll back social acceleration and advocate the pleasures of slower lives. They stretch or deflate time not to frustrate our attention spans but to intensify perceptual processes and sharpen our attention for what the rush of the contemporary renders mostly invisible. Best known for his long-take extravaganza *Russian Ark* (2002), Sokurov has summarized this valuation of extended short durations as such: "The most important quality the film image can possess is its capacity to offer the viewer sufficient time to peruse the picture, to participate in the process of attentive looking for something."[1]

Though much of this book will be dedicated to filmmakers urging their viewers to practice what Sokurov calls attentive looking, its central premise is that we miss the full import of the cinematic long take as a twenty-first-century laboratory of wondrous viewing if we see it in isolation from widespread efforts to engage the durational in other and digitally inflected moving image work today, be it screen-based installation art,

computer-generated animation, or sound-based work meant to activate the virtual screens of our visual imagination. In order not to set up wrong expectations, let me clarify at the outset that *The Long Take* is trying neither to contribute to cinephilic discourse nor to espouse recent writing on slow life and slow cinema as last repositories of authentic meaning in times of digital speed. Long takes today reference older normative assumptions about durational images. They tend to decelerate narrative economies, approximate what Justin Remes calls "motion[less] pictures,"[2] feature barren spaces, and screen states of affective alienation. Frequently they simply capture the sheer passing of time, as if André Bazin's concepts of cinematic realism still defined the order of the day. Yet as will become clear in the course of the chapters to come, the long take today is by no means bound to one medium alone. It travels across different platforms of moving image culture, many of which no longer rely on classical tools of capturing, disseminating, projecting, and storing pictures in motion at all. Mediums matter, but no medium has only one particular logic; nor can we associate one genre or mode of capturing time solely with the operations of a single particular technological configuration. As an effigy of the wondrous, the twenty-first-century long take serves as a focal point to rethink what it means to speak of art cinema today. What this book profiles as the aesthetic of the contemporary long take contests our culture of ceaseless alertness—not because it seeks to insulate different moving image practices from each other, but because it asks viewers to allow diverse practices in and beyond the cinematic auditorium, the museum's white cube, and the gallery's black box to cast light on each other. In this, *The Long Take* advocates expanded concepts of art cinema that cannot but cause considerable unease among those who ardently love celluloid-based modes of filmmaking and presentation.

As much as this book seeks to emancipate the long take from the grip of recent cinephilia, so does it resist the idea that long-take projects are primarily meant to preserve islands of contemplation, stillness, and silence. To be sure, most of the

films and screen-based works discussed in this book challenge the viewer's patience and endurance. They evoke temporal commitments that upend the pressures of chronological time while often offering little to guide the viewer's attention. While much of the work discussed here insists on the productivity of boredom and unstructured time, none of it will simply promote deceleration as a palliative to the ills of contemporary speed. Following and expanding the argument of my previous book, *On Slowness: Toward an Aesthetic of the Contemporary*,[3] the following pages understand slowness as a reflexive engagement with temporal passage, one that maps the heterogeneous copresence of multiple temporalities, of old and new, fast and sluggish, private and public times within the fabrics of the present. Rather than simply seeking to invert speed (and thereby confirm its dominance), slowness allows us to experience spatial realities as being energized by various rhythms, narratives, and historical dynamics. What I explore as the twenty-first-century long take follows this expanded notion of slowness and thus cannot be claimed as an automatic candidate for slow-life agendas. The long take distends time, derails the drives of narrative and desire, and hovers around the border between film and photography. But it does so not simply to slow down the speeds of twenty-first-century life. It instead seeks to gaze the present straight into the eyes so as to envision an altogether different order of temporality. By holding on to the figure of wonder in the form of an aesthetic promise, the long takes of this book, in their very probing of the durational, hope to clear attentional ground for a radical rupture in the temporal fabric—one able to allow newness to enter the present without shock and fear, one suspending any need to encounter the unknown with the nervous activism of contemporary self-maintenance. As presented in this book, long takes occupy a unique position in moving image art today to make time for time. They endorse the seemingly paradoxical effort to take time amid our ever-more timeless time to reflect on and push against the many proclaimed ends of time.

Consider, as a compelling exemplar for the long take's ex-

panded and polymorphic role in twenty-first-century visual culture, French artist Sophie Calle's *Voir la mer*, a multiscreen installation created in 2011 and impressively staged at the Musée d'art contemporain de Montréal (MAC) in spring 2015 (Figures 1, 2, and 42). *Voir la mer* captures the image of Istanbul residents—many of them migrants from distant areas of Turkey—who had never before seen the ocean. Calle notes, "I went to Istanbul, a city surrounded by water, I met people who lived there and had never seen the sea. I filmed their first time." The installation in Montreal consisted of nine large screens, some attached to the gallery's walls and others protruding at various angles into the exhibition space, thereby systematically obstructing the possibility to see everything at once. Each screen shows a medium close-up of a single person who first faces the sea, then turns toward the camera and faces the viewer directly. Captured in continuous long takes that last several minutes, Calle's collaborators respond differently when facing the camera and communicating the experience of first sight to the observational look of the apparatus. Some close their eyes; others smile; some remain seemingly stoic; others have tears streaming down their faces. Wondrous looking—the experience of first sight—here produces highly individual responses and traces; the sense of awe and newness yields different, often inscrutable reactions on screen.

While the spatial and temporal integrity of the long take in Calle's installation plays a crucial role in unfolding the nuances of looking and of being looked at, the viewer's experience—seeing multiple screens at once—certainly differs from the stillness displayed in each individual film. If the gaze of Calle's collaborators was initially directed toward one object alone, ours can peruse multiple screens at once, enacting what Harun Farocki has called the soft montage of multiscreen exhibition spaces.[4] Ours might at first be perceived by some as a highly distracted gaze impatiently hopping from one frame to another, whereas the postures of Calle's collaborators could not express a more heightened sense of attentiveness, focus, and presence. Yet Calle's architectural staging of first-time viewing certainly

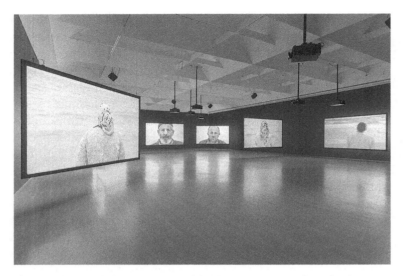

Figure 1. Sophie Calle, *Voir la mer*, 2011. Installation view from Sophie Calle, *Pour la dernière et pour la première fois*, exhibition at Musée d'art contemporain de Montréal, February 5–May 10, 2015. Photograph by Richard-Max Tremblay.

has the power to usher the visitor into a state of wonder. The installation structures our perception in such a way that the gallery environment as a whole pulls us out of ourselves and causes viewers to look with wide-open eyes at their surroundings: the museum's ambient world of things, bodies, screens, and images. Rather than merely looking at individual representations of wondrous looking, we experience a certain suspension of our own willful strides amid the space of the entire installation—a force attuning us to Calle's screenscape as much as allowing us to tune the visible field to our own moving perception. *Voir la mer* thus makes us pause to take in, navigate, modulate, and be modulated by different articulations of time in space. By showing wonder, it offers a temporally open ground for us to wonder about the people on screen—their biographies, the textures of their everyday life, the specificity of their emotional responses, and the tensions between intimacy and publicness, as well

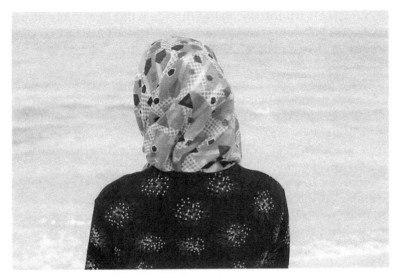

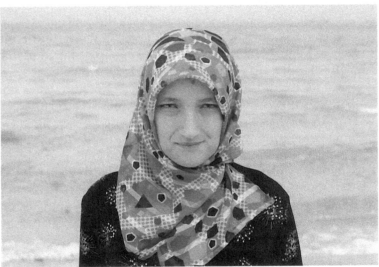

Figure 2. Sophie Calle, *Voir la mer. Smiling Woman,* 2011. 1 hour, 38 minutes, digital film with color and sound, TV screen, framed color photograph. 20¾ × 35¾ × 5¼ inches (screen) + 13¼ × 20¾ × 1 inches (photograph). Copyright 2017 Artists Rights Society (ARS), New York/ ADAGP, Paris. Courtesy of Galerie Perrotin, New York.

as how their wondrous seeing the sea will affect their future lives—and how our seeing them seeing the sea for the first time might affect our own seeing the sea next time.

As 24/7 media culture pushes more streams of information through screen-based interfaces, the twenty-first century causes wonder's spaces—such as the one of Calle's *Voir la mer*—to dwindle. To be sure, the virtual landscapes of the Internet are full of amazing surprises, and our electronic devices so well connected that possible objects of curiosity shout at us at all times. Nothing would be more mistaken, however, than confusing the agitation of contemporary screen life with the unsettling experience of wonder. As it ceaselessly compels users to formulate responses to the new, to follow links to amplify and monetize initial surprises, and to relay our astonishment to others, the culture of 24/7 in fact progressively undercuts what empowers wonder in the first place: a certain absence of expectation and a deliberate postponement of reaction, activity, and interpretation. Neither connected to shock nor to the sensational, the concept of wonder registers as quiet and pensive, judicious and discriminating responses to phenomena that strike the viewer as rare and first time. It initially exists outside the realm of the will, defers any demand for instant reply and communication, and defies impatient efforts of narrative integration. Contemporary screen culture, by contrast, with its omnipresent interfaces designed to communicate information, manipulate data, play games, purchase objects, measure fitness levels, and be guided to desired destinations while on the go, increasingly erases what it takes to register first-time experiences with quiet awe rather than edgy astonishment. Though the extraordinary may populate our screens at almost all times, we increasingly lack the resources to recognize it as such.

Few issues might matter more in our culture of digital media than the ongoing battle over attention: how omnipresent interfaces reward certain forms of attentiveness at the costs of others, how they screen and screen out viable experiences, how they enable or block productive negotiations of activity and

receptivity, focalized perception and distributed awareness, intentionality and the nonintentional. This book argues that the long take in contemporary moving image practice at once probes and recalibrates what it means to be attentive today. It deflates the disruptive haste of contemporary screen life to play out the promise of the wondrous against a culture of vigilant connectivity and mostly reactive self-maintenance. It slows down processes of perception—not for the sake of slowness itself, but to rebuild what it might mean to recognize and attend to the new as new, as a wondrous event in time. As this book will show in greater detail, the wondrous results from experiences that are neither expected nor fit preexisting concepts, categorizations, narratives, and meanings. Wonder happens suddenly. It ruptures the fabric of time, yet unlike the traumatic experiences of shock, the wondrous neither overwhelms nor petrifies the senses. It produces curiosity rather than fear, rapt attention instead of sensory edginess or mental shutdown. Unlike speechless astonishment and attention-grabbing spectacle, wonder energizes minds and senses to cross over or hover above the limits of the comprehensible. Unlike sublime shudder, it suspends the impulses of self-preservation with something that exceeds the workings of strategic reason. Though wonder disrupts temporal continuity, it requires time and duration. Understood as a twenty-first-century effigy of drift, dream, sleep, and unstructured passage, the long take serves as a stage and condition for wonder's possibility.

Robert Altman's *The Player* (1992) famously begins with a virtuoso eight-minute take explicitly referencing the history of the long take, in particular the dazzling opening shot of Orson Welles's *Touch of Evil* (1958). However, the rest of the film exhibits few takes that might stand out as unusually long. This book is not about projects that, like *The Player*, may only occasionally use extended-shot durations, be it to show off a filmmaker's talents to choreograph complex action, give talented actors the opportunity to play out their expressive potentials, or invite special effects crews to put to work their magic. Instead,

all works discussed in this book engage long takes in the expanded field of contemporary cinema as a cornerstone of their aesthetic ambitions; rarely will the focus be on acrobatic exercises that only showcase hypermobile camera operations and directorial control. My interest, in other words, is in long takes that result not in spectators shouting, "Wow, how the heck did they do that!," but in viewers who may find themselves investigating possible relations among the different temporalities on screen, the temporal orders of the projection situation, and the rhythms of their own physical and mental worlds. My interest is in moving image work that embraces extended-shot durations as a medium to provide a space not for mere spectacle and astonishment but for reconstructing spaces for wondrous looking in the face of its ever-increasing disappearance. To unfold the dimensions of the wondrous in detail and clarify how it differs from other concepts often used as if they were interchangeable, let's go for a brief ride with one of the most demanding long-take filmmakers of the last decades: Hungarian director Béla Tarr.

A Horse with No Name

For more than six minutes, the opening shot of Tarr's *The Turin Horse* (2011) tracks the movements of an old horse as it pulls a cart and its driver along a wooded path. Fierce winds blow from all directions. The camera follows the horse with uncompromising curiosity and focus. At times it closes in on the horse's head, or it moves slightly around and ahead of the horse. At other times, it draws back a bit, sinks nearly toward the ground, or lifts upward in order to open the frame and intensify the shot's kinetic energy and its affirmation of motion for motion's sake (Figure 3). Later in the film, we come to learn that the cart driver, his nameless horse, and his nameless daughter live a life of dreary routines and repetitions—an existence devoid of newness and difference, meaning and transcendence. For now, however, Fred Kelemen's camera simply offers a technically complex choreography of forward motion, a riveting dance whose dynamic properties celebrate what cinema as an

art of moving images might be all about. Though God is dead, as Tarr will detail in the remainder of his film, cinema—at least in the opening shot of *The Turin Horse*—appears alive and well. It might refuse to tell a story; it might offer views that do not really demand any interpretative work from us. But cinema here certainly extols its constitutive ability to set images into motion, to capture and project temporal passage, and hence to animate the space of both representation and perception.

Yet most viewers, accustomed to the dominant conventions of visual storytelling and editorial pacing, will find little in Tarr's long take to maintain attention. At first we may admire Kelemen's proficient camera work; we may allow the camera's and the horse's motion to affect our own desire for mobility. But in the complete absence of any narrative cues or teleological direction, Tarr's shot will soon inevitably cause irritated reactions. "I get it, so now please cut!" it shouts inside our heads as the camera holds on without giving us any hint at what could possibly end the shot's durational excess. Our fingers start tapping our knees; our eyes begin to veer across the screen, yet they fail to discover anything new. We squirm in our seats, look around for support. Contemplativeness yields to exasperation.

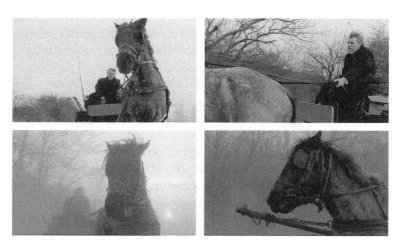

Figure 3. Béla Tarr, *The Turin Horse*, 2011. Screenshots.

Annoyance takes over and defeats whatever may be left of our initial sense of engagement. Claustrophobia stifles the earlier joy of movement. We crave for a cut. We demand a cut. We feel violated by the shot's stubbornness. We yearn for redemption by something as simple as a perspective different from the present one. And finally (if we haven't left the theater already), we may give in and open up to our own exhaustion, to how Tarr's shot has completely consumed our initial sense of anticipation. We surrender to the slow passing of time, we suspend narrative expectations, and we eventually might even experience the shot's utter drainage of wonder as the film's true wonder itself. Sooner or later, of course, some cut will happen and transport the viewer somewhere else. It takes thirty or so more takes to go over the course of more than 140 minutes, each take probing anew our ability to delay desire and forsake the drive of narrative progression. All of the takes exhaust our endurance beyond redemption, yet they thus precisely activate something forgotten amid the pulsating images of contemporary screen culture: a desire for a world in which we can again afford the pleasure and passion of wonder.

It might be difficult to find two viewers able to agree about the exact point at which the opening shot of *The Turin Horse* turns into a long take (three seconds? thirty seconds? three minutes?). Yet the absence of temporal certainty and impartiality—the ontological fuzziness and phenomenological relativity of what may count as long in the first place—define one of the central features of the long take's ecology in the twenty-first century. Long takes like Tarr's embrace the mechanical time of moving image projection to open a door for the unpredictable temporality of human experience. They cast the viewer's perception back onto itself so as to make us sense or own seeing and explore the immeasurability of the durational amid today's fast-paced screenic environments. As even seasoned Tarr viewers will be happy to admit, today's long takes encourage us to probe the difficulties of sustained attention, not to punish viewers conditioned by the rhythms of 24/7, but to set up a space in which we can investigate what is irreducibly indeter-

minate and incommensurable in our lives as viewers of images in motion. Though Tarr's images at first often appear haunted by a remarkable absence of affect, a traumatic logic of repetition and indifference, their aim is to envisage futures where trauma, fear, and ever-alert self-management cease to have a hold on what we know, how we act, and what we sense. In essence, they, like the individual displays as much as the entire screenscape of Calle's *Voir la mer*, surreptitiously insist on the fundamental productivity and openness of time—time's ability to make us experience the unexpected, sudden, extraordinary, and wondrous.

In Plato's dialogue *Theaetetus*, Socrates famously identified the feeling of wonder (to thaumalein) as the true and only beginning of philosophy. Wonder emerges from a moment of surprise, a sudden knowing of our own ignorance. It sparks our passion to know, to think, to be curious, and to overcome the unexpected disorientation of our minds and senses. Centuries later, René Descartes described wonder as the most fundamental of all the passions, one that, unlike any of the other passions, would know no opposite and hence affords remarkable purity and vehemence: "When the first encounter with some object surprises us, and we judge it to be new or very different from what we formerly knew, or from what we supposed that it ought to be, that causes us to wonder and be surprised; and because that may happen before we in any way know whether this object is agreeable to us or not so, it appears to me that wonder is the first of all the passions."[5]

Wonder in both Plato's and Descartes's sense defies anticipation and narrativization. What makes us wonder transcends possible expectations and must happen in excess of advance reflection. It is triggered by the sudden experience of something extraordinary, singular, and incommensurable. "For the full experience of wonder," writes Philip Fisher, "there must be no description beforehand that will lead us to compare what we actually experience with what we are told, or even with the level of expectation raised by the one who told us to close our eyes. The object must be unexpectedly, instantaneously seen

for the first time."[6] In the moment of wonder, objects or events suddenly stand before us in all their detail, presence, and totality. Rather than simply add something interesting or stimulating to the flow of time, the event of wonder disrupts given temporal fabrics and structures of expectancy altogether. It bursts asunder the textures of the ordinary by presenting the subject with something rare and unforeseen—with something we can neither will nor desire; with something that because of its radical newness resists repetition, standardization, and interpretation.

Because of the modernist privileging of active and critical over passive and merely consumptive forms of viewership, we have come to think of (and be suspicious about) the wondrous as a mode of experience that overwhelms the viewer, knocking us out of our minds and senses. But to understand wonder as a force paralyzing the subject largely misses the qualities ascribed to it by its philosophical advocates. Unlike the violent forces of shock and trauma, wonder has the more moderate ability to make us thoughtful. It captures our attention to make us see the world without possible obstructions, and in so doing, it permits us to learn how to sense our own seeing. While wonder can certainly emerge from situations charged with threat and terror, in most cases, it describes experiences of affirmation and amazement. Wonder accompanies perceptions of a world in which we can joyfully surrender our willfulness and open our senses and minds without fearing damage or annihilation.

The category of wonder has not fared well in what Max Weber famously called the modern age of disenchantment and rationalization.[7] Romantic scientists around 1800 still aspired to turn the passion of wonder into a viable engine of individual research and discovery, hoping to fuse the poetic and the scientific, awe and systematic exploration.[8] Yet modernity's inherent stress on routinization and standardization, its privileging of reflexivity and rational explanation, its ever-increasing proliferation of sensory stimuli and spectacular distractions, and its emphasis on interpretative agency and autonomous meaning making have all largely diminished the space for what Roman-

tic explorers such as Joseph Banks and Wilhelm Herschel considered the productivity of wonder. Wonder shriveled in face of Kant's call for reflective intellectual maturity as much as it was flattened by the spectacles of Theodor W. Adorno and Max Horkheimer's culture industry.[9] It had equally little to claim for itself in Taylorist manufacturing plants as amid the restless crowds of the modern metropolis. Regimented research practices depleted wonder's accent on first-time experience as much as the rise of modern telecommunication, in whose wake instantaneous connections across dissimilar spaces have become the order of the day. If modern urban culture, in Walter Benjamin's observation, largely evacuated true experience and favored traceless distraction over contemplative absorption,[10] then this age equally weakened the grounds for what it, according to premodern philosophers, took to be moved by wonder. To find oneself in Weber's iron cage of modernity meant to be deeply suspicious about the wondrous—about the association of curiosity with vehement passion, the sudden suspension of strategic willfulness, and the disorienting interruption of ordinary time.

Scholarly writing on cinematic temporality, in its frequent effort to infuse Gilles Deleuze's thoughts on time and motion with Lacanian and Žižekian psychoanalysis, tends to consider Tarr's long-take aesthetic as a direct continuation of what in Weber disenchanted the modern world and killed the wondrous. Todd McGowan's notion of atemporal cinema, meant to amend Deleuze's concept of the time-image, provides a symptomatic example for this tendency.[11] For Deleuze, the cinematic time-image in the work of postwar European auteurs presented time as the continual emergence of the new. It described the cinematic unfolding of durations that carry the past along yet avoid the cliché and boredom of repetition. What McGowan calls atemporal cinema—films such as *The Constant Gardener* (2005; dir. Fernando Meirelles), *21 Grams* (2003; dir. Alejandro González Iñárritu), *2046* (2004; dir. Kar Wai Wong), and *Memento* (2000; dir. Christopher Nolan)—is designed to renounce this kind of optimism, the narrative film's built-in

desire for transcendence and redemption. It acknowledges the lasting structures of painful losses, and by denying our hope for an open future, it teaches spectators to accept the traumatic origin of subjectivity and the temporal. The glacial long takes of Tarr's *The Turin Horse* at first certainly invite us to be seen as stylistic exercises in getting, in McGowan's terms, beyond temporality, to radically refuse any progressive notion of history and hence amend our lives to the stagnation of Weber's disenchanted age of modernity. Yet it is one of the principal ambitions of the following chapters to correct such one-sided understandings and to show that today's most demanding use of sustained shot durations, in its very exploration of the durational as a point of resistance against the contemporary logic of compulsive connectivity and interactivity, beats the templates of atemporality at their own game and envisions the return of wonder in the form of an aesthetic promise. Tarr's long takes, similar to those of many image makers discussed in this book, radically exhaust images, viewers, and narrative time to supersede the mind-numbing effects of ceaseless interruptions and quasi-Pavlovian expectations of instant responsiveness. They withhold the displacing energy of the cut and explore the boundaries between the animated and the static—not in the name of disenchanting realism or stoic endurance but to make us probe our economies of attention and preserve the promise of a world in which we may recuperate our ability to be amazed by something that unexpectedly presents itself to our eyes. Like the shot of the nameless horse, the contemporary long take fuels our passion for passion, inviting us to desire something that Tarr's images themselves often systematically refuse to show.

Consider another crucial scene in Tarr's *The Turin Horse*. After showing, for almost two hours and in painstaking long takes, the daily routines of farm life during a relentless windstorm, Tarr's camera eventually pictures the attempt of farmer Ohlsdorfer and his nameless daughter to escape their desolate homestead (Figure 4). They pack up their things, load the cart, and yoke their horse. The film, without a single cut, first follows the farmers' journey along the ridge of a nearby hill, the

camera at times gently panning, at times almost imperceptibly zooming in on our traveling protagonists; it allows the travelers to exit frame and image as they move across the crest into the next valley; it lingers for some time on the evacuated sight of the hill, as if probing the threshold of our willingness to no longer perceive the visible field as being structured by the farmers' absence. Then, when our two farmers, horse, and cart suddenly return again, it retraces every step it initially took to move the viewer along with the film's protagonists from farm to hilltop. While the motivation for the farmers' flight is clear, Tarr leaves us in utter darkness about both the intended destination of their journey and the actual reason for their aborting the trip and returning to the routines of farm life. The sequence of events is no doubt devastating. But how, in face of the long take's provocative denial of explanation and narrative representation; how, in the wake of not being invited to see beyond the hill and not knowing what may have caused the farmers' return, can we as viewers not find ourselves struck with curiosity? How can we, vis-à-vis the crucial riddle of Tarr's long take, not ponder the promise of a life beyond the farm's senseless repetition? And how can we, without anything left to interpret, not contemplate the desirability of what the camera itself declines to show: the productivity of time to produce difference and newness; a rupture in the fabric of temporality transporting protagonists and viewers alike to a world categorically different from the postutopian stagnation Jacques Rancière locates at the center of Tarr's cinematic world?[12]

Wonder, then, in contemporary cinema's renewed affair with the long take, often performs the function of a message in a bottle: a promissory note projected into and drawn from a future more hospitable than the present. Film at times approaches still photography so as to confront what critics such as Paul Virilio consider the rushing standstill of our accelerated present—that is, the way in which speed and furious mobility today no longer appear to lead anywhere at all.[13] Pessimistically, the contemporary long take provides durational images that often have nothing left to tell, show, or explain. Yet in doing so it does not seek to offer a mere realistic index of (empty) time but rather

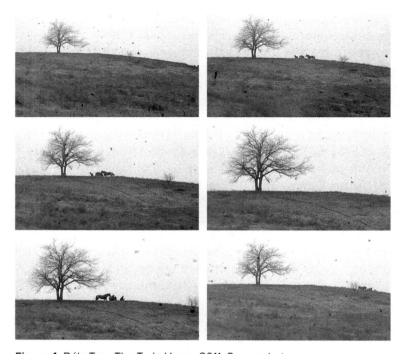

Figure 4. Béla Tarr, *The Turin Horse*, 2011. Screenshots.

to rekindle our hope for a different order of temporal experience, one able to release us from the secret standstill of our frantic present and its fast-track pursuit of the next big thing, of postcontemporaneity.[14] "My heart," Wordsworth wrote in 1802 to illustrate the vehement passion of wonder, "leaps up when I behold / A rainbow in the sky."[15] The long take today seeks to clear ground, frame, screen, and space as a precondition to make our hearts leap again. It makes us probe our attentional commitments and provides images and narratives that do not seem to want all too much from us, well aware that the breathless intensity of contemporary (screen) culture, as well as its almost seamless commodification of emotion and affect, deplete our very ability to be moved and amazed by any sudden first-time experience.

Undoing Distraction?

It is appropriate for this introduction to surround our concept of the wondrous with related concepts of viewership to clarify its specificity. Five neighboring categories come to mind: contemplative viewing, reverie, absorption, pensive spectatorship, and possessive looking. All echo some elements of the wondrous, yet none of them is fully compatible with our notion of a viewer encountering the uncut passing of cinematic time to wait for something that—all things told—cannot be awaited.

Contemplative viewership requires attentive spectators eager to devote considerable time to look at a particular object or image and scrutinize it in all its possible detail and depth. As John Armstrong reminds us, the process of contemplation involves five interrelated aspects. It moves from noticing certain details (animadversion), seeing relations between selected parts (concursus), and seizing an object or image in all its totality (hololepsis), to allocating a lingering caress to the thing in question, and, last but not least, to experiencing a sense of absorption, of "taking something inside so that it is retained and has influence upon our reflections and habits."[16] Contemplation can be thought as an open-ended and by no means teleological process. It in some measure relies on what we bring to the work; we may return to any of its aspects at any moment; we may find ourselves abandoning its course at various junctures without necessarily annulling its success. In Benjamin's famous conceptualization, contemplative viewing was additionally associated with the recursive and premodern time of religious ritual, the authoritative uniqueness of certain works, and the viewer's desire to relinquish desire—our willingness to disappear into what is in front of our eyes similar to the legendary Chinese painter who vanished in his own creation. To contemplate a work of art was to behold and surrender to its aura, its unquestionable here and now, the "unique apparition of a distance, however near it may be."[17]

Acts of reverie by and large miss what is dialectical about the process of contemplation—its constitutive back-and-forth

between subject and object. Whereas the contemplative requires delicate negotiations across the boundaries of interiority and exteriority, the imaginative and the material states of reverie return the observing subject to itself. In reverie, we allow external stimuli—a painting, an architectural volume, a melody—to set our imagination into motion and follow the lead of ever-shifting associations. Reverie is therefore devoted less to a particular object in all its details and relations than to the wanderings of the mind itself, its ability to suspend the pressures of the real, its resistance to logic and structure, its unpredictable power to generate mental images and affects. To revel in an object is to permit this object to trigger thoughts, memories, anticipations, and feelings without us perceiving any need to check the appropriateness of our response. It is to ingest the object, to intoxicate ourselves with it—not in order to do justice to the object's material or semantic richness but to be transported to interior places no one, including ourselves, has ever visited before. In states of reverie, linear or chronological time ceases to exist, while body and mind playfully delay existing dictates of causality, order, reason, and meaning.

Easily confused with both contemplation and reverie, absorption, as a state of its own, was perhaps most poignantly defined by Denis Diderot in the eighteenth century. In the *Encyclopedie* of 1751, Diderot explained absorption by juxtaposing it with a state of being engulfed by something: "To absorb expresses a general but successive action, which, beginning only in one part of the subject, continues thereafter and spreads over the whole. But to engulf indicates an action whose general effect is rapid, and seizes everything at the same time without breaking it up into parts."[18] Though defined as an active state of attention, absorption required the subject to enter a certain state of obliviousness and unconsciousness, a ceding of self-awareness and willfulness. For art to appeal to the viewer's absorptive faculties, it had to do everything at its disposal not to acknowledge the viewer's presence in front of the painting or play. Absorptive art had to represent human figures engrossed in certain activities while entertaining the fiction that possi-

ble audiences were not in existence. In more recent criticism, the category of absorption has played a central role in the work of Michael Fried, which initially rallied against the way in which minimalist and conceptual art of the 1960s enlisted the viewer—theatrically, as it were—as an active participant in the "work," and later and less polemically was used to probe the staging of human action, narrative, and time in contemporary photography.[19]

Pensive spectatorship had first been conceptualized by film theorist Raymond Bellour to describe retardations of cinematic time—for example, the representation of a photographic picture within what appears to be a frozen frame—that grant viewers time to add to the image on screen. In their most common form, cinematic images, Bellour argues, never achieve completeness. They are constantly drawn toward other images, frames, and perspectives; they are in flux, impelled to displace each other and hence to block the viewer's ability to ponder and reflect. Pensive spectatorship, by contrast, emerges in response to volatile suspensions not only of narrative linearity but also of the mechanical drive of cinematic recording and projection. Sudden moments of stillness such as the view of a photograph provide an aperture for the viewer to "recoil from the image,"[20] to explore the possibility of other times and narratives, and to reflect on the operations of cinema itself. It may even enable the spectator to behold what Roland Barthes famously called the photographic punctum—that unpredictable event of being personally wounded or touched by the indexical power of a photograph and its ability to display the past in all its uncoded contingency. More recently, Laura Mulvey has further developed Bellour's notion of pensiveness in order to flesh out what she calls delayed cinema: expanded forms of cinematic viewership in whose context digital technologies empower spectators to freeze individual images or repeat selected scenes at will and thus to watch films on one's own temporal terms. Pensive spectatorship today, according to Mulvey, results from our relatively new ability to control cinematic time. It involves shifts of consciousness between different temporalities, and it reflects

a willful dissolution of narrative, fiction, and cinema's illusion of movement so that the indexical force of cinematic representation and "the time of registration can come to the fore."[21] By halting a film's flow of time, we can ponder the image and use moments of attentive stillness as a means to move visual pleasure beyond the classical template of voyeuristic distance.

In Mulvey's more recent work we meet the notion of the possessive spectator: a highly attentive viewer empowered by digital technology to delay or freeze narrative temporality to most intensely consume the image of the star, in particular in form of a close-up. Possessive viewership suspends the presumed narrative laws of cause and effect; it willfully interrupts a film's drive and its elusive progression of images in hopes of gaining control over the appearance of desired objects and thus turn acts of viewing into means of fetishistic pleasure. As Mulvey writes, "The possessive spectator commits an act of violence against the cohesion of a story, the aesthetic integrity that holds it together, and the vision of its creator."[22] While such violence may express desire for mastery and sadistic power, it at its best reminds the viewer of cinema's uncanny power to show the past as present and to reanimate the dead. Fetishism, rather than merely channeling sadism, allows viewers to attend to the way in which great stars perform their talent, beauty, and attraction on screen, even long after their physical demise. In his or her effort to delay narrative flow so as to consume iconic images most perfectly, possessive spectatorship thus has the potential to make us experience cinema's indexical mummification of change, its mysterious embalming of time. Mulvey notes, "In the act of halting the flow of film, then returning it to its movement and vitality, the possessive spectator inherits the long-standing fascination with the human body's mutation from animate to inanimate and vice versa."[23]

What I call the wondrous spectator—that is, a viewer probing the durational as an aesthetic laboratory to reconstruct our sense for experiencing things at first sight—shares some of the key features of the contemplative, the revering, the absorbed, the pensive, and the possessive viewer—not least of

all their quest for sustained and intensified forms of attention as well as their constitutive attachment to a certain suspension of narrative teleology and linear time. Similar to all these different types of attentive viewership, the wondrous spectator runs up against the different temporalities that constitute the cinematic experience: the apparatus's mechanical time of projection, a film's narrative time, the audience's own temporal rhythms and expectations. As enabled by the long-take aesthetic of contemporary art cinema, wondrous looking encounters moving images as a source of untapped opportunities and curious promises. Like its five neighbors, it desires a recalibration of attention in the hope of changing dominant templates of moving-image consumption as much as it seeks to press the medium of cinema—its definition as an art of moving pictures—toward its own technological, formal, or phenomenological limits.

Yet we do well to note some fundamental differences at this point already. Unlike the contemplative viewer, wondrous spectators have little desire to disappear into the image on screen. They might tune and retune the relationship between sensory systems and their environments, but they are not in pursuit of altogether relinquishing the difference between subject and object, perceiver and percept. Nor does wondrous viewing—viewing that partakes of the promise of wonder—mean to encounter visual representations as auratic or religious icons. In the context of this book, wonder functions as a nontheological category, and unlike the contemplative viewer, wondrous spectators cannot do without allowing their curiosity to probe what might exist beyond the unique frame of representation, the particular space and time of display. In contrast to viewing in reverie, wondrous spectatorship emerges as a response to a systematic draining of the image and its ability to trigger processes of free imagination. States of reverie revel in subjective experiences of plenitude and excess; wondrous spectatorship commences with the experience of a radical reduction and formalization of perception while it is fundamentally opposed to exploiting the image as a mere crutch for acts of unbound

association. Absorptive viewing, with its fiction of undisturbed onlooking, has been at the heart of classical narrative cinema. Its antitheatrical moment, however, as well as its reliance on the representation of human figures deeply engrossed in their respective activities, is hardly compatible with what I call here wondrous spectatorship. Unlike Diderot's and Fried's absorbed viewer, wondrous spectatorship today largely emerges vis-à-vis and amid images that may show no signs of significant human action whatsoever. Rather than celebrating the impenetrability of the cinematic fourth wall, wondrous spectatorship originates from how particular long-take experiences provoke our patience, upend our will to interpretation, and hence—at least initially—actively recognize our mental and physical presence in front of an individual screen, or in the midst of an entire landscape of screens.

While wondrous spectators clearly share a pensive and possessive viewer's pleasure in narrative delay and pause, their crucial differences cannot be overemphasized. According to Mulvey, pensive and possessive viewership today is deeply indebted to digital technologies of time shifting. It relies heavily on how contemporary viewers actively manage the flow of cinematic and filmic time, on how remote controls, random-access technologies, and digital interfaces allow us to manipulate the speed of moving images and hence consume cinema selectively and according to our personal temporal terms. The wondrous, by way of contrast, cannot do without a certain cessation of temporal willfulness, without the viewing subject's ability to let go, drift, and submit to the very passing of time presented on screen or enabled by the environments of screen-based installation art. Wondrous spectatorship relies on and fosters mimetic relationships to the sheer movement of cinematic time. It hopes to reinstate the art of nonintentionality not in order to celebrate the end of the humanist subject but rather to reinvigorate and enrich what we might want to understand as subjectivity in the first place. Rather than reassemble a given film entirely according to an individual's temporal agendas, wondrous viewership seeks to move beyond the willful and the instrumental, be-

yond the logic of self-preservation and self-empowerment that largely drives contemporary screen culture and neoliberal individualism. Unlike the pensive and the possessive spectator, wondrous viewers probe and suspend the dominant rhetoric of sovereign viewership. They hover in between the sensory and the cognitive, the active and the passive, not only because they no longer believe in the normative frameworks that once automatically valorized spectatorial activity over mere acts of visual consumption but also because in our culture of all-pervasive networking and ubiquitous screenic entertainment, spectatorial activity and interactivity often turn out to be the actual problem. Wondrous spectators take aesthetic pleasure in delay, drift, and suspension; they partially submit to the pure passing of time on or amid screens precisely because they no longer endorse what drives Mulvey's account of the emancipatory power of pensive and possessive viewership. For wondrous spectators, the central dogma of twentieth-century modernist filmmaking has lost its critical viability. As they encounter the long take as a source of aesthetic experience in all its indeterminacy and openness, wondrous spectators complicate our understanding of what good and critical filmmaking once was believed to be about: to activate viewers by exposing the basic operations of the cinematic apparatus.

It is against this background that I can also, and without much additional effort, eliminate any possible misreading of wondrous looking as a mere reinscription of early cinema's so-called aesthetic of attraction, of astonishment and spectacle. The concept of attraction has served film theorists and historians for the past three decades as an important conceptual staple to discuss how cinema in its first decades of existence solicited conscious awareness of the filmic image at the cost of providing integrated fictional worlds and how cinema sought to stimulate astonished responses by turning the viewer's attention to the machinations of cinema itself—the very spectacle of putting images into motion.[24] Though the logic of attraction by 1910 was largely succeeded by films eager to tell self-enclosed stories and not simply cater to the viewer's hunger for visual

thrill and sensory spectacle, the early cinema of attraction has found potent heirs in the era of full-length feature filmmaking in elements as diverse as the dance number of a musical; the sight of a fantastic space ship; a shootout on Main Street; a car chase in a crime film; even a close-up of a beloved star seemingly presented for our personal pleasure. In continuation of cinema's early pleasures, such moments stress the exhibition value of cinema, its ability to show something for the sake of showing. They appeal to viewers who enjoy cinema as a mechanism less to tell stories than to produce powerful illusions, magic sensations, and sensory spectacles of first rank.

The concept of wonder in many respects anticipates and relates to cinema's attraction and spectacle, which appeal to viewers' curiosity. Yet whereas spectacle is mostly associated with short-lived astonishment about the machines and apparatuses that make this viewing possible, attraction relies on unexpected and unprecedented experiences of resonance—a reciprocal tuning of viewer and viewed that each relies on and requires the other to dissolve preconceived boundaries between subject and object, self and object. Unlike the spectacular appeal of the early cinema of attraction, the wondrous elicits surprise and curiosity about the "what" rather than the "how" of the visible, about the world conjured by the moving image rather than the sheer power of machines to project such a world. Whereas we mostly have come to use the concepts of attraction and spectacle to describe viewing pleasures that numb viewers' senses, overwhelm them, engineer useful emotions, and offer instant gratification, the wondrous denotes experiences that open the door to what is incommensurable and unexpected, to what defies measurability and reconfigures what we identify as a viewer in the first place. Wonder, spectacle, and attraction all engage the senses and disrupt temporal flow. But whereas the latter two anticipate surprise, cast it into prefabricated forms, and thereby affirm existing structures of subjectivity, wonder resists measure and standardization. At once drawing on and producing different dynamics of attention than astonishment and spectacle, wonder's principal force

is to retune the very relation between world and perceiving self, the dynamic of anticipation and recollection.

Viewing Time

To make a film, Daniel Yacavone has written, "is also to construct a world. As viewers, we are invited to enter into this world, to share it with its maker(s) and with other viewers."[25] Twentieth-century film theory largely imagined this act of sharing as part of a process in which viewers, by being fully focused on the flickering light on screen, understood how to amalgamate the presentational and representational aspects of moving image display. We eagerly entered the two-dimensional images on screen because cinema managed to surround these images with a world, and cinema was able to construct such worlds because it could take for granted the figure of the silent onlooker, situated in a darkened auditorium and fully attentive to the entirety of the filmic product. Though certain avant-garde projects throughout the twentieth century fragmented, imploded, or expanded the space of projection, mainstream filmmakers, art-house auteurs, and film theorists saw little reason to question the most basic institutional foundations of filmic world making. They considered the immobile and fixated viewer as the central pivot of the cinematic situation, and when creating or theorizing different film worlds, they presupposed this viewer as a normative model to produce effective structures of absorption, challenge the codes of commercial cinema, and develop disruptive categories of critical viewing.

Film today no longer just constructs a world for viewers to enter. We instead encounter it as being part of various worlds already—as something that, because it often no longer can presuppose fully attentive viewers, begs and wildly beckons to enter our media-saturated environments. To live in an age of ambient media is to live in a world in which different mediated worlds surround, penetrate, and press against each other, a world in which we look at screens as part of larger spatial configurations as much as we look on and through them. In

the wake of these developments, the model of the silent and static spectator has lost much of its normativity, challenging both makers and critics to come up with new concepts to engage, describe, and critique acts of viewing—concepts that understand spectatorship as a situated practice that allows us to enter filmic worlds as much as it allows moving images to enter our world. This is not to say that we need to conceptualize moving images as mere ornaments of contemporary screenscapes, designed for viewers that may never show up or engage in any effort to read what they see. It is to say, however, that contemporary writing on spectatorship can no longer simply presuppose what it once took for granted: the existence of viewers not only unconditionally dedicated to enter the filmic world on screen but eager to do what these images—their intensities as much as their formal organizations—wanted them to do. Historical and contemporary efforts of expanding cinema beyond the classical projection situation, beyond the presentational and representational, might matter as never before to theorize today's exploded landscapes of cinema and spectatorship.

The Long Take approaches extended-shot durations and experiences from the standpoint that nothing about spectatorship today can be taken for granted anymore—not the viewer's undivided attention, and not whether a film's formal arrangements and narrative structures really produce the kind of reactions our writing and teaching typically proclaims. Screen-based installation art like Sophie Calle's, which often encourages mobile viewing practices with contingent durational structures, holds at least as much potential to think through the role of viewership in contemporary media culture as work primarily produced for theatrical exhibition, like Tarr's. It reminds us of the extent to which the specific milieu of moving-image display might matter as much for how the images interact with their viewers as to what is solely visible on screen; it draws our attention to the fact that processes of attunement—of how viewers explore synchronicities and nonsynchronicities between the temporalities of screenic images, their spatial configurations, and the movements of their own bodies—have moved to the

forefront of how we have come to live with and attend to moving images today.

The Long Take is about visual strategies that reckon with viewers who approach screens not as self-effacing windows onto and representations of other worlds but as dynamic architectural elements of their own world—viewers of the digital age who enter even classical theatrical auditoriums as environments in which durational commitments, physical immobility, and one-screen attention no longer count as an aesthetic or epistemological given. The twenty-first-century long take not only provides aesthetic spaces in which the workings of time and attention, structures of repetition, and promises of newness can be viewed, sensed, and contemplated, but with its aim to offer attentional stages for the possibility of wonder, it also invites viewers to develop reciprocal relationships between their own sense of time and the times and movements presented on screen and across entire screenscapes.

In an effort to move beyond worn discussions about the index, Tom Gunning has suggested that we reassess the nature of movement as a central ingredient of what today defines film as film. Film theory, he argues, not only needs to overcome its historical marginalization of animation, which largely resulted from its primarily photographic understanding of cinema, but it also needs to understand that cinema's engagement of motion—the technological animation of still images; the representation of movement across time; the manipulation of temporal passages across space on screen—can connect discussions of film style to the study of spectatorship: "The physiological basis of kinesthesia exceeds (or supplements) recent attempt to reintroduce emotional affect into spectator studies. We do not just see motion and we are not simply affected emotionally by its role within a plot; we feel it in our guts or throughout our bodies."[26] Film moves, puts things in motion, and in doing so moves us. Yet in the age of portable new media and multiscreen environments, our bodily or perceptual movements play a critical role in moving film as well, to animate screenic images and dynamize the experience of space. In Gunning's perspective,

a renewed focus on questions of motion will not only allow for a better understanding of the polymorphic nature of cinema today but will also move film theory and film studies beyond listlessly seeking to couple discussions of film style to arguments about the putative realism of the indexical and the phantasmagorias of the nonindexical image: "Like Mercury, winged messenger of the Gods, cinematic motion crosses the boundaries between heaven and earth, between the embodied senses and flights of fancy, not simply playing the whole gamut of film style but contaminating one with the other, endowing the fantastic with the realistic impression of visual motion."[27]

Like cinema in general, art cinema today too exists in the plural. It can take place in classical auditoriums as much as in gallery spaces, on domestic television screens as much as with the assistance of handheld devices. Continuous efforts to categorically distinguish between art cinema and a cinema of art, between artist's cinema and auteur cinema, between art-house cinema and film art, no longer meet the diversity of distribution channels and viewing platforms for moving image work in the twenty-first century. Instead of trying to play out different institutional sites, disciplines, traditions, mediums, and artistic practices against each other, *The Long Take* deliberately navigates the reader across the expanded landscapes of moving image work today and tracks twenty-first-century art cinema in hybrid spaces that neither film historians nor art critics, cinephiles nor new media theorists can claim as rooms of their own. Yet though art cinema is messy and polymorphic today, *The Long Take* recognizes as one of its common denominators the reflexive exploration of motion and the promise of wonder: the way in which the kineticism of moving images can raise profound questions about memory and anticipation, presence and absence, progress and standstill, speed and slowness, continuity and rupture.

Regardless of its platform and institutional setting, art cinema's principal focus today is on the experience of motion in time, of temporal passage within and across the frame of the screen. The long take figures as a privileged medium to carry

out this inquiry. It offers temporalized spaces in which the worlds of filmic images and the worlds of spectators coevolve and can openly and without coercion engage with each other, whether these worlds push against another, take over, nestle into, or partly penetrate the limits of the other. In 1952, Adorno wrote about the promissory character of contemporary music: "By voicing the fears of helpless people, it could signal help for the helpless, however feebly and distortedly. In doing so, it would renew the promise contained in the age-old protest of music: the promise of a life without fear."[28] The long take in the expanded world of contemporary art cinema might often test, tease, provoke, and perhaps even suspend our ability to wait and our desire to anticipate. All things told, however, it pursues nothing other than what music and art, in Adorno's modernist view, was all about: to keep alive the promise of a future able to eliminate fear, the promise of a future in which we no longer need to dread what cannot be predicted and in which we can be curious about what exceeds existing templates of interpretation, explanation, and understanding.

Rather than simply continue the legacy of postwar auteurism, then, long takes reconstitute art cinema today as a form of cinematic practice whose principal aim is to investigate the temporal dimensions of attention in the face of 24/7's stress on ceaseless alertness; it is to probe what Laura Mulvey has called the "difficulty of understanding passing time" today.[29] The book's architecture is designed to lessen some of these difficulties. The first chapter reviews the history and theory of the twentieth-century long take and its echoes today. Contrary to traditional emplotments, I will place this history in a conversation with the emergence of what artists and critics in the late 1960s began to call expanded cinema, understood as an intervention challenging the dominant templates of cinematic exhibition and unknowingly anticipating the explosion of moving images, screens, and cinematic time into all aspects of life in the twenty-first century. The following chapters discuss and juxtapose the work of filmmakers and visual artists in what I hope to be innovative and mutually illuminating ways.

Even-numbered chapters typically explore certain concepts and aesthetic practices in more experimental forms, probing interpretative perspectives that will then be developed in more systematic fashion in the next odd-numbered chapter. Recalling a perhaps somewhat seasoned art historical practice, many of these chapters follow a certain stereoscopic logic as they revolve around the work of two different image makers and develop their arguments by exploring one position in light of another. Other chapters, however, in particular the one on Michael Haneke (chapter 5), focus on a single thing. In this case, I argue primarily that we should not think that all long takes produce the wondrous and that some filmmakers, in contrast to most of the work profiled in this book, even use extended shot durations to elicit what I call antiwonder. The concluding chapter, rather than merely summing up and synthesizing everything that has been said, makes a final case why any writing on the long take today cannot afford to ignore work done for mobile viewing platforms and even video games. In spite of the fact that many critics continue to associate the latter in particular with popular mass culture, the operative images of handheld screens and games help sharpen our understanding of the unframing of cinematic time in the twenty-first century, and of how the ubiquity of screens and moving images today recast society and culture as cinema with other means. It has become commonplace for authors, in our era of sleepless haste and 24/7 availability, to invite readers to read their books in any given order. Though *The Long Take* was by no means written across one continuous stretch of time, the rhymes and echoes between individual chapters will become most apparent when read in the order presented.

TO CUT OR NOT TO CUT

The Art of Sleep

On January 17, 1964, the Gramercy Arts Theater in New York premiered Andy Warhol's *Sleep*, a film lasting 321 minutes and featuring the sleeping body of Warhol's friend, John Giorno, in probing long takes (Figure 5). Rumor has it that only nine people attended the opening, two of whom left during the first hour. The film's length and static images seemingly asked for resources audiences were not willing to contribute. *Sleep* fared somewhat better when first shown at the Cinema Theatre in Los Angeles in June 1964, with around five hundred viewers in attendance. Yet as Jonas Mekas reported later, many attendees showed as little discipline as the group of spectators in New York earlier that year. People began to leave the auditorium fifteen minutes into the film and insisted on their money back; others yelled at the screen, moved restlessly around the theater, or talked to other patrons while Giorno continued to sleep on screen. Only fifty viewers made it to the end. Contrary to expectation, however, Warhol himself "was apparently untroubled by viewers becoming distracted, talking, or even walking in and out of the theater during the screenings of his films. And that is precisely what happened. Sympathetic audiences often lingered for a time, went into the lobby to 'hang out,' then went back into the theater after a time to continue the experience."[1] What mattered for Warhol was not to glue the gaze of his audience to the images on screen. What mostly mattered was to invite

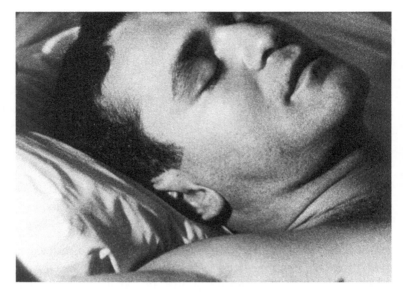

Figure 5. Andy Warhol, *Sleep*, 1963. 16mm film, black and white, silent, 5 hours, 21 minutes at 16 frames per second. Copyright 2016 The Andy Warhol Museum, Pittsburgh, Pennsylvania, a museum of the Carnegie Institute. All rights reserved.

audiences to drift, roam, and acquaint themselves with each other, with the film's long takes providing a hospitable space to engage with much more than the projection of an artistic work.

At once overtaxing and undisciplining the viewer, Warhol's pondering exploration of sleep materialized at precisely the moment when European art cinemas, dedicated to the figure of the auteur, developed unsettling cinematic languages for new strata of sophisticated critical viewers. The years 1961 and 1962, for instance, witnessed the American release of Michelangelo Antonioni's famous trilogy of modern disenchantment and discontent, its films not simply challenging classical models of cinematic storytelling but designed to probe the viewer's temporal endurance and precisely thus defining clear distinctions between the art of art cinema and the entertainment of commercial filmmaking (Figure 6). Though extended

shot durations were certainly not the only way by which new wave cinemas antagonized the mainstream circa 1960 (just think of Godard's disruptive jump cuts), Antonioni's systematic use of long takes—the average shot length of *L'Avventura* (1960) was 17.7 seconds, of *La Notte* (1961) 15.8 seconds, and of *L'Eclisse* (1962) 11.9 seconds[2]—was clearly not designed to provide something for everyone. It explored a shot's durational qualities as a formal touchstone for the representation of existential disorientation and psychological ambiguity, subtracting from the grammar of film the kind of elements classical editing had used to elicit viewer identification: point-of-view inserts, subjective camera perspectives, shot/reverse shot patterns. But Antonioni's application of the long take, while no doubt frustrating dominant modes of viewing narrative time, clearly also reckoned with different practices of spectatorship than Warhol's extended images of sleep. To put it schematically, European art cinema rested on the silent agreement that film viewers would dedicate their undivided attention to the entire product on screen. Regardless of how and how much certain directors would test the patience of their viewers, they could count on their patrons' focus and consider those leaving the theater as canceling the contract of art cinema without questioning its basic premise.[3] Warhol's films of the early 1960s, by contrast, aspired to move viewers beyond what art cinema still took for granted. It embraced duration as a medium to define film as event and thereby stress the performative and postrepresentational qualities of spectatorship, including the viewer's decision to drift in and out of the auditorium. Antonioni's long takes needed to be seen without interruption to establish the viewer as a responsive viewer of art cinema; Warhol's images of sleep simply opened a space that invited audience members to bring into play and probe their own temporal commitments, and to see themselves as patrons of art simply because they, in one way or another, and for some time or another, participated in the event of the screening.

Though often perceived as decisive relay stations in the history of film style, neither Antonioni's nor Warhol's systematic

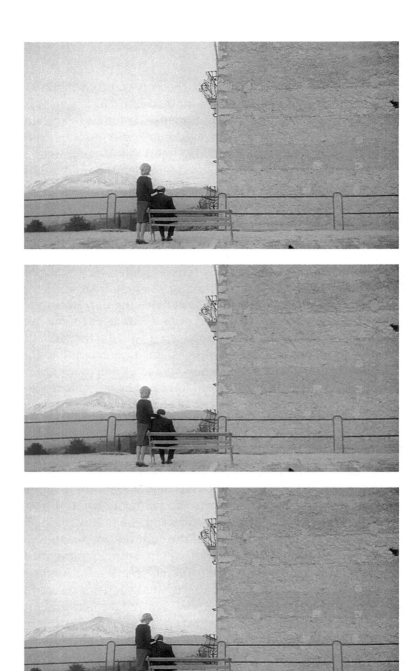

Figure 6. Michelangelo Antonioni, *L'Avventura,* 1960. Screenshots.

use of extended shot durations emerged from a historical vacuum. If we simply defined long takes as part of a cinematic practice that avoids or delays cuts as much as possible, then there are good reasons to think of early cinema as a cinema of the long take already. Before the full development of the classical conventions of visual storytelling, filmmakers as much as viewers had no resources to distinguish between a take and a sequence or to consider cuts as filmic punctuation marks. The time of moving images was largely unedited and precisely thus appealed to itinerant viewers meeting the display of moving images as one of many other fairground attractions. Cinema tapped into the particular experience of modern time as structured by rupture and contingency,[4] but the earliest features presented moving images as if they existed outside the ordinary temporal continuum altogether—as if they, like the work of many long-take filmmakers today, displaced the very system allowing us to identify measurable time to begin with. Early cinema's one-reel and one-take features were long not because they foreshadowed the slowness of Antonioni but because they did not prompt viewers to differentiate between or find measures for existing temporal extensions.

Both Antonioni and Warhol could have claimed the temporalities of early cinema as a model for their respective cinematic interventions. As film studies has come to retell its story, however, the long take's history after the advent of classical storytelling primarily led up to and through the Italian auteur's practice of the early 1960s, whereas Warhol's cinema of (dis)attraction and the varied visions of expanded cinema that were to follow it are typically considered, if at all, as a mere sideshow. Film historians would name F. W. Murnau's and Carl Dreyer's work of the 1920s and 1930s when tracing the archeology of the long take, or the intricately choreographed shots of Max Ophuls during his German, French, and American careers, including the legendary transom sequence of *Letter from an Unknown Woman* (1948). Yasujiro Ozu's prolonged frontal takes of the 1940s and 1950s and Kenji Mizoguchi's sophisticated traveling shots of the same period will come to mind as much as Alfred

Hitchcock's playful use of the long take in *Rope* (1948) or Orson Welles's acrobatic opening of *Touch of Evil* (1958), despite the fact that each of these directors used extended shot durations for very different formal reasons and staged very different degrees of action before a cut would finally move things somewhere else. And when trying to place Antonioni's pondering shots in their more immediate historical context, film scholars will typically not hesitate to point at the metaphysical voyages of Andrei Tarkovsky, the exquisite compositions of Miklós Jancsó, Stanley Kubrick's relentless stares in *2001: A Space Odyssey* (1968), the efforts of young Werner Herzog or Wim Wenders to index the sheer passing of time, and John Cassavetes's ambitions to break with linear editing to accommodate more spontaneous forms of acting. Historians of cinema are much less inclined, on the other hand, to understand the long take, as it (re)emerged in the 1960s as a signature technique of European art cinema, in light of and as being in conversations with various efforts to expand both art and art cinema beyond their institutional domains.[5] Meant to upset the *dispositifs* of the white cube as much as the protocols of art cinema itself, various 1960s experiments with motion, animation, cinematic projection, and early video—think of some key works from the 1960s and early 1970s by Peter Campus, Valerie Export, Dan Graham, Anthony McCall, Nam June Paik, Carolee Schneemann, Stan Vanderbeek, and of course Warhol—often delayed cuts as much as art-house directors did. In contrast to their auteur counterparts, however, the practitioners of expanded cinema located the durational no longer simply on screen alone, but rather in how viewers interacted with the specific site of projection and in how uncut (video) footage unlocked a milieu for exploring the movements of bodies, minds, and sensory organs in physical space. In this, the practitioners of expanded cinema joined forces with how Minimal Art and Happenings of the 1960s questioned the integrity of the aesthetic work and form, and, seeing art as something that always happened in space, began to envision new roles for the artist and audience alike, as famously summarized by Allan Kaprow in 1968: "It may be proposed that the context, or surrounding, of art is more potent, more meaningful, more

demanding of an artist's attention, than the art itself. Put differently, it's not what the artist touches that counts most. It's what he doesn't touch."[6]

In presenting the work of Béla Tarr and Sophie Calle, the preceding introduction indicated already a dire need, when trying to understand the full import of the long take today, to move beyond the split between art cinema and expanded cinema that originated in the 1960s. Though Antonioni and Warhol pursued fundamentally different, and in fact often oppositional, visions of moving image display and spectatorship, contemporary writing on the long take can no longer ignore the fact that today's expanded mediascapes have dissolved the dialectics of postwar art, art cinema, and expanded cinema of the early 1960s. The long take today is neither an exclusive matter of film studies nor of art criticism. It requires hybrid perspectives and categories that combine insights about durational experiments within and beyond the classical cinematic auditorium. The task of this first chapter is to map the genealogy and polymorphism of the long take in greater analytical, historical, and theoretical detail to clarify the stakes for the succeeding presentation of different long-take work across different mediums today.

Stretching Time

The language of classical film analysis distinguishes between the long take and the sequence shot. The first describes a prolonged and unedited capturing of profilmic events; the latter involves a camera that moves through various planes of action, follows the trajectories of different actors, and might perform a series of panning or tracking maneuvers with the aim of integrating, within the space of one extended single take, the narrative events usually comprised in an entire filmic sequence. Not every long take is a sequence shot, but almost every sequence shot, or *plan-séquence* as it is called in French, involves a take longer than a film's average shot length. Whereas the sequence shot is a term conceptualizing structures of visual storytelling, the notion of the long take is meant primarily to explain cinema's modulation of temporal passage, the way in

which filmic technique defines and explores the durational. The occasional use of a sequence shot today often turns out to be a competitive bravura act, a testing ground for directorial control and creativity, with Hitchcock's *Rope* and Welles's *Touch of Evil* serving as historical landmarks of how to package as much action as possible into one spectacular shot without causing viewers to lose sight of narrative exigencies. The notion of the sequence shot thus describes an objective and clearly identifiable building block of narrative cinema. It refers to nothing other than a film's attempt to synthesize cinema's dual legacy of narrative and spectacle, to charge the display of visual attraction with narrative functions. What defines a long take as long, by contrast, eludes unambiguous classification and quantification. We certainly know it when we see and feel it. But there is no standard measure for what we mean with and experience as "long" when encountering a long take in a traditional cinematic situation. Long takes become long only whenever they push against subjective thresholds of temporal endurance and sustained attention. Your long might not be my long, yet both of us will certainly be able to name all kinds of personal thresholds indicating a shot's journey into the territory of the long take. Much of what even in recent cinematic practice is unquestionably meant to be long—consider Aleksandr Sokurov's *Russian Ark* (2002), shot in one athletic ninety-six-minute take while traveling through more than 200 years of Russian history; Alejandro González Iñárritu's *Birdman* (2014), mimicking the appearance of one continuous take while tracking the stage and backstage dramas of a former superhero actor; and Sebastian Schipper's *Victoria* (2015), capturing the dramatic experiences of a young waitress in Berlin between 4:30 AM and 7:00 AM in one virtuoso take through real time— may not be perceived as long at all as a result of the frantic action of a hypermobile camera. Sokurov, Iñárritu, and Schipper provide astonishing sequence shots. They visibly or invisibly nestle different takes and narrative blocks into the apparent unity of a single take. But by the end of each film, we may not think of what we saw as pertaining to the realm of the long at

all simply because not a single minute of their films probed the viewer's patience and temporal commitment. Though mostly known as a theorist of the long shot and of deep focus photography, the shadow of André Bazin continues to loom large over any approach to understanding the role of extended shot durations. Bazin argued in 1946 that the guiding myth inspiring the invention of cinema was the achievement of a new and integral form of realism—that is, "a recreation of the world in its own image, an image unburdened by the freedom of interpretation of the artist or the irreversibility of time."[7] In his writing on Italian postwar cinema, Bazin considered the disappearance of professional actors, stylized sets, and teleological narratives in neorealist filmmaking as one possible strategy of actualizing cinema's ontological mission of showing the world in its own image. In his engagement with the films of Orson Welles, on the other hand, Bazin championed the absence of intrusive editing and the use of evenly focused long shots as other means of accomplishing the task of realist cinematic representation: Welles's camera presented diverse elements and planes of action with equal sharpness and thus invited viewers to peruse the cinematic image at their own measure and will.[8] In both cases, a filmmaker's refusal to interpret physical reality with the help of ever-changing camera angles and montage interventions allowed cinema to live up to its original promise, namely not simply to capture the visible without overdetermining the visual activity of their eyes but also to offer an indexical record of the passing of time itself and hence reduce the difference between the various dimensions of cinematic temporality. In Bazin's perspective, one of the central tasks of cinema was to represent images of things as images of their duration. Cinema was at its best not when seeking to embalm the unique appearance of an object (like photography) but when aspiring to preserve the very flow of time in all its movement and objectivity—"change mummified as it were."[9]

In much of modernist film theory and practice, the perceptual jolt and spatiotemporal rupture of filmic montage had counted as the primary means of cinematic meaning making.

To cut and juxtapose different images was to realize what cinema was all about. Bazin's notion of realism broke with this conception. Stressing cinema's power to provide indexical representations of both space and temporal passage, Bazin hoped to center cinematic meaning and pleasure not in the fleeting moment in between two discontinuous images but in the integrity and relative autonomy of each individual shot. The durational qualities of the long take seemed ideally suited to perform this task and hence define a framework in which to define a variant of cinematic modernism different from the one of earlier montage theorists and practitioners. Within Bazin's framework, long takes served as warrants of cinematic authenticity, the apparatus's self-effacing capturing of multiplicity within the continuous unity of the cinematic frame. As Monica Dall'Asta notes, "By adjusting the duration of the shot to the duration of the action produced, the long take puts the spectator in front not of an image, but an event such as it presented itself to the camera eye during the process of recording."[10] If deep-space photography activated the viewer to explore the frame for different zones of importance and meaning, long-take cinematography had the potential to make viewers recognize time as something that was irreversible and could actually never coagulate into a static picture, a frozen slice of totality. For a number of reasons that need not be discussed here, however, Bazin himself never really developed a full-fledged aesthetic of the long take. It was left to his contemporary, Italian poet, intellectual, and filmmaker Pier Paolo Pasolini, in a momentous 1967 essay, to formulate what has remained the most compelling reflection on the long take and its creative potential until today.

Grafting Saussure's distinction between *langue* and *parole* onto the different dimensions of filmmaking, Pasolini's "Observations on the Long Take" developed its insight against the backdrop of what Pasolini considered to be the structural difference between cinema and film.[11] Whereas the first category describes the material substance and technological substrate of filmmaking, the latter addresses the way in which filmmakers shape the materiality of cinema into meaningful rep-

resentations. The long take, in Pasolini's view, belongs first and foremost to the primordial realm of the cinematic; it designates cinema's inherent ability as a medium to record the pure unfolding of reality in real time and hence to reproduce the real, as it happens, in the present tense. For Pasolini, film begins with the invention and intervention of montage, not simply as a means to interrupt the sheer flow of time but as an expressive technique to render the present past and in this way to do what cinema on its own cannot do: produce meaning. While the inherent substance of cinema is to provide one unending long take—to reproduce the present as it simply passes by—the task of film is to interpret and order action, a task we cannot achieve without invoking some sense of finality, without establishing some form of completion from which, like a dying man's consciousness, to reflect on the past in all its pastness. "So long as I'm not dead," Pasolini ruminates, "no one will be able to guarantee he truly knows me, that is, be able to give meaning to my actions, which, as linguistic moments, are therefore indecipherable."[12] Film, then, in the form of montage, brings death to the life of cinema. Every cut basically slays and sacrifices the presentness of the cinematic image and its unending long take, yet precisely in doing so, each cut also renders action, time, and existence readable and transforms what is infinite and unstable about being present into finite and stable expressions. Pasolini concludes, "Montage thus accomplished for the material of film (constituted of fragments, the longest or the shortest, of as many long takes as there are subjectivities) what death accomplished for life."[13]

The function of the long take in postwar cinema was certainly varied and cannot be reduced to one mode and model alone. Pasolini's reflections are helpful, however, to identify one defining feature of extended shot durations in the work of postwar auteurs such as Antonioni. When used as a signature technique of postwar filmmaking, the long take served much more ambitious purposes than merely to communicate an auteur's personal expression or develop a recognizable style. The postwar aesthetic of the long take instead provided a representational site of disruptive paradoxes, tensions, and ambiguities.

Its aim was no less than to reveal and articulate, within the *parole* of filmmaking, the *langue* of the cinematic medium; to lay bare, amid the prevalent order and historical specificity of filmic enunciation, the very system that made film possible in the first place. As they ran up against the closure of montage and cut, extreme long takes like those of Antonioni were meant to inject a sense of presentness into the retrospective past-ness of filmic storytelling, not in order to impose alternative meanings but to disrupt film's restrictive quest for meaning al-together. They mobilized cinema's life and principal openness against film's death and closure, with the aim of temporarily collapsing film back into cinema and thereby recharging the language of filmmaking with either new or forgotten possibili-ties. The postwar aesthetic of the long take in this sense had the task to authorize a deliberate return of film's repressed: to release representation from film's logic of death, from its com-pulsory drive toward meaning, and to reclaim cinema's quasi-primordial ability to reproduce the sheer passing of time in all its void of meaning and finitude. As seen through and en-ergized by Pasolini's and Bazin's reasoning, long takes in sum aspired to nothing less than to represent a Sisyphean rebellion of nature against culture, of presentness against interpretation. At its core, the long take performed reality's outcry against the imperialism of meaning as much it presented an insurrection of the medium against its historical uses and abuses.

Pasolini's and Bazin's realist valuation of the long take cer-tainly offered, and continues to offer, a viable framework to discuss the decompression of narrative time in postwar auteur-ism. Whether we think of Antonioni's extended images of detached urbanites strolling across deserted Mediterranean is-lands (as in *L'Avventura*); the prolonged take of Milan as a space of urban abstraction during the lengthy credit shot of *La Notte*; or the famous final shots of *L'Eclisse*, relentlessly documenting the very absence of expected narrative events—in all of these instances, long-take photography at once reduced cinema's narrative drive so as to offer a realist index of temporal pas-sage, and it engaged the long take's relative indifference toward meaning and interpretation to allegorize the existential void,

alienation, and disenchantment of postwar capitalism. Playing out cinema against film, auteurs such as Antonioni used the long take as an emblematic means to reveal—realistically and relentlessly—the utter poverty of presentness in the modern world. They often privileged, in Gilles Deleuze's perspective,[14] time over movement, temporal multiplicity over chronological development, and the indexical over meaning to present postwar modernity with its own image and hence capture the extent to which this modernity had drained all resources for understanding time as a realm of newness and difference, as a site of substance and meaning. Long-take photography thus helped define postwar art cinema as a heroic effort coldly capturing the coldness of contemporary existence. In particular in the work of Antonioni, long takes gaze straight into the eyes of postwar agony in the hope of situating the viewer as a critical observer—as a viewer at once able to reflect on the differences between the *langue* and *parole* of twentieth-century filmmaking and to remain unmoved by the affective lure and clichéd meanings of commercial film production.

The works of many celebrated long-take directors of the last two decades often recall the representational strategies of earlier art-house filmmakers, and Pasolini's metaphysics of the long take remains helpful to approach these works and place pressure on theories of the atemporal. We would be mistaken, however, to see the function of the long take in the work of, for instance, Nuri Bilge Ceylan, Abbas Kiarostami, Béla Tarr, Tsai Ming-liang, Apichatpong Weerasethakul, or Jia Zhangke as a direct iteration of what auteur directors such as Antonioni sought to accomplish in the postwar period. On the one hand, rather than merely repeating how postwar cinema relied on long takes to represent existential alienation, ambiguity, disillusion, and emotional exhaustion, long-take photography today, in its very effort to reconstruct spaces for the possibility of wonder, often appeals to the dreamlike and surreal, the indeterminate, playful, and open. Jia Zhangke sends drab modernist apartment complexes into outer space in the middle of one of his signature long takes in *Still Life* (2006); Apichatpong Weerasethakul uses extended shot durations in films such as

Uncle Boonmee Who Can Recall His Past Lives (2010) as a portal
to allow ghosts from the past to enter and reenchant the present.
On the other hand, long-take cinematography today, in contrast
to the auteurs of the immediate postwar period, responds to and
reworks what David Bordwell has described as the postclassi-
cal regime of intensified continuity. It reckons with viewers for
whom the dramatic acceleration of shot sequences since the
late 1960s defines cinema's norm and who consider the haste
of often illegible editing strategies as a method to keep possible
distractions at bay and audiences in their seats.[15] If postwar au-
teurs used the long take to play out cinema's life against film's
death so as to unsettle classical film's regime of seamless nar-
rative integration, then today's aesthetic of the long take could
be understood as a second-degree intervention: it decelerates
cinematic time for the sake of revealing underlying continui-
ties between the past and present of commercial filmmaking;
it defies representational strategies, no longer remembering
the difference between life and death, cinema and film, at all; it
offers time-images whose rigorous formalism challenges view-
ers eager to mindlessly bask in both too much intensity and too
much continuity.

Yet to think of the aesthetic of the contemporary long take
in merely reactive terms, as a strategy negating the negativity
of dominant filmmaking, cannot but do injustice to the diverse
and complex presence of sustained shot durations in contem-
porary art cinema. Nor does it recognize that art cinema, in all
its different institutional settings and artistic formations today,
might offer more than merely a recto to Hollywood's norma-
tive verso (whatever "Hollywood" might mean to begin with).
Similar to Pasolini, the principal effort of cinematic long-take
practitioners today may still be to restore our hope in the con-
stitutive openness and contingency of (cinematic) time, to mo-
bilize cinema's life against film's death. Yet to understand this
effort as a mere instance of neoauteurist formalism will not
only fail to illuminate how contemporary cinema indexes the
fundamental transformations of moving image mediums and
cultures over the last decades but will also blind us to what I
understand as the postrepresentational dynamic of the won-

drous as it resides at the very heart of the contemporary aesthetic of the long take. Neither film nor cinema today are what Pasolini thought them to be when theorizing the formal logic of extended shot durations. Unlike the postwar period's auteurs, long-take image makers in the twenty-first century reckon with viewers who encounter moving images in every corner and moment of their everyday life, and who often experience culture, society, and politics as a continuation of cinema with other means. What typifies these viewers is no longer their mere discontent with the false promises of classical Hollywood narrative and postwar affluence, but the fact that they are deeply accustomed to encounter pictures in motion at all times *and* to control the temporal terms of filmic consumption on their own terms, whether they watch moving images on handheld devices while on the move, or whether they actively navigate the speed of motion pictures with various types of remote controls. We turn our attention next to how the many sites of expanded cinema today, as they inherited Warhol's interventions of the early 1960s, also urge us expand our notion of the long take.

Other Cinema

The same time period that has witnessed international filmmakers systematically embracing extended shot durations in order to probe the templates of visual attention since the 1990s has also seen a wide array of art practitioners eager to claim for their own work—in Maeve Connolly's words—"the narrative techniques and modes of production associated with cinema, as well as the history, memory and experience of cinema as a cultural form."[16] Once a source of noise and unwanted distraction, moving images figure as a significant component of contemporary museum and gallery spaces. They not only offer screen-based milieus that help explore the site-specific aspects of moving image reception but also—because of their stress on public, collective, often contingent, mobile, and in most cases nonvoyeuristic modes of engagement—question the former dominance of psychoanalytically inflected models of spectatorship. Though it would be too simplistic to draw a direct

line between practices of expanded cinema around 1970 and screen-based installation work after the mid-1990s, the presence of moving images in galleries and museums today once again asks profound questions not only about the place of the cinematic but also about the locations of art and the aesthetic in society. Even though the contingencies of gallery-based spectatorship at first simply seem to trouble the nostalgic rhetoric of many a contemporary long-take filmmaker, the claims artists have made for the cinematic during the last two decades provide compelling arguments about why we cannot afford not to reframe and expand the concept of the long take amid a culture of ubiquitous screens and 24/7 distractions.

A gem of phenomenological insight, the opening segment of Don DeLillo's *Point Omega* (2010), neatly illuminates the stakes of such a reframing and expansion. The novel's first chapter is set in 2006 at MoMA, featuring an initially nameless protagonist visiting the installation of Douglas Gordon's *24 Hour Psycho* (1993). The reader is allowed to witness the protagonist's reflections on the glacial pace of images on screen (slowed down to about two frames per second) and their relation to the original film, his perusing of the entire installation situation, and his thoughts about other visitors and their respective viewing practices. Impossible to be seen during one continuous visit, Gordon's marathon work invites the novel's protagonist to roam freely through the gallery in both physical and intellectual terms, zooming in and out of different states and zones of attentiveness. At times his gaze is entirely glued to the screen and to minute changes of the visible, leading to reflections such as this:

> He found himself undistracted for some minutes by the coming and going of others and he was able to look at the film with the degree of intensity that was required. The nature of the film permitted total concentration and also depended on it. The film's merciless pacing had no meaning without a corresponding watchfulness, the individual whose absolute alertness did not betray what was demanded. He stood and looked. In the time it took for

Anthony Perkins to turn his head, there seemed to flow an array of ideas involving science and philosophy and nameless other things, or maybe he was seeing too much. But it was impossible to see too much. The less there was to see, the harder he looked, the more he saw.[17]

At other times, his eyes wander to the sight of other gallery patrons, not because Gordon/Hitchcock no longer offer anything to see but because the seeing and sensing of the seeing of others are integral parts of entering the media environment of *24 Hour Psycho*. What matters, in the end, to the protagonist is less to sustain a totally concentrated look onto the images on screen than it is to explore the whole site of projection as a space in which one can experience time differently from the everyday. Because the narrative is more than familiar, and because the slowness of Gordon's projection leaves ample room to wonder about each and every aspect of the screening event, to see *24 Hour Psycho* is to free oneself from the drive of storytelling and instead watch one's own watching of film. It is to encounter moving images as architectural features shaping the experience of space and its material framing of diverse relationships in time; it is to see fiction entering the reality of lived experience and moving images defining a space to probe the movements of one's attention—its steadiness, its fickleness, its oscillations. And it is to experience this plurality of sensory, cognitive, reflexive, and self-reflexive operations, the ongoing yet pressure-free movement between different modes of presentness, as the core of what constitutes aesthetic experience today, "to see what's here, finally to look and to know you're looking, to feel time passing, to be alive to what is happening in the smallest registers of motion."[18]

Many trained film scholars will no doubt resist the idea that Gordon's *24 Hour Psycho* features long takes in any conventional sense of the word. Yet because of Gordon's strategies of deceleration, it may often take minutes before viewers detect a cut, with each take almost taking on the character of a sequence shot. Even Hitchcock's shower sequence, when projected at two

frames a second, causes the role of editing to recede into the background while completely deflating the drive of narrative teleology and the viewer's impatience about what is to come (Figure 7). More importantly, however, as described in De-Lillo's novel, the entire gallery setting opens a screen-based environment in which screenic images, architectural volumes, bodily movements, and perceptual processes join together to allow the viewer calmly to ponder the copresence of multiple temporalities in the space of the present: the rhythm of one's own attention, the glacial speed of images on screen, the itineraries of other patrons, the pulses of individual memories and anticipations, the temporal stability of the architectural space, the absence of the velocities of life outside the museum's black boxes and white cubes. In spite, or precisely because, the media-based milieu of 24 *Hour Psycho* reckons with roaming spectators whose temporal commitments cannot be taken for granted, it activates and expands on what long takes in international art-house cinema since the mid-1990s are all about. It offers a liminal site to interrogate, attune, and retune the operations of sustained attention across time and amid a 24/7 culture of fast-paced information streams and compulsive connectivity; it offers a space of aesthetic experience in which viewers may learn how to approach moving images as something that can produce the shudder of newness and wonder again.

In the eyes of many contemporary critics, self-directed viewers such as the protagonist of *Point Omega* are viewers principally unfit to wait and linger in what Siegfried Kracauer once called the horror vacui of secular modernity and its post-metaphysical relativism.[19] For them, Daniel Birnbaum's " 'other cinema' of today"[20]—the ubiquity of screen-based installation art as a medium of installing time in contemporary museum and gallery spaces—fails to provide prolonged viewing experiences and train viewers in the art of waiting. Allowing spectators to dip in and out of given installation spaces at random intervals, this new type of moving image culture encourages merely exploratory forms of durational looking and, by unburdening the viewer from external timetables and the temporal demands

Figure 7. Alfred Hitchcock, *Psycho*, 1960. Screenshots.

of a work's formal structure, endorses—as some suspect—utter arbitrariness.[21] As the ruminations of *Point Omega* suggest, however, the viewers of contemporary screen-based installation art can very well partake of durational experiences that at once expand, illuminate, and complicate our understanding of the concept of the long take. Though media installations such as Gordon's or Sophie Calle's *Voir la mer* may not involve the kind of elongated shots we so prominently encounter in the feature films of Tarr, Kiarostami, Tsai, and Weerasethakul, they offer moving-image environments in which viewers themselves may

assume the role of a virtual camera of sorts, one whose physical movements capture screenic images and spatial configurations as if taken in one extended take. As DeLillo aptly points out, screen-based installations not only have the potential to make self-directed viewers "conscious of film or video's temporal flow"[22] but also to produce unpredictable echoes and tensions between the viewer's perambulations, the site's architectural arrangements, and the moving imagery presented on screen or screens—echoes and tension that allow us to explore aesthetic modes of self-directed viewing that radically differ from the alleged freedom of consumer choice in the age of instant connectivity and willful image consumption.

Heir to 1960s projects of expanding cinema, then, contemporary video and installation art by no means seal the fate of prolonged attentiveness and rigorous looking, the very possibility of the long take and its dedication to the wondrous. It instead importantly contributes to how expanded (art) cinema today seeks to engage with and deflect the pressures of compulsive connectivity and instantaneity—our ever-increasing unwillingness to wait, our fear of everything smacking of repetition or being void of the intentional. Because it often asks us to reframe and expand our very understanding of attentive looking and perceptual rigor, screen-based installation art emphasizes the bodily base, the kinesthetic and sensorimotoric maneuvers, that make attentive viewing possible, and in doing so, it allows viewers to probe new experiences of images in motion and what it might take to recognize the new as new. To the extent to which screen-based environments invite their viewers to perform the phenomenological functions of a roaming camera, they draw our awareness to the role of the body as a primary medium of experience, and in doing so they also ask us to search for the durational and the wondrous in how, through acts of physical and perceptual movement, we produce moving images in the first place. Dominant theories of spectatorship, including those that once informed the rise of auteur cinema, fall short of addressing this move of the filmic image from the (re)presentational to the postrepresentational, from film as a projection of moving images to cinema as a physical environ-

ment of images in motion. Screen-based installation art urges us to recognize that our tending to moving images, to their temporal flow as much as their promise of wonder, cannot be understood in isolation of how the architectures and media-scapes of twenty-first-century life have profoundly reshaped the rhythms, speeds, and temporalities of modern (aesthetic) experience. And it offers persuasive arguments not to submit to apocalyptic visions when neither cinema nor film fully represent anymore what Pasolini, Antonioni, and other advocates of modernist filmmaking wanted them to present.

Let me develop this claim in a little more theoretical and historical detail before concluding this chapter with a reading of a filmic example in which DeLillo's roaming spectatorship enables not simply durational forms of looking but also a ground for experiencing something wondrous indeed.

Between High and Low Resolution

Back in the heyday of aesthetic modernism, Walter Benjamin famously theorized film as a revolutionary medium whose ontology—the logic of apparatical recording and disruptive editing—empowered transformative acts of virtual nomadism. Hitting the viewer like ballistic shocks, film's cuts unsettled the claustrophobia of the everyday and invited viewers to travel to the unknown: "Our bars and city streets, our offices and furnished rooms, our railroad stations and our factories seemed to close relentlessly around us. Then came film and exploded this prison-world with the dynamite of the split second, so that now we can set off calmly on journeys of adventure among its far-flung debris."[23] Following Benjamin's writings and those of other critics of the first half of the twentieth century, cinematic viewing practices not only advanced to the normative compass mapping the entire circulation of moving images in modern culture but also their (revolutionary or escapist) ability to transport spectators to different elsewheres and elsewhens came to rest on the categorical assumption of physical immobility and stillness.

The apparatuses with which we have chosen to surround us

today call much of this into question. Theatrical exhibition no longer marks the center of moving image consumption, and the majority of screens with images in motion no longer produce mechanized patterns and semiautomatic states of physical inactivity. Screens are as much on the move, or engage the diffuse attentiveness of nomadic viewers, as the images they once presented. Ubiquitous interfaces today no longer simply figure as frontal windows of visual consumption at all, as Benjamin still had to assume. They instead navigate our paths through cities and landscapes, make space and time browsable, and mutually embed the physical and the virtual, body and screen, into augmented realities. While pervasive computing may mean ever more control, surveillance, and isolation, it also provides means to restructure our understanding of built environments and develop what theorists such as Malcolm McCullough understand as a future of ambient commons—that is, architectural spaces in which bodies and screens, built spaces and mobile viewers, flux and stability, the durational and the ephemeral, can establish reciprocal relationships and nonhierarchical interactions.[24] Ambient commons in McCullough's sense consider the difference between screenic rhetorics of disruptive speed and architecture's stress on the solidity of spatial forms not as an irresolvable opposition. No screen exists in a vacuum, independent of spatial and architectural arrangements shaping how users may relate to their images in the first place. As a project and process, ambient commons articulate the relation of screen and architecture, information flows and spatial volumes, as one of mutuality and coevolution. They recognize the extent to which today architecture and new media can no longer do without the other, and in mindfully meshing the high resolution of physical spaces with the low resolution of ever-accelerating screen media, they may provide what it takes not to be entirely washed over by the streams of 24/7 and its dual protocols of agitated alertness and disruptive interactivity. McCullough notes, "Although usually taken for granted and sometimes sought to be overcome by fashionable kinematic installations, fixity distinguishes architecture. Few other works

of design are intended to hold still, and to last so long. Once this was valued more; many scholars and cultures have equated civilization with permanence. Yet even today when almost nothing seems permanent, the persistence of some forms relative to others still matters. An age of flux still needs host forms and channels, much as a river needs banks."[25]

Critics of contemporary of visual culture often forget that rivers and banks require each other. Few of them, therefore, are willing to share McCullough's ambition to see today's incorporation of media and architecture, of mobile images and slow spaces, as an opportunity rather than a loss. In his *24/7: Late Capitalism and the Ends of Sleep*, art historian Jonathan Crary argues that the proliferation of screens and ambient interfaces today directly feeds into how neoliberal capitalism is shaped around ideas of ceaseless competitiveness, gain, appropriation, and self-advancement: "Most images are now produced and circulated in the service of maximizing the amount of time spent in habitual forms of individual self-management and self-regulation."[26] He adds, "The idea of long blocks of time spent exclusively as a spectator is outmoded. This time is far too valuable not to be leveraged with plural sources of solicitation and choices that maximize possibilities of monetization and that allow the continuous accumulation of information about the user."[27] According to Crary, today's mediascapes effectively condition their users to assume that possible adventures may happen with every individual click, touch, and move; that one more interaction with screenic representations might produce decisive advantages, a final absence of fear, a redemptive end of the monotony of self-preservation. Constantly wanting something from their hypermobile and hyperactive viewers, most screens in our age of 24/7 place the future so close at hand that durational experience completely dissipates and Benjamin's dream of mediated nomadism resurfaces as our worst nightmare—as something that directly nourishes neoliberalism's destruction of what it takes to warrant sustainable networks of human care, trust, and solidarity.

Crary's seemingly apocalyptic assessment finds echoes in

how slow cinema advocates over the last decade have come to challenge both the pace of commercial cinema and the expansion of moving image culture beyond the classical templates of cinema. One of its most prominent advocates, Ira Jaffe, defines slow cinema as a cinema of visual minimalism and durational obstinacy: cameras stay unusually still or move quite slowly; interior and exterior spaces are often empty and unappealing; plot and dialogue gravitate toward the flat and quiet; protagonists lack spectacular traits and dramatic gestures; editing and cutting remain infrequent.[28] With its sparse story lines and austere compositions, slow cinema stresses the thickness of time so as to cater to contemplative modes of viewing film. According to Jaffe, slow cinema is a formalist cinema of the long shot and the long take, both used to stress the indexical qualities of the cinematic image and its ability to embalm time, both embraced to conjure cinematic worlds that pause digital culture's pull of the future and allow viewers—in the words of David Lynch's infamous diatribe against smartphone viewing, to "get real" again.[29]

In the eyes of many of its advocates, slow cinema offers a palliative against the disruptive frenzy of Crary's 24/7 media society. It defines art cinema as a medium delivering representations of uncut time so as to compensate frazzled minds with visions of temporal coherence. As well-meaning as this effort might be, slow cinema advocacy often rests on theoretical assumptions too narrow to do adequate justice to the polymorphic multiplicity of screen practices and art cinema today. It reduces cinema to and reifies film into what we see and can analyze on screen, whereas the true challenge would be to recognize that—paraphrasing Adorno—nothing concerning cinema or film is self-evident anymore, not what we might want to call their inner life and logic, not their precise place in and relation to the world, not even their right to exist as an autonomous art form.[30] It is in Crary's work itself, however, that we can find certain elements to correct the nostalgic preservationism of slow cinema discourse and, in conversation with McCullough's concept of the ambient commons, develop

concepts of durational looking that are not blind to the ambi-
guities and pluralisms of moving image cultures today. Though
of course no less dismayed about the attentional economies of
the present than slow cinema advocates, Crary identifies re-
sidual forms of resistance to the neoliberal inflection of con-
temporary screen culture in nothing less than the experience
of sleep, the uncut passing of dream images not fully under
our control or subject to reigning ideologies of efficiency and
self-maintenance. Sleep not only disentangles the threads that
enmesh us in our everyday haste and decenters the self as the
organizational hub of strategic action but in doing so produces
time—the deep and common time of the durational—in the first
place. Crary: "As solitary and private as sleep may seem, it is not
yet severed from an interhuman tracery of mutual support and
trust, however damaged many of these links may be. It is also
a periodic release from individuation—a nightly unraveling of
the loosely woven tangle of the shallow subjectivities one in-
habits and manages by day."[31] As it relaxes the imperatives of
intentionality, control, and self-management, sleep allows us
to inhabit a time during which we accept our own vulnerabil-
ity and, consciously or not, hand us over to the potential care
of others. To sleep, and to sleep deeply, is to abandon the false
hopes of hypermediated nomadism, diffuse attentiveness, and
screen-based multitasking. It is to reconstruct the condition for
the possibility not just of uncut time but of sociability and the
ethical. Sleep's obstinacy reminds the awaking subject of the
promise of a world in which we can surrender to what exceeds
our will without harm and fear.

Crary's understanding of sleep provides some good argu-
ments to think about cinema and film today, not just—as slow
cinema discourse argues—as vehicles to expose the agitated
logics of 24/7 and please burned-out viewers with alternative
temporal representations, but as mediums articulating what it
means to view time in space and to probe attentiveness amid
the imperative speeds of ubiquitous media. For sleep itself,
far from simply operating like a classical film projected onto
a stable quadrilateral screen, of course surrounds the sleeping

subject as if it were an ambient commons in McCullough's sense—a screenscape in whose context various percepts, frames, and images blend into an integrated ecology of perception, a dynamic yet self-contained space in which viewer and viewed, dreamer and dream, body and image, movement and stasis constitute each other. We may be restless while sleeping, regurgitate rapid afterimages of past impressions, or encounter the frantic work of displaced wish fantasies. Yet no matter how quickly images may pass during our dreams, to sleep is to submit and attend to the projections of the mind as if seen in one continuous take of uncut duration. To wake up is to recognize how sleep not only folds fixity and mobility into one dynamic but also may engage the "viewer" with wondrous images of time and duration precisely because it suspends willful input and calculating activity.

What sleep is in Crary to the frenzy of 24/7 self-maintenance, the ambient commons is in McCullough to the sheer flickering of images on isolated screens today. As postrepresentational models of articulating moving images and bodies in space, both sleep and the ambient question seasoned hierarchies of distraction and contemplation, film and cinema, of screen and screenscape, image and architecture. Slow cinema advocates approach film as if cinematic auditoriums still monopolized the display and consumption of moving images in contemporary society. They want us solely to focus on what is in the picture in order to partake of pleasurable or edifying representations of duration. By contrast, Crary's sleep and McCullough's ambient—or, better, the idea of sleep as a mode of the ambient and of the ambient as a variation of sleep's productivity—urge us to behold of images in all their plurality, and like DeLillo's roaming spectator in *Point Omega*, they remain open to messy definitions of what might constitute an image in the first place, its location, its orders, its context, extensions, and existence in time. Both make us understand that the undisciplining of attention, as it began with Warhol's interventions in the 1960s and informs much of what we do with screenic images today, need not necessarily result in a complete loss of durational experi-

ence and a concomitant failure to make space and time for the possibility of wonder. What it takes to solicit time and space for the durational and the wondrous today is to learn how to see screens as elements of larger spaces in which architectural fixity and spectatorial movement may produce highly contingent interactions. What it requires, in stark contrast to discourses of cinephilia, is to account for the fact that no image of flux and interruption today exists independent of certain architectures modulating what images may to do us today and what we may do to images in return. What it takes, in sum, is to move beyond how criticism has typically considered immobile spectatorship in darkened auditoriums as the normative anchor of our entire thinking about viewership, and to continue where Warhol took off in the early 1960s: to tap into the wondrous power of sleep to reshape media spaces as ambient commons, and to thereby envision other sites of moving image displays as at least as important to theorize viewership than the perceptual template of classical cinema.

Screen-based installation art today, indebted to the promissory note of Warhol's *Sleep*, provides highly pertinent aesthetic laboratories to probe profound tensions between low- and high-resolution experience, between permanence and flux, the fast and the sluggish, cinema and film. In what follows, I will therefore discuss screenic environments that enable durational experiences and phenomenological long takes even to roaming spectators and precisely thus, and contrary to what critics of new media practice often presuppose, appeal to the promise of the wondrous. While the images presented on the screens of these ambient commons themselves may not always come even close to the shot frequencies of Tarr's or Tsai's films of utter slowness, the kind of installations of interest here all set up media ecologies in which the viewer—like DeLillo's protagonist—can take time to investigate the tempos, rhythms, and durations of contemporary attention and experiment with alternative models of screen culture in general. They offer zones of aesthetic ambiguity in which the copresence of physical fixity, screenic flux, and bodily mobility allows the viewer to

investigate nothing less than the sustainability of attention in neoliberal media economies; the contingencies of uncut seeing and sensing; the productivity of drift, nonintentionality, and awakening; and most importantly the openness of time and continued possibility of the wondrous today.

At the Intersection

What is vital, then, to map the momentous transformations of both film and cinema in the twenty-first century is to mend the split between art cinema and expanded cinema that emerged in the 1960s and that continues to drive much of contemporary criticism. What is critical to exploring the role of time in and of twenty-first-century screen arts is to have concepts from cinema and new media studies, from film and art criticism, from architectural theory and the phenomenology of movement impact each other. What is indispensable to do justice to the polymorphic presence of the long take today, and to any understanding of the wonders it may have in store for us, is to think of the roaming viewers of screen-based installation art and the immobile spectators of more traditional theatrical projection situations as viewing subjects much more familiar with each other than various academic disciplines are willing to admit.

Consider the final take of Ulrich Köhler's 2003 *Bungalow* (Figure 8) as a shot performing this very task. The film and its maker were associated with the so-called Berlin School, a loosely structured neoformalist movement known for its eagerness to preserve the integrity of each cinematic frame and to savor the continuity of represented action; for its anticlimactic narratives and affectless antiheroes; for its pondering aesthetic of long takes rigorously exploring what often turns out to be the absence of rigor and transformative energy in the lives of its protagonists.[32] The film tells the story of Paul, a young soldier unwilling to return to service after spending a holiday at his parents' bungalow in a nondescript small town in Germany. The final sequence has Paul sleeping with his brother's girlfriend, Lene, in an equally nondescript hotel room, less in

order to quench bursting desire than simply to mark the bland passing of time. The film's final three minutes begin with Paul pensively looking out of the hotel window before we cut to what we initially must assume to be his point of view: a static view through the window, its frame no longer visible, situating the viewer as a cool and detached witness to whatever unfolds within the visual field. We first see the car of Max, Paul's brother, as it approaches the camera and comes to a stop in the hotel's parking lot. Max exits the car and moves a few steps toward the bottom of the frame, only to meet Lene, who has entered the frame at the same time from below. As they talk to each other, an army jeep pulls into the image and comes to a halt on the right. Two soldiers, eager to pick up the deserter, exit the car and move toward the right corner of the frame, with Max following at a slight distance and Lene slowly approaching Max's car in the opposite direction. A few seconds after Max and the soldiers have left the frame, Paul suddenly enters the image from the left. First he approaches Lene; then he crosses the street to the jeep, awaiting the soldiers' imminent return, as we must assume. A huge gasoline truck swiftly enters the image from the right. The driver leaves his vehicle such that, for a decisive minute or so, it will block our view of Paul and the jeep. A few seconds later, the soldiers and Max return; Max joins Lene again while the soldiers walk toward and around the truck in order to return to their jeep, presumably frustrated about having been unable to fulfill their mission. Meanwhile, the truck driver reenters his vehicle and drives off, away from the camera, thus unblocking our view of the military jeep. Its doors already shut, the jeep will make a U-turn and drive off into the opposite direction from the truck, leaving Max and Lene as motionless witnesses to the final departures of both vehicles—and leaving us in a complete state of wonder about both the curious emptying of the frame and Paul's exact whereabouts.

In spite of its apparent detachment and theatrical tableaux, Köhler's final long take leaves the viewer with more questions than it is willing to answer. The shot in fact is charged with remarkable reversals, inversions, and paradoxes, a rhetoric of choreographed ambiguity that stands in stark opposition

to the camera's seemingly aloof posture of distance and non-involvement. Köhler's final shot initially invites us to read the image through Paul's indifferent eye, then allows Paul to enter the image himself, thus disrupting our bodily and perspectival alignment and situating us as Paul's proxies without granting us his final sense of mobility. Left, as it were, in Paul's undesirable shoes, the viewer cannot but be challenged in his or her seemingly neutral distance by the drama that unfolds in the film's final minutes: the highly choreographed display of contradictory movements; the traversals, sudden intrusions upon, and inconclusive exits from the frame; the final shot's graded emphasis on ever-shifting constellations of bodies and vehicles within the space of the visible.

While the film's viewer remains static, albeit perplexed, Köhler's long take itself stages the transformation of a classical cinematic spectator into the perambulating viewer of expanded cinema. Like Warhol's cinema patrons of the early 1960s, Paul enters and conceives of the space of projection as a durational space of action—a site of unscripted events. As he literally carries the film's long take into the streets, he breaks with the legacy of the fourth wall and the fixity of the quadrilateral screen so as to convert the wandering of his mind into movements of wandering. Like DeLillo's gallery viewers, he strays through space to probe different perspectives and explore the meeting of architectural shapes, technologies of motion, and bodily movements as a zone of principal ambiguity—a zone of ambient possibilities powerful enough to retune his sense of time, place, and futurity. But the real protagonist (or, perhaps, better, antihero) of Köhler's long take is, of course, the viewer him- or herself: we are the ones being left behind in what turns out to be an immobile position of detachment; we are the ones who find ourselves strangely out of sync with what viewers, once emancipated from the disciplining regimes of the cinematic auditorium, are able to do and accomplish. In the end, the trick of Köhler's long take is on us as we come to realize that classical cinematic looking can no longer claim the normativity it once possessed and that Paul's distracted wandering—a sleepwalking of sorts—attunes his life to the passing of time at least as

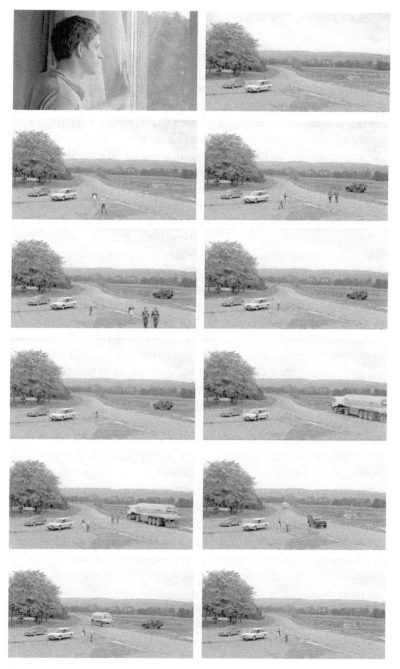

Figure 8. Ulrich Köhler, *Bungalow,* 2003. Screenshots.

productively as our own contemplative stillness vis-à-vis the film's long take.

If mainstream cinema's intensified continuity today often demands Pavlovian attention to discontinuous shot sequences, Köhler's long-take aesthetic places the viewer in a rather impossible position of indetermination. While the shot's pondering temporality clearly gives us time to peruse the image, contemplate the action on screen, and become absorbed by the protagonists' sense of temporal suspension, the theatrical aspects of Köhler's shot—its staging of ambivalence and contradiction—constantly remind us of our own act of looking, of being actively addressed by the framing power of the camera, of being positioned as a viewing subject eager to see something in the first place and move along the protagonist's paths. At once pushed away and pulled into the long take's simultaneously static and animated image, we hover in between a stance of contemplative distance and of projective engagement; we allow ourselves to get lost in the shot's staging of Paul's own expanded long take, and we cannot but ignore that whatever we see is designed for us to be seen in the first place. Though seemingly aloof and utterly distant, we are struck by a profound feeling of wonder about what the shot's staging of spectatorial roaming—in spite of all its stress on visibility—refuses to show to us in the end, an inquisitive amazement about what may have happened behind the truck and what has led to Paul's disappearance.

In the various readings that follow we turn to the many ways in which long takes today—whether screened in a classical auditorium or experienced in a museum's gallery space, whether encoded in photographic images or staged within a complex architectural setup, whether projected on individual screens or considered as parts of an entire ambient commons—encourage viewers to probe what it takes to be and stay attentive, to drift in and out of different zones of focus, to convert the power of sleep into moving experiences of awakening, and to partake of durational experiences as the condition of the possibility of the wondrous.

IMAGES OF/AS PROMISE

Borderlands

The one is a photograph trying to incorporate the passing of time and thus approximate the cinematic; the other is a twelve-minute video whose almost imperceptible visualization of change at first makes us think of it as a photographic image. The first has been meticulously centered around a luminous white rectangle in the middle of the frame; the second's seemingly simple task is to track a day's fading into night. The first is typically exhibited in a museum gallery's white cube; the latter has been displayed as part of an omnibus collection of video work in a museum's black box setting, the arrangements of seats replicating the stress on frontal, stationary looking in a traditional cinematic auditorium. Both ask tough questions about how images can embody, present, and be time rather than merely represent it. And both of them, as they echo certain compositional elements of each other, extend a promise to the patient observer—the promise of something wondrous emerging not from what resides plainly within the reach of our eyes but from what we do not see, from what has become obscured in the very process of showing.

The first image, *Union City Drive-In, Union City* (1993) (Figure 9), is part of Hiroshi Sugimoto's praised theater series, shot over several decades at various locations around the globe. Like every other photograph of this and various other of Sugimoto's many other series of the last forty years, this one follows

a program as rigorous as it is austere. It owes its existence to Sugimoto placing his camera centrally in front of a screen of an empty movie theater and then opening the shutter for the entire duration of an (unidentified) film screening such that the excess of light on screen will create a white rectangle in the center of the frame. The second object in question is Philipp Lachenmann's video installation *SHU (Blue Hour Lullaby)* (2002/2008) (Figures 10 and 11), which digitally compresses several continuous hours' worth of footage of a high-security prison in the Mojave Desert into a single shot lasting a dozen minutes. The soundtrack varies in different installation settings; the video has been shown silent, but it has also been screened with a composed reconstruction of desert sounds or with a mix of quotations from Wagnerian opera, postwar minimalism, and techno music. Representative of Lachenmann's repeated efforts to blend the observational with the force of special effects, *SHU (Blue Hour Lullaby)* witnessed its most widely recognized showing at the Hamburger Bahnhof in Berlin in 2010 and 2011.

Neither of these two works qualifies as a long take in the sense embraced by twentieth-century auteurism, the one—in spite of the duration of its production—simply addressing the viewer as a photographic still image after all, and the other—as a result of its technical manipulation—unsettling what many count as motion and the durational in the first place. Yet both works can be seen as bracketing what this book discusses as the contemporary long take in all its different shapes, sizes, and institutional settings. It is by exploring what lies at or just across the borders of the long take that we begin our journey into the territories of durational images in the expanded culture of motion pictures today.

The Power of White

Though drive-in theaters had started to spread across the landscapes of American film viewing as early as in the 1930s, they reached their most iconic presence during the 1950s and early 1960s. During the first decades after World War II, drive-ins

stressed the event character of going to the movies, seeking to lure suburban audiences away from the miniaturization of visual pleasure after the advent of television. Drive-ins not only presented pictures in motion in order to engage the viewer's desire for virtual transport but also allowed spectators to consume a film's images from the standpoint of the postwar period's principal instrument of physical mobility: the private automobile. To be sure, historical audiences found it difficult to ignore that the peculiar conditions of drive-in theaters had a negative impact on the audiovisual quality of cinematic projection. In fusing postwar longings for virtual and physical mobility, however, in at once mobilizing visual pleasure and deliberately privatizing the public space of the classical auditorium, drive-in theaters were able to feed directly into the postwar period's ambivalent economy of desire. With the car's windshield serving as a secondary frame and screen of motion pictures, viewers could feel simultaneously mobile and stationary, inside and outside, at home and outdoors; they could participate in the rapid transformations of postwar American society and inhabit a secure position in the distance.

In Sugimoto's *Union City Drive-In, Union City*, the unique features of extended-exposure photography play a key role in encoding these ambivalences and evoke the past as a site of dramatic tensions between stasis and mobility, the visible and the obscure. The screen of Sugimoto's drive-in theater, which was torn down in the late 1990s, sternly occupies the very center of the image, half of its width separating it from the left and right edge of the frame, its height duplicated to mark its distance from the upper and lower boundary of the image. The general composition could not be more symmetrical, with the exception of the white projected rectangle on screen (which appears slightly off to the left of the middle of the screen), and the three speaker hookups in the foreground (whose positions also tilt the symmetry in the lower third of the image somewhat to the left). What adds to the serene classicism of the overall composition is the rigor of horizontal lines and layers: the immediate foreground takes up approximately a fifth of the image while

Figure 9. Hiroshi Sugimoto, *Union City Drive-In, Union City*, 1993. Copyright Hiroshi Sugimoto. Courtesy of Fraenkel Gallery, San Francisco.

the horizon line dissects the image at roughly a third, leaving about two-thirds of the image for the depiction of the night sky (minus the space screened out by the screen in the front).

Sugimoto's screen clearly serves as a magnet of attention. There is something ironic, however, about our impulse to direct our gaze at the white rectangle, given the fact that there is nothing to see and hold on to, and given the fact that the extended duration of Sugimoto's exposure time has turned the flickering shapes of thousands of cinematic frames into an appearance of weightless transcendence, an impression of distance at once absolutely static and full of dynamic appeal. Yet soon our eyes will start to wander away from the white vortex. It will traverse the bushes and speaker hookups in the front, in all their illumination, and what—thanks to the absence of any lighting source other than the film projector—looks like their otherworldly glow. And it will, of course, navigate for some time

the lattice of lines crisscrossing the upper parts of the image: traces of moving planes, stars, and satellites that Sugimoto's open-shutter technique has transformed into a captivating, albeit utterly strange and unreadable, form of writing with light. We may have the best seat in the auditorium, but nothing in our approach to Sugimoto's image will resemble the phenomenological process by which we follow the "normal" theatrical screening of motion pictures. Open-shutter imaging, as it mimics the cinematographic procedure of the long take, mediates both cinema and photography into something unfamiliar and surprising. It layers different processes and temporalities of representation on top of each other, and in so doing, it turns white into a simultaneously utterly austere and compellingly complex signature of time.

In his 2010 book *White*, Kenya Hara describes the use of white as the center of what he calls Japanese aesthetic: a medium that conveys potentiality and limitless opportunity, inviting viewers to unscripted responses and affects, rather than simply signifying absence or nonbeing. According to Hara, a white and "unpainted space should not be seen as an information-free area: the foundation of Japanese aesthetics lies in that empty space and a host of meanings have been built upon it. An important level of communication thus exists within the dimension we call 'white.'"[1] For Hara, white results from aesthetic strategies of absolute reduction and simplification. Yet precisely in radically decreasing the complexities of the real, white also opens a space for the imagination, a space of plenitude and radical openness. White makes viewers pause to contemplate the present as a space charged with unconstrained and nonconstraining futurity, as well as with the possibility of wonder.

Though certainly informed by the traditions of Japanese art and aesthetics, the use of white in Sugimoto's *Union City Drive-In, Union City* exceeds and complicates Hara's considerations. For Sugimoto, white does not result from a deliberate process of reduction, subtraction, or simplification. On the contrary, white in Sugimoto's theater series in general, and here in particular, is a direct effect of photographic overexposure: a

too much of light, a calculated overstimulation of photographic chemicals. What we thus perceive as a space of mysterious transcendence and unlimited potentiality in truth turns out to be a space of oversaturation, a profound split between seeing and knowing. Moreover, if white in Hara's understanding largely represents a site not just of mediation and contemplation but also of purity and uncluttered immediacy, then in Sugimoto's work it achieves such qualities as a deliberate consequence of exploring and rubbing against the limits of given technologies of mediation. White in Sugimoto is what you get when you treat photographic apparatuses like film cameras. White comes to communicate potentiality when you defy the modernist search for decisive photographic moments and transform photography into a mechanism practicing the art of the long take. However, to argue about the question whether this is still photography or film with other means misses the point. Sugimoto's white instead indexes the mutual implication of both media, the fact that one cannot do without and—in each and every of its applications—contributes to the formation of the other. White traces the extent to which photography is cinema's base as much as it allows cinema to complicate our understanding of photographic temporality.

What is profoundly wondrous about the luminosity of Sugimoto's image, then, is how photographic technique here transforms a ruin of the past and its investments into utter mobility and user-friendly diversion into a window onto an open present, one freed from both the temporal exigencies of narrative cinema and the speed of late industrial life. While Sugimoto, so to speak, performs the long take's work for us, he sets viewers free to peruse the image at their own pace and leisure. He thus not only unsettles, reverses, and comingles the phenomenological processes involved in looking at both photographic and cinematic images but in doing so also fires up our curiosity and invites us to think through our own ability to wait. Time, in Sugimoto's image, doesn't come in the singular. It is precisely for this reason that his image succeeds in encouraging viewers to linger and reflect on temporal structures and

durations that run counter to the dominant regimes of time in contemporary image culture. Given the quick pace of visual streams today, perhaps nothing causes greater wonder than the simultaneous experience of measured movement and vibrant stillness offered by Sugimoto's image.

Into the Blue

We hear the blowing of the wind a few seconds before the camera opens its eyes and presents the viewer with a wide desert panorama at dusk: sand, exposed soil, and dispersed bushes in the foreground; a jagged horizon of distant mountains defining the limit of the lower third of the image; evening sky above gradually changing from red and pink to darker blues as the eye moves upward; a strange architectural configuration just below the mountain range, stretching horizontally almost across the entire frame. The compound's gray geometry at first appears to stand in stark opposition to what is desolate and rough about the surrounding landscape. But then again, as seen from afar, the building's shape and style look just as hostile and inhospitable as the surrounding desert. Both present geographies not meant for comfortable dwelling. While the one seems to be without limit and the other blatantly communicates its boundedness, neither of them appeals to our desire for play, for letting the imagination wander, for ambiguity and uncertainty. It is difficult to imagine a place more lifeless and dead. What we see is a landscape whose natural and man-made features appear modeled for the gaze of a photographic still camera. The real, in fact, in all its austerity and immobility, here seems to beat photography at its own game. Who needs to take pictures if reality itself approaches the viewer like a fixed image?

What we see could at first be taken for a still extracted from a road movie by Wim Wenders, shot somewhere in the American West to celebrate open landscapes as conduits to unregulated meaning and movement. Or it could be a frame enlargement from Michelangelo Antonioni's *Zabriskie Point* (1970), the Italian auteur's disturbing portrait of nonconformity and unrest in

Figure 10. Philipp Lachenmann, *SHU (Blue Hour Lullaby)*, 2002/2008. Video Still_1: *Planes/Stars*. Copyright Philipp Lachenmann.

late 1960s America. In spite of its hostile features, the landscape and its openness might also cause some viewers to think of Romantic nature painting—Romanticism's appeal to the sublime as a medium to reveal the humble place of human subjectivity in face of the overwhelming power of the external world. As it turns out, however, Philipp Lachenmann's camera in *SHU (Blue Hour Lullaby)* is directed at a high-security prison in the heart of the Mojave Desert. Part of the California Correctional Institution, the depicted building is one of four that provide level IV security housing units (SHU)—that is, solitary confinement to inmates deemed in need of maximum coverage during a lifetime sentence. In 1998, Amnesty International classified SHU confinement as a form of torture, yet within the American legal system, SHU practices today still serve as the most severe form of penalization, after a death sentence. There is, in other words, nothing Romantic or sublime about what we see. Nor should we expect any wind of indeterminacy, rebellion, and uncontained mobility blowing through this landscape either. Time appears utterly still, as void of anything that might invite

the viewer to develop some kind of contemplative or attentive relationship to the image on screen—until, of course, we come to realize that we aren't dealing with a still image at all, that the image on screen is animated despite the apparent absence of life within the frame. With that realization, our entire relationship to the image changes profoundly.

The footage of the prison was filmed in 2004 in high-definition video. Its different possible soundtracks were composed and arranged some time later, including the one representing a reconstruction of possible desert sounds. Lachenmann then condensed several hours of film into twelve and a half minutes that—as a result of the film's time-lapse effect—move us swiftly, yet without any sense of discontinuity, from day to night. As a result, in the course of the screening, we slowly but surely see the prison building come to life, not because of the movement of individual bodies (there aren't any) but because of the intensification of light as emitted from the prison's security lamps as well as the headlights of a car approaching the compound. Moreover, the longer the video and the darker the sky, the more lights will illuminate in the upper portion of the image—traveling spots of light left by airplanes as they approach and then partially fly over our point of view and thus increasingly fill the evening sky with a delicate fabric of luminosity. There is something surreal, however, about this gradual accumulation of moving lights in the sky. It doesn't correspond to familiar perceptions and expectations, yet even our knowledge of Lachenmann's time-lapse procedure doesn't help explain perceptible disjunctures of linear perspective. As Lachenmann himself clarifies in his exhibition statement, "The lights in the sky are digitally composed of hundreds of single airplanes arriving in flight corridors during the *blue hour*, filmed on digital video from 2002 to 2005 at the airports of Los Angeles, Frankfurt, London, New York."[2]

Though Lachenmann's compression of real time leads to a considerable acceleration of temporal registers, the resulting image has none of the frenzy often associated with time-lapse photography—no bodies that move like robots, no clouds

Figure 11. Philipp Lachenmann, *SHU (Blue Hour Lullaby)*, 2002/2008. Production Still_1 *Filming*. Copyright Philipp Lachenmann.

hastening by as if nature had lost its sense or was getting ready for an apocalyptic doomsday event. Instead, Lachenmann's video possesses a certain tranquility and composure, and it owes this quietness to the way in which special effects here animate what would otherwise strike the viewer as lifeless and dead. The speed of film technology and digital manipulation produces a sense of slowness that no single photographic still image of prison and surrounding landscape could ever achieve. The effect of this recalibrating of real time and the digital insertion of moving lights into the sky is therefore puzzling, to say the least. While the landscape itself appears void of life and movement, the image's formal properties endow the visible with the promise of dynamic traversal and change; they also refer the viewer to imagery well known from the vocabulary of commercial visual culture. As Lachenmann informs the viewer, the choreography of moving lights was largely inspired by the opening logo of Disney film productions: the animated

image of stars assembling over a mighty castle, pledging millions of viewers every day temporary relief from the pressure of the ordinary.

High-security prisons as a romantic castles of the imagination? Hostile landscapes as playgrounds for adventure? Bleak realities transfigured into sites of fantastic dreaming by both the temporal openness and spatial malleability of digital media?

Rather than pursue such simple ideological suspicions, my suggestion is to read Lachenmann's *SHU (Blue Hour Lullaby)* as a rigorous investigation of ambivalence and uncertainty. As we move both slowly and at an accelerated pace through the day's blue hour into the dark, Lachenmann's video invites the viewer to do what Disney most often denies: to attend to minute, quiet, and almost imperceptible changes that do not follow any narrative teleology, involve clear-cut conflicts, or soothe spectators with a final release of dramatic tensions. Lachenmann's point, in fact, could not be more different than to Disneyfy the inhuman politics of solitary confinement. Rather, Lachenmann seeks to explore secret complicities between the temporal logic of commercial cinema and the ideological protocols vindicating level IV security housing. Whereas the earlier presents time as a dramatic drive powered by the promise of complete resolution, the latter aspires to halt the fundamental productivity of time—time's ability to make us experience the unexpected—in the hope of containing existing conflicts and future crimes. While initially one could not be more different from the other, both repress what makes Lachenmann's video itself tick: the video's ambition to sharpen our awareness for the unresolvable copresence of different structures of temporality in what we experience as the present. Disney's logo warrants a harmonious coming together of different temporal vectors at the end of each narrative that will leave no room for further surprises; the politics of solitary confinement want to halt time even before it could unfold into unpredictable directions. *SHU (Blue Hour Lullaby)*, by contrast, precisely by mapping these two different logics of time onto each other, makes

a plea for a different, more open, and more human conception of temporality, one according to which movement and stasis, traversal and standstill, confinement and transcendence, the ordinary and the unexpected, could and should coexist. In allowing special effects to animate the photographic immobility of the prison, Lachenmann reminds us of the fact that the logic of neither photography nor film alone could ever represent the potentiality and productivity of human experience.

Out of the Black

Sugimoto toys with photography's desire to be film; Lachenmann seeks to push film toward the photographic. The earlier converts physical movement into a luminous image of transcendence, the latter pictures a static universe as if it were animated by energizing forces. Both actively compress extended durations and thus release the viewer's phenomenological operations from attending to the entire process captured within their respective frames. Both re-present the logic and work of the filmic long take more than they seek to impress it onto the viewer. Yet it is precisely in doing so that they make us contemplate the contemplativeness of extended shot durations and incite our curiosity about the wondrous nature and creativity of prolonged looking today.

Creativity, Hara concludes about the power of white, is what animates emptiness by asking ongoing questions: "A creative question is a form of expression—it requires no definite answer. That is because it holds countless answers within itself."[3] Though Sugimoto and Lachenmann move along very different paths, their respective works seek to absorb us, the viewers, not in order to make us forget our own subjectivity as onlookers but to stimulate a creative and open process of questioning, to explore the power of questions that refuse singular or definite answers. Sugimoto's white—his traces of light—is no different from Lachenmann's ever-intensifying blue. Both define the apparent emptiness of extended durations as sites of experiencing the creativity of time, of asking questions that hold more

than one possible answer. Instead of offering images that directly answer to our desires, they want us to learn the art of encountering images like question marks; they act as promissory notes, prying open possible futures in spite of what is calamitous about the course of time.

In the nineteenth century, French writer Stendhal famously defined beauty as a promise of happiness. As they emulate and represent the operations of the long take within their respective media, both Sugimoto's *Union City Drive-In, Union City* and Lachenmann's *SHU (Blue Hour Lullaby)* identify their camera's patient writing with light as a contemporary version of Stendhal's vision of art. Extended shot durations, Sugimoto and Lachenmann teach us, allow viewers to acknowledge (and praise?) what photography and cinematography are all about: the deliberate staging and rewriting of light's triumph over darkness, no matter how devastating a particular subject matter might be. By suspending our desire for instant gratification, long takes hold on to a promise of light and happiness that 24/7 media culture betrays whenever it seeks to provide fast, unquestionable answers to our thirst for visual pleasure.

"IT'S STILL NOT OVER"

Hong Kong Passage

Twenty-one shots, spread out over little more than twenty-five minutes. Some of these shots last up to almost five minutes; a very few cut away after less than thirty seconds. With two exceptions, the camera in all of these takes remains utterly static, unmoved by what happens in front of the lens. It grants us, the viewers, ample time to look, to peruse, to attach our gaze to the body whose deliberate pilgrimage through urban space and the image's frame is at the core of what we see on screen.

What we witness in these twenty-one shots is the birth of cinema from the spirit of photography—or conversely a film trying everything at its disposal to escape the demands of forward motion and return back to the photographic. In each shot, we see the figure of a Tibetan monk, played by Lee Kang-sheng, as, head rigidly bent toward the ground, he traverses the busy streets of Hong Kong by day and night (Figure 12). The camera's distance varies in each of the film's takes. So does the angle from which the director chose to capture his protagonist. Lateral and frontal points of view prevail, stressing the frame's stability and detachment. Yet now and then the camera will also cut to more oblique angles—angles that invite the viewer to search for the walker in the first place, and/or display selected sections of his body with the help of internal framing devices.

One could easily imagine this film—Tsai Ming-liang's *Walker* (2012)—to be shown on its own in a gallery space, labeled as

Figure 12. Tsai Ming-liang, *Walker*, 2012. Screenshots.

video or installation art and presented to roaming museum pa-
trons instead of immobile cinema spectators. Yet participating
in East Asia's early twenty-first-century micro-film movement,
Walker was first exhibited as part of an omnibus film by Chang-
wei Gu, Ann Hui, Tae-Yog Kim, and Tsai himself entitled *Beau-
tiful 2012* and premiering at the Cannes Film Festival in 2012.
Walker's role within this collaborative effort resembles that of
Tsai's monk amid hypermodern Hong Kong: it suspends domi-
nant structures of (cinematic) time so as to refract how today's
ever-accelerating mandates of global capital, information, and
entertainment displace viewers into permanent elsewheres
and elsewhens. Like Tsai's monk passing through Hong Kong's
urban landscape, *Walker* inserts something strange and incom-
mensurable into its filmic context—something that makes us
pause, not simply in order to come up with new readings but to
unsettle the very way in which we tend to expect meaning and
intelligibility when directing our attention to texts and images,
moving or not.

With an average shot length of a little more than one minute,
Walker may not strike cinemetric scholars as particularly slow.
Tsai—born in 1957 and raised in Malaysia before moving to
Taiwan at the age of twenty—has certainly directed films that
more radically probe the viewer's ability to hang on to individ-
ual shots. Consider the scrupulous slowness of films such as *The
River* (1997), *The Hole* (1998), *What Times Is It Over There?* (2001),
The Wayward Cloud (2005), *I Don't Want to Sleep Alone Any-
more* (2006), *Stray Dogs* (2013), and, as discussed below, *Good-
bye, Dragon Inn* (2003). Statistical analysis, however, cannot but
fail to account for what is centrally at stake in Tsai's micro-film,
not least of all its desire to challenge a culture of instantaneity
obsessed with the metrics of speed, density, transaction, and
ownership. For *Walker*'s most provoking temporal intervention
takes place within the duration of each individual shot itself:
the way in which Tsai's monk, with utter concentration, allows
each of his steps to take pretty much exactly thirty seconds, as
if captured in slow motion, as if the monk's body had absorbed
cinematic technique and technology into its own kinesthetic

operations, as if this body achieved its slowness not simply by ignoring the agitated rhythms of the Now but by exploring what is medium about the body itself and consciously setting the body's clockwork against the profusion of speed and technological mediation in the present. The photographic here re-emerges as film's unconscious, cinema's dark continent, just as much as the body takes on the function of a special effect, a time piece probing the durational in active engagement with the fast-paced itineraries of urban life. Tsai's pilgrim, camera and projector at once, may initially strike the viewer as deeply anachronistic. In truth, however, his path is that of an unconditional contemporary. His very slowness allows us to reflect on the velocity of the moment and press against the modern dominance of chronological time over the inner time of experience.

Korean German philosopher Byung-Chul Han describes pilgrims as masters of the threshold.[1] Pilgrims not only traverse space but also embark on intricate acts of time travel. They might be on their way toward distinct destinations, but unlike tourists, who chase from one sight to another, pilgrims consider movements and paths as something meaningful in themselves. The ability to wait and linger, the desire to delay desire, a dedication to hesitate in threshold areas—all this defines the pilgrim's path, his pursuit of structures of temporality that are open to the semantic and sensory richness of what is at once transitional and durational.

Walker's use of the long take defines Tsai's cinema as a cinema of thresholds—as threshold cinema. This chapter explores the dimensions of threshold cinema in greater detail. Its primary objects are films whose long takes linger at the edge of movement and transformation; whose carefully choreographed acts of framing not only suspend the viewer's desire for narrative development but also probe the very relationship between sense and intelligibility, sensory perception and narrative meaning; and whose utter formalism and austerity serve as a means of maximalist aspirations, namely a relentless inquiry into the conditions of contemporary life coupled with a fundamental investigation of the past, present, and future of cinema.

The static and deeply meditative frames of Tsai Ming-liang, in particular as used in his 2003 *Goodbye, Dragon Inn*, will mark one pole of the argument. The other pole will be the itinerant yet contemplative shots of Béla Tarr's *Werckmeister Harmonies*, the Hungarian auteur's 2000 masterpiece. In some respect, the work of both filmmakers could not be more different. One is deeply concerned with the spaces of the body and its sexuality; the other maps unrelenting landscapes of the mind. What both share, however, is their stress on the nonmetaphorical aspects of durational images, their efforts to evacuate meaning and narrative teleology from what we see and in this way to recalibrate cinema's relation to the real. What both also share is a profound sense of nostalgia driven by the feared disappearance of celluloid culture, yet one that is—as I will argue—by no means closed to the possibility of a wondrous turn of events.

Tsai's and Tarr's aesthetic of the long take defines camera, image, screen, and auditorium as thresholds of lingering and ambivalence. Like Hegel's owl of Minerva, their cinema invites viewers to recognize film's full potential as a medium of picturing presence in the very moment of cinema's presumed historical demise. Yet far from merely mourning a vanished past, the nostalgia of Tsai's and Tarr's uncompromising long takes functions as a conduit of sensory self-experimentation and interpretative deferral, at once pulling viewers into and pushing them out of the image. Contrary to expectation, the look that Tsai's and Tarr's cameras cast at human realities is not necessarily a human look. It violates the anthropomorphic mandates of mainstream cinematography and editing, and because of its formal rigor, it highlights its own machinic origins: the mechanical aspects and artifice of cinematic recording. No one ever looks at things in the way that Tsai and Tarr frame filmic space. To therefore think of Tsai's or Tarr's nostalgia as a romantic protest of the past against the present, the authentic against the mediated, misses the point. Like the seemingly anachronistic yet uncannily automated monk in *Walker*, nostalgia in Tsai and Tarr actively reflects on and recomposes the antidurational logic of 24/7. It situates the viewer at the thresh-

old of the sensory and the technological, of what is machine about the body and body about the machine, so as to suspend automated responses and retrain our ability to linger without prospects for resolution. Their cinema of the threshold does not present the slow as a mere inversion of today's speed but rather as a medium to develop fundamentally different notions of movement and spatiotemporal mapping. Its aim is to transform both camera and viewer into pilgrims who appreciate the experience of path and passage as cinema's greatest and continually unfulfilled promise.

(Un)Framing Time

Modernist film theory often argued that cinema, for it to become an autonomous art form, had to practice strategies of subtraction, inversion, and reduction. To live up to its potential film had to explore modalities of vision categorically different from the operations of the human eye. It had to envision the unseen, frame the real from unexpected angles, and focus entirely on the medium's ability to dissect the optical field and engage the viewer in a dialectic between the visible and the off. As Rudolf Arnheim summarized in 1933:

> Since our eyes can move freely in every direction, our field of vision is practically unlimited. A film image, on the other hand, is definitely bounded by its margins. Only what appears within these margins is visible, and therefore the film artist is forced—has the opportunity—to make a selection from the infinity of real life. . . . The delimitation of the image is as much a formative tool as perspective, for it allows of some particular detail being brought out and given special significance; and conversely, of unimportant things being omitted, surprises being suddenly introduced into the shot, reflections of things that are happening "off" being brought in.[2]

For Arnheim and others, the deliberate use of formative elements defined film simultaneously as art and as modernist; it

situated film as the most modern of all arts. Such a modernist will to form clearly finds certain echoes in Tsai's and Tarr's cinemas of glacial slowness. In the work of both directors, the long take imposes certain constraints on our "organic" field of vision so as to investigate film's ability to make the viewer see anew and ponder film's logic of mediation. Tsai's desire to form the durational character of cinematic images examines—and, as it turns out, destabilizes—our understanding of the screen as either frame around or window onto the real. Tarr's highly choreographed camera work, on the other hand, engages—and, as it turns out, unsettles—our view of cinema as a revolving door or portal of sensory immersion. Though equally probing their viewer's structures of attentiveness, the long takes of both directors are thus based on very different philosophies of cinema as an art of visual delimitation. Yet what both share is their effort to upset the dominant understanding of their own position from within, to approximate the other by rubbing against the conceptual and aesthetic limits of their own formalist agendas, and in doing so to define contemporary art cinema as a cinema of threshold sensibilities—that is, as threshold cinema enabling possibility, emergence, and the wondrous.

As Thomas Elsaesser and Malte Hagener have summarized, the concept of cinema as window and frame rests on three presumptions: "First of all, the cinema as window and frame offers *special, ocular access* to an event (whether fictional or not)— usually a rectangular view that accommodates the spectator's visual curiosity. Second the (real) two-dimensional screen transforms in the act of looking into an (imaginary) three-dimensional space which seems to open up beyond the screen. And third, (real and metaphorical) distance from the events depicted in the film renders the act of looking safe for the spectator, sheltered as s/he is by the darkness of the auditorium."[3] To be sure, whereas the notion of cinema as window primarily envisions self-effacing or seemingly transparent modes of representation, the concept of the frame aims at visual strategies that exhibit the very act of framing and hence the material specificity of the medium. What both notions share, however, is

a mode of being and sensing (the world of) cinema that stresses the ocular, transitive, and disembodied nature of the viewer's relation to the screen. Whether we look through a screen's window or at its frame, the act of viewing in both scenarios is primarily defined in terms of optical access, the fact that viewers look at something without being looked at, and the fact that spectators can enjoy distant sensory relationships to the world depicted on screen.

Tsai's uncompromisingly static frames often appear to oscillate between notions of cinema as window and frame. In all of his films, starkly frontal tableaux alternate with dramatic orthogonal compositions that foreground the very mechanisms of perspective. Whereas the first strategy, in particular when allowing protagonists to enter and exit the frame without causing the camera to move at all, presents the diegetic world as if it continued to exist even in the absence of the camera, the second strategy accentuates the frame and hence the image's constructivism while underscoring the power spatial structures hold over the lives of Tsai's often highly isolated characters. As a result, Tsai's images at once provide impressions of depth and flatness, temporal openness and closure, centrifugal and centripetal composition—and precisely thus exhibit the extent to which the notions of cinema as window or frame might not be that different after all because both postulate the fundamental independence of the image from the act of viewing and thereby hope to situate the viewer as a spectator able to peruse the image in all its compositional wholeness from a critical distance.

Or so it may seem, at least at first. Let me now continue to argue that it is the particular function of the long take in Tsai's work to collapse frame and window into each other, to unsettle the view of viewership as primarily ocular, transitive, and disembodied, and thereby to approximate a notion of the screen as a site of sensory encounters and transactions. Meticulous attentiveness to form here displaces the kind of expectations and politics usually associated with certain formal devices. It liquefies modernist oppositions between realism and formalism, transparency and self-reflexivity, so as to envision a cinema in

whose context the constraints of form enable the contingent and unpredictable, the curious and wondrous, to emerge amid this cinema's overt melancholia and nostalgia.

Consider some of the last shots we see of the auditorium of Taipei's Fu Ho Theatre in Tsai's *Goodbye, Dragon Inn*, first capturing one of the theater's male patrons and then picturing the box office attendant as she traverses the empty rows of seats (Figures 13 and 14). *Goodbye, Dragon Inn* chronicles the final screening of King Hu's 1967 kung fu classic *Dragon Inn* at an old movie palace of the same name, doomed to close forever. Long and static takes place us in the cinema's almost empty auditorium, but they also transport us to a number of labyrinthine spaces that make up the rest of the building: a bathroom with a long row of urinals, the basement, the box office, the projection booth, dark passageways, and wet storage areas that do not seem to have any explicit function. Throughout the film's ninety minutes, we witness mostly unsuccessful efforts of establishing human contact between the theater's very few patrons on the one hand and its two remaining employees on the other. Tsai's theater is an uncanny place, a space whose lack of futurity calls forth all kinds of specters from the past. As it turns out toward the end of the film, two of the viewers in the auditorium starred in Hu's original *Dragon Inn*, viewing their past performance with a mournful sense of loss and distance. A young Japanese tourist explores the auditorium and back spaces as a location for sexual encounters. As he cruises through the building's mystifying architecture, it is up to this stranger to trigger the first (and almost last) dialogue of the film more than forty minutes into what doesn't really amount to any narrative at all: "Do you know this theater is haunted?" Repeatedly, we see the ticket woman (Chen Shiang-chyi) trying to find the projectionist (played by Lee Kang-sheng, the monk of *Walker*). The camera follows her patiently as she—with a severe limp—works herself through the building, yet the film refuses to show us any successful culmination of her quest. Though the film as a whole, unlike *Walker*, may not qualify to show outside regular theatrical settings, its diegetic staging of *Dragon Inn*, its

nestling of one film and screen into another, make the Fu Ho Theatre look like a dilapidated gallery space inviting itinerant viewers to dip in and out of a black box installation. The theater itself is the film's main actor and protagonist. It not only sets the frame for the "action" but also encourages us to contemplate the framing of both sensory perception and meaning in contemporary visual culture—a kind of visual culture in which neither celluloid nor single-screen experiences can claim normative authority over the transmission of moving images.

The sequence in question starts with a shot showing two men from the rear, seated in different rows of the otherwise empty auditorium (Figure 13). Though we at first can't see the screen, a series of strange sounds indicate the ongoing showing as much as the blue light that faintly illuminates the auditorium. Eventually the man closer to the screen makes some effort to establish visual contact with the man in the rear. We cut to a medium close-up of the man in the front as he turns around, blurry images on the theater's screen now visible behind him. His gaze remains unanswered; he therefore turns his eyes back to the screen, on which we can now detect a fight between two warriors (played more than thirty years earlier—as we are to learn later in the film—by the very same men who are at the

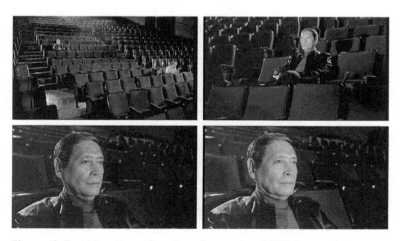

Figure 13. Tsai Ming-liang, *Goodbye, Dragon Inn*, 2003. Screenshots.

center of this sequence). The camera cuts to a medium shot of the man in the rear. He briefly, too late—deliberately too late?—turns his head after all, as if to respond to the other man's gaze, before we cut back to the man in the front, the camera's focus now however directed on the ongoing action on screen. For a few moments, the image entirely centers on the screen before we get another view of the auditorium with both men in very different areas of the image, arrested in a distance that could not be greater. A few more shots show screen and auditorium, so as to further explore the tension between the spectators' sense of stasis and the ecstasy of action on screen, before we cut to a medium close-up of the man in the rear that will linger on his face for more than ninety seconds, with a certain kind of tenderness that at the same time could be read as a gesture of unyielding curiosity.

Throughout these ninety seconds, blue light flickers on his face. We are in a territory familiar from Hiroshi Sugimoto's photographic theater series: the use of screen projection to bring things other than the screen to light. What we thus see, however, is no longer a completely static interior or the sight of a man whose immobile body defines him as an integral part of a larger architectural assembly, an object among other objects. For what Tsai's relentless long take brings to the fore is a welling up of tears in the man's eyes, a sentimentalism and articulation of embodied presence rendered visible by the reflected light from the screen. There is no need to disparage the man's tears as kitsch or sappy overindulgence. What matters is to acknowledge how Tsai's long take here seizes the screen's reflected light to postulate the mutual implication of mediation and embodiment, absence and presence, past and present, stasis and movement. Even though Tsai's minimalist narrative gives the viewer almost nothing to reflect on what may cause the man's tears, Tsai's long take transforms this moment into a scene of public intimacy, a scene pushing the viewer—like the man himself—beyond the brink of a merely optical relationship to the screen and making us wonder what Tsai's stagnant frames seem to refuse to show.

Figure 14. Tsai Ming-liang, *Goodbye, Dragon Inn*, 2003. Screenshots.

Let's not forget, however, about what happens in the next two shots. We briefly cut to a view from behind the ticket woman's head as she gazes through a curtain into the auditorium while *Dragon Inn*'s credits become visible on screen. Then we cut to a shot from the perspective of the screen, the auditorium's neon lamps slowly filling the empty room with diffuse, cold light (Figure 14). The woman enters the space from the right, the presumed location of her earlier viewing. For the next three minutes, we see her limping along the rows of red seats, traversing sideways, descending a few rows again, and finally exiting the frame of the image on the left—only to then witness an image that lingers on for another ninety seconds on the tableaux of the now entirely empty auditorium. The camera remains absolutely still during these ninety seconds. It not only records the absence of anything to record but also, like a surveillance camera, pretends to show the real as if cinematic recording did not rely on someone's intentionality or subjectivity, as if machines and their automatisms had taken over because humans and their temporality had left the scene.

Tsai's long take here seems to provide a perfect medium to literalize the fact that time is running out on the Fu Ho. What

Tsai's persistent camera appears to posit, once the woman from the box office has exited the frame, is that there is nothing to show anymore; futurity and the productivity of time have been swallowed by the present. As much as the photographic here appears to absorb the cinematic and thereby reverse the technological origin of film, so does memory occupy the space of anticipation, a sense of utter suspense the place of forward movement. Tsai's own view about the mnemonic politics of *Goodbye, Dragon Inn* is well known:

> It is really a film about the memory of this movie theater, which is the main "character" of the film. When we go into a movie theater to watch a movie, it's a kind of timeless space, time is in suspension. So the memories of this theater are really kind of fragments. Just as you see fragments of *Dragon Inn*. The theater remembers, for example, times when a lot of people were there together watching, or when only a few people were watching. It's not necessarily the case that *Dragon Inn* is actually playing there, it's really a kind of memory of when it had been playing there. Likewise there are memories of people eating in the movie theater, especially the part about eating watermelon seeds, which is a very deep memory for Chinese audiences. If we think about the film as the whole memory of the theater, then we see that it all comes together at the end.[4]

But do long takes like the one of the auditorium, in particular its final ninety seconds, fully ratify Tsai's nostalgic view of both history and architecture as memory? Does the shot's impassive recording of the sheer passing of time, of suspended temporality, of voided humanity, really succeed in sealing off the future and oblige the viewer to solely live with the spectral remnants of the past?

Tsai's politics of framing is of essential importance to answer these questions and argues that the end of (celluloid) cinema is not coequal with the end of time. The static camera work in this sequence certainly alludes to modernist conceptions of

cinema as window and frame. At first Tsai's rigid choreography of diegetic space appears to display the world on view as one to which we may have primarily ocular access. It frames orthogonal perspectives and shifting vanishing points in such a way that the screen's two-dimensional flatness impresses itself on the viewer as plastic deep space. In foregrounding the screen's independence from the viewer's act of viewing, it seems to render the act of looking as safe and detached from what is shown on screen. Yet Tsai's painstaking long takes of both the tears of the male spectator and the limping of the ticket woman clearly invite the viewer to move beyond a merely ocular model of cinematic viewership. Here as elsewhere, Tsai's long takes linger and stare as if some hidden consciousness and intentionality told the camera to simulate the apparatical and nonintentional. The camera's lingering pretends to capture mechanized views of the world as if no cinematographer or viewer was present, yet it does so with such deliberation, obstinacy, and excess that we cannot but experience Tsai's images as highly performative interventions, calculated automatisms that evoke the very opposite of the automatic and calculated. Tsai's long takes expose technique as technique. Their slowness rubs against the strictures of the frame, of any sense of spatial containment, so as to invite viewers to move their gaze across and beyond the material surface of the image, whether this image has something to say to them or not. In doing so, Tsai not only draws attention to what is rhetorical about the very notion of frame and window but also situates the viewer as no longer entirely external to the screen. Instead of safely framing the world from a distance, Tsai's long takes move us toward experiencing the screen as a surface of haptic attachments—as skin, perhaps even as physical membrane. The man's tears, the woman's limp: both invite viewers to latch their perception to the materiality of filmic (re)presentation while asking them to suspend predominant notions of the screen as window or frame. Rather than safely contain the world on view, both images define the cinematic screen as a threshold, as a space of performative lingering in which our hesitation between different modalities of looking

enables us to touch on something that exceeds any stream-lined and transparent understanding of the world. In Tsai's world, the long take's very association with mechanization and desubjectivization formulates promissory notes of something that might be able to beat the devastating automatisms of mod-ern life at their own game.

Though time might be running out on the Fu Ho, the cam-era's "as if" cracks the closure of space, time, and meaning nostalgically associated with the end of celluloid cinema. Tsai makes us look hard in desperate search for meaning and ad-ditional information, yet what we come to realize is that good looking involves much more than merely using our eyes, and that meaning might not be something cinema at its best is all about. The relentless stare of Tsai's camera, lingering as if it were a mere surveillance apparatus, comes to evoke nothing less than the presence of an absence, the riddle of a lack that drives time forward. It presents projected images as material points of contact whose inherent blind spots and vacancies make us curious not only about what has been lost but also what is to come. There is no way for us, as viewers, not to follow, imagine, and reframe the woman's limp, even long after she has exited the frame. There is no way for us not to infuse with movement and be curious about what at first presents itself to our eye as a melancholic regression of the cinematic into the photographic. Cinema as we know it might have little to show anymore, but the history of images in motion is certainly not over yet. In fact, it may not have yet even fully begun.

Temporalizing Space

Film critics like to read Tsai's systematic use of long-take cine-matography as an attempt to rework the legacy of the postwar European auteurism, the measured temporalities of Antoni-oni, Jancsó, or Tarkovsky. What is more important to point out, however, is the extent to which Tsai's stretching of cinematic time responds to and amplifies stylistic idioms that have driven East Asian art cinemas since the mid-1980s and achieved a cer-

tain codification on the international film festival circuit in the course of the 1990s. The films of Taiwanese new wave directors such as Hou Hsiao-hsien and Edward Yang, Korean Kim Ki-Duk, Thai Apichatpong Weerasethakul, and mainland Chinese Jia Zhangke have no doubt influenced or been influenced by Tsai's deflating of narrative time, creating a transnational body of work in which extended shot durations provide an instantly recognizable form of art cinematic practice. As Jean Ma and others have persuasively argued, the deliberate and at times almost formulaic slowness of East Asian art cinemas during the last few decades should not simply be seen as a mere negative to the accelerated protocols of Asian mainstream and "postclassical" filmmaking.[5] Instead, East Asian art cinema's experiments with the durational register and respond to larger processes of modernization and globalization, understood not simply in terms of a dramatic acceleration of individual lives but in terms of the ever-increasing copresence of multiple temporalities and speeds within the hybrid space of an expanded present. As I will explore in greater detail in chapter 7, the deliberate slowness of Asian art cinema provides an active and by no means merely escapist mechanism to reflect on the dramatic collapsing or fraying of former temporal horizons during times of fast-tracked social, economic, and technological transformations.

Similar arguments certainly can and have been made about the work of Hungarian filmmaker Béla Tarr, reading the apocalyptic mood and melancholic slowness of films such as *Damnation* (1988), *Satantango* (1994), *Werckmeister Harmonies* (2000), *The Man from London* (2007), and *The Turin Horse* (2011) as sundials of larger historical transformations: the breakdown of communism in Eastern Europe, the disappearance of utopian thought and alternative social visions after the fall of the Berlin Wall, but also the arrival of new sensibilities toward the textures of the material world after the vanishing of redemptive notions of historical progress.[6] Loosely based on the 1989 novel *The Melancholy of Resistance* by László Krasznahorkai, *Werckmeister Harmonies* in particular seems to fit this bill. Tarr's film tells

the story of a provincial town in Hungary shaken up by a travel-
ing circus and its exhibition of a dead whale on the town's cen-
tral square. At once the town's postman and its eccentric fool,
János—played by German actor Lars Rudolph—seeks to make
sense out of what he sees, yet becomes increasingly drawn into
what exceeds our understanding as well. He navigates between
some of the film's principal locations and figures: the house
of composer György Eszter (Peter Fitz) who speculates about
the extent to which the modern Western harmonic system ex-
presses or betrays the cosmic order; the farm of his estranged
wife, Tünde Eszter (Hanna Schygulla), who will come to play
a critical role in instigating the increasing disorder among the
townspeople; the town's central square, with the giant trailer
containing the whale, the circus's sinister impresario, and an
increasing number of local residents battling the cold; and,
toward the end of the film, a hospital at the edge of town, its
patients brutalized by a violent crowd. In thirty-nine exqui-
sitely choreographed shots, *Werckmeister Harmonies* stages
the breakdown of order and common value as well as a uni-
verse no longer held together by utopian visions or teleological
concepts of history. The liberating experience of radical con-
tingency here produces disaster triumphant. The vanishing of
social control and choreography yields tumultuous irrational-
ism. Instead of producing anything new, revolutionary energy
unleashes a monstrous return of archaic violence. How can we
not read all this as a commentary on various social transforma-
tions in Eastern Europe after the breakdown of state-sponsored
socialism? How can we not see in all this the telling of a story
about things in crisis, about the contracted temporalities that
define the experience of crisis in the first place?

While it is tempting to read *Werckmeister Harmonies* as
political allegory, its most provocative intervention lies—like
Tsai's *Goodbye, Dragon Inn*—in using extended shot durations
to probe our very relationship to the world viewed, and as a con-
sequence to make us wonder about how to read filmic images
and narratives to begin with. This is not to say that Tarr's films
shun the political. It is to say, however, that we do well not to

read their melancholic mood and apocalyptic pessimism as direct expressions of Tarr's politics. It is to say that the political aspect of Tarr's films emerges not from what they have to say in terms of their overt narratives but from how they do it—from their judicious modulations of different temporalities and the way in which, similar to Tsai, the extended durations of Tarr's shots seem to implode, or at the very least push against, what we at first might consider the narrative content of these shots.

Consider the opening shot of *Werckmeister Harmonies*, a ten-minute tour de force set in a local bar shortly before closing (Figure 15). The shot begins with a close-up of a furnace, the intricate grid of its iron door allowing us to see the flames of the fire inside, its sight from the outside resembling a graphic representation of the sun's rays emanating from a dark center. It ends, an aeon later, with a medium close-up of the face of the bar owner, standing at the door so as to usher his drunken patrons out of the bar. What happens in between is a virtuoso performance, not only of mailman János as he choreographs the bar's intoxicated clients into an animated (re)presentation of a solar eclipse, but also of the camera as it shrewdly participates in the rotation of celestial bodies. At times the camera spins along or against the revolution of human participants; at times it draws closer, to become an orbiting planet itself; or, in the very moment of perceived total darkness on earth, it retracts to take up a position right underneath the bar's ceiling light, as if to look down at the spectacle from the sun's perspective.

János's ballet charges human and cinematic temporality with the *longue durée* of planetary time. Circular time—the original, astronomical meaning of "revolution"—here comes to absorb any concept of time as linear, progressive, and transformative, the eternal swallowing the merely mortal. Listen to how János, assuming the role of a film's diegetic director and choreographer at once, describes, and through his very words conjures, his modeling of planetary motions:

> All I ask is that you step with me into the boundlessness
> where constancy, quietude and peace, infinite emptiness

Figure 15. Béla Tarr, *Werckmeister Harmonies*, 2000. Screenshots.

reign. And just imagine in this infinite sonorous silence
everywhere is an impenetrable darkness. Here we only
experience general motion and at first we don't notice
the events that we are witnessing. The brilliant light of the
Sun always sheds its heat and light on that side of the Earth
which is just then turned towards it. And we stand here in
its brilliance. This is the Moon. The Moon revolves around
the Earth. What is happening? We suddenly see that the
disc of the Moon, the disc of the Moon, on the Sun's flam-
ing sphere makes an indentation, and this indentation, the
dark shadow, grows bigger . . . and bigger. And as it covers
more and more, slowly only a narrow crescent of the Sun

remains, a dazzling crescent. And at the next moment, the next moment, say that it's around one in the afternoon, a most dramatic turn of events occurs. At that moment the air suddenly turns cold. Can you feel it? The sky darkens and then goes all dark. The dogs howl, rabbits hunch down, the deer run in panic, run, stampede in fright. And in this awful, incomprehensible dusk even the birds . . . the birds too are confused and go to roost. And then. Complete Silence. Everything that lives is still. Are the hills going to march off? Will heaven fall upon us? Will the Earth open under us? We don't know. We don't know, for a total eclipse has come upon us. . . . But . . . but no need to fear. It's not over. For across the Sun's glowing sphere slowly the Moon swims away. And the Sun once again bursts forth, and to the Earth slowly there comes again light, and warmth again floods the Earth. Deep emotion pierces everyone. They have escaped the weight of darkness.

János ballet enacts the wise fool's desire for cosmic order, a kind of prestabilized harmony of things in which even moments of apocalyptic silence—the radical absence of meaning—allow us to think of what is to come and hence assume a certain meaning in the larger rhythm of movements. János's world of celestial bodies is void of what the modern political or historical world understands as revolutions. There are no radical ruptures here, no rebooting of historical time, no change of calendars or any transformative contractions of temporality. János's cosmic time instead rests on the figure of the eternal recurrence of the same and precisely thus attributes significance even to what seems to deny meaning, that which makes dogs howl, rabbits hunch down, and the hills march off the horizon.

Allowing János to take on the role of both sage and master showman, the opening shot of *Werckmeister Harmonies* presents the viewer with an overdetermined effort to fuse sense and meaning into a unified whole. János's innermost hope is to erase the difference between actions and thoughts, gestures and words, movements and interpretations. Nothing, however,

could be more erroneous than to see János's planetary choreography as key to or allegory of what will ensue in the next 130 minutes of the film. Eszter's rumination about the incommensurability of Western harmonic principles and the inherent structures of the universe belie János's visionary choreography as much as the course of the narrative itself, the way in which no identifiable logic propels and ends the villagers' rebellion, the way in which words and ideas here emerge as fundamentally inadequate to interpret, let alone change, the world. *Werckmeister Harmonies*, as it turns out, is not about the causes that drive worldly matters but about our futile and in fact precarious hope to translate visions of natural harmony and meaning into blueprints of human affairs. Nature is as foreign to what makes societies tick as reason is to how crowds behave once they are fired up by anger, despair, and destitute conditions.

It is the function of Tarr's gorgeous long-take opening not simply to situate the viewer as János's accomplice in the dream of planetary harmony but to communicate a certain sense for what the film will eventually present as the unbridgeable abyss between sense and meaning. With its profoundly mobile frame, Tarr's camera might at first be considered as a self-effacing apparatus trying to draw the viewer into the film's diegetic space and place us sensorially amid János's celestial bodies. One among various orbiting objects, the camera—it could be argued—invites viewers to cross the screen, to abandon the stasis of a purely observational stance and immerse ourselves bodily into the world viewed. However, while Tarr's roaming camera indeed unsettles common notions of the screen as a transparent window, its very measured acts of reframing the visible at the same time displays the camera as an apparatus endowed with a certain consciousness and subjectivity, more as a mediator and commentator than as a detached mechanical witness. Like János, Tarr's camera figures as an active presence evoking or conjuring what we see in the first place. The resulting viewing position for the onlooker is a difficult one as we simultaneously get pulled into and pushed out of the image, spin with János's bodies and become aware of our own spin-

ning, see through the frame and see the frame doing its work. Whereas the image at first might come across as wanting us to transgress into the film's diegetic space, Tarr's extended shot durations allow us to see and sense our own seeing in such a way that we end up in a curious state of suspension somewhere in between of what classical film theory would consider fundamentally incompatible attitudes toward the screen. Viewing Tarr's camera viewing thus becomes a threshold experience. It asks us to oscillate between proximity and distance, immersion and detachment, between enjoying the purely sensory aspects of the image and contemplating the frame's suggested acts of commentary and meaning making.

"Screens," Elsaesser and Hagener remind us, "are (semipermeable) membranes through which something might pass, but they can also keep something out: they act as sieve and filter. They are rigid and solid, but they can also be movable and flexible. Screens are in effect something that stands between us and the world, something that simultaneously protects and opens up access."[7] Tarr's long-take cinematography collapses the multiple meanings and possibilities of screens into something that deeply unsettles preconceived notions of representation. His elaborate camera moves, as they push time and again to the limit of what celluloid film can technically record in one continuous take, define the cinematic screen as both membrane and filter, as being movable and static at once, as something that produces worlds as much as it stands between us and the world viewed. If the durational qualities of individual shots in Tsai open surprising windows toward the sensory, in Tarr the long take tends to destabilize the frame from within, allowing us to enter a zone of ambiguity in which absorption and distance, sensory and visual go hand in hand without ever achieving closure or balance. Neither exclusively physical membranes nor self-reflexive windows, Tarr's extended shots allow the viewer to contemplate what Eszter investigates in terms of musical theory: the abyss between concept and nature, the model and the real. As we hover, seemingly forever, at the threshold between incommensurable notions of screen

and viewership, we glimpse the possibility of a future world in which, for the sake of overcoming fear and warranting meaning, logic and reason no longer need to tame the unknown and make the foreign utterly familiar.

Asked about the technological limitations of Kodak film stock, Tarr once quipped that a regular 35mm reel's length of 1,000 feet, as it allows for maximum shot lengths of about eleven minutes when filming at twenty-four frames per second, imposes significant burdens on his practice as a filmmaker: "Yes (laughs), this is my limit, this fucking Kodak (laughs), a time limit. A kind of censorship."[8] The political, in Tarr's cinema, is less about the disintegration of communities and the kind of violence that lurks at the edges of civilization contracts and structures of power. It is all about the shaping and unshaping of time, the way in which cinema may insert different speeds, rhythms, and temporalities into given economic, social, and technological orders of time. Kodak's decision to max out its reel length at 1,000 feet may be arbitrary, a mix of technological exigencies and considerations of cost efficiency. Such arbitrariness, however, results in a disciplining of what can be shown, sensed, and thought within the unity of a single shot. As they run up to the eleven-minute limit with stubborn regularity, each shot of Tarr's cinema formulates a deliberate attempt to expose what remains mostly imperceptible about the social formation of time. What is political about Tarr's long takes is not how they allegorize the mechanism of social integration and fragmentation. The political in Tarr's cinema instead resides in how each of his takes challenges the viewer's structures of attention with the intention to illuminate larger frameworks of temporal disciplining and to envision alternative orders of time.

The Wonder of the Everyday

In postwar art and auteur cinema, long-take photography was often used as a medium to communicate a heightened sense for the everyday in all its drabness, its absence of transformative events, its dreary repetitiveness and lack of aesthetic ecstasy.

Think of Chantal Ackerman's *Jeanne Dielman, 23 Quai du Commerce, 1080 Bruxelles* (1976) as it painstakingly tracks the domestic chores of a widowed housewife as she seeks to find meaning and stability in routine behavior. Think of young Wim Wenders's desire to capture the course of passing events outside his windows so as to dwell on the rawness of the ordinary and not allow narrative arcs or subjective camera operations to obscure the textures of the mundane.[9] Long-take photography here offered an antiaesthetic panacea to the sheen and drive of mainstream cinematography. It defined a type of filmmaking that equated the mechanical automatisms of cinematic recording with a revelatory disappearance of authorial intentionality and all the violence it may do to representing the everyday.

Though quite different in design and intent, Tsai's and Tarr's work clearly echoes an earlier generation's voyage into the quotidian. Mechanical routines and ritualized automatism, the simultaneous comfort and dullness of iterative behavior, the marked absence of what usually counts as the stuff of dramatic storytelling—all these are at the core of Tsai's and Tarr's cinematic interventions. Moving images here push against whatever could smack of aesthetic and narrative transfiguration in the hopes of—in Siegfried Kracauer's famous and often ill-understood terms—redeeming reality in all its ordinariness.[10] Yet in both directors' work, the dwelling on the quotidian should not be mistaken for directorial efforts of finding pockets of meaning amid what narrative cinema and mainstream discourse usually consider unworthy of further attention. Nor can we think of it as an attempt to isolate forgotten allegories or lost symbols underneath the clutter of the everyday. Neither Tsai's nor Tarr's long takes are metaphorical or allegorical in nature. They frustrate hermeneutic desires as much as they lodge splinters in the eyes of those eager to reveal what might be hidden beneath the surface of the visible. Tsai's protagonists piss, shit, masturbate, or simply desist from action on screen, not in order to make viewers peel away symptomatic layers of existential crises but because this is what constitutes the everyday for these protagonists. Tarr's camera endlessly follows people as

they walk along endless streets and railroad tracks, not to give us time to decode any deeper meanings of their movements but to fasten our gaze to the presence of motion itself. In both Tsai's and Tarr's long takes, what you see is what you get, no more and no less.

It is certainly tempting to read the scrupulous literalness of Tsai's and Tarr's long-take aesthetic as a sign of intensified realism. By privileging the sensory over meaning, both directors evacuate metaphor and symbolism from the cinematic image so as to reveal the real in all its naked facticity. In Tsai's work, this quest for literalness manifests itself in the frequent depiction of deep perspectival spaces that precede, succeed, frame, and dwarf any human presence and action; it also results from Tsai's ongoing interest in the animality of human existence— that is, the exigencies of the creaturely as they may exist beyond frameworks of discourse and signification.[11] Whether Tsai's camera is situated in private or public spaces, it is equally interested in capturing space as if it was never intended to be an environment for human interaction and in recording human subjectivity as if it could entirely be reduced to a matter of how to negotiate physical movement and stasis in the midst of the everyday, of how to establish topographical distances and proximities between one's own body and the mundane materiality of the world. By contrast, the literalness of Tarr's cinematic aesthetic hinges on how the ruthless duration of each and every shot eventually wears down any desire for interpretation, leaving both Tarr's protagonists and his viewers in a void in which words, concepts, metaphors, and interpretations, let alone metaphysical speculation, ring utterly hollow. Like Tsai, Tarr's cinematic universe is one that wants to be seen and sensed in all its material concreteness, one in which the disenchanting logic of modern time leaves no room for transcendental thought or grandiose philosophies of meaning making. God is dead, ontology reigns triumphant, the human often finds itself stripped down to the status of bare life. Tarr's films might be difficult to watch, yet what they want to show is life reduced to its naked

simplicity and unadorned everydayness. In Tarr's eyes, this is not a bad thing; in fact, it is what cinema is all about. As Tarr ruminated in an interview in 2007, playing on how both German and French use the same word for a camera's lens and for taking an objective look at the world:

> You have to know that a movie is the most simple thing in the world. If you are a writer and you have an ashtray like the one I have in front of me now, you can write 20 pages about this ashtray, with metaphors and symbols, you can say a lot of theoretical things, because everything depends on the imagination of the reader. But I am a filmmaker; I have just the concrete, definitive ashtray. And the question is how am I able to show you the ashtray. In this case, I'm able to develop emotions from you, but it's always physical, concrete, and clear. I cannot use any metaphors. I cannot use any symbols. What I have are just some lenses, which are objective. I tell you and show you real things.[12]

As an advocate of austere literalness and nonmetaphorical visions of the real, the twenty-first-century long take often wants us to explore our ability to attach our gaze to the material surface and temporal milieus of the cinematic image. No matter how hard and thoroughly the viewer will look, the long take's images are not designed to be read, decoded, or subjected to symbolic or allegorical analysis. Yet when considering the work of Tsai and Tarr, to think that the long take's stress on the literal and concrete would necessarily be in support of a realist agenda is questionable. Even though the long takes of both directors expel metaphor and interpretation from the image and instead hope to discover in the screen a powerful medium to explore temporal figures in space, neither Tsai's nor Tarr's images ever claim for themselves the kind of transparency or intelligibility realist and neorealist filmmakers attributed to cinematic representations of the world. Each of Tsai's and Tarr's long takes exhaust whatever could be said about the visible

and sensible world, but in the end, much of what we see and sense resists understanding and remains deeply enigmatic and riddlelike, obscure and mysterious.

Think of one of the many extended shots in *Goodbye, Dragon Inn* capturing the nameless woman working in the theater's box office. For some time she has sought to encounter the projectionist and please him with a culinary gift; the camera has witnessed her slow, limping gait as if there existed no possible shortage of celluloid or spectatorial attention in today's world. The shot in question now shows the woman in the projection booth, the projectionist himself being absent, the desired meeting with him once again having failed (Figure 16). We hear the steady noise of the projector beaming moving images into the auditorium that remain, at least at this juncture of the film, invisible to us even though we know these images are being watched with various degrees of attention by the handful of viewers of the theater. We hear the soundtrack of *Dragon Inn*: dialogue and frenzied martial-arts action—sounds that stand in stark opposition to the silent and immobile posture of the woman. Tsai's shot of the woman holds on for about four minutes, its frame as static as the woman. Her eye line is directed at the booth's rear wall, yet Tsai's framing does not allow us to determine the exact object or area of her stare. If it weren't for the shot's soundtrack, this could just as well be a photographic insert, a replay of Chris Marker's experimental strategies in *La Jétee* (1962). For Raymond Bellour, the insertion of still into moving images is to transform the hurried spectator into a pensive viewer able to add something to the image it may not contain: "The presence of a photo on screen gives rise to very particular trouble. Without ceasing to advance its own rhythm, the films seems to freeze, to suspend itself, inspiring in the spectator a recoil from the image that goes hand in hand with a growing fascination. . . . Creating another distance, another time, the photo permits me to reflect on the cinema."[13] Tsai's play with the photographic in this sequence allows for a similar yet different effect. Though Tsai doesn't actually freeze the frame in technical terms, the perceived deanimation of the image gives

the viewer time to pause and reflect on the nature of cinema as a medium. However, it gives us nothing at hand—no symbol, no gesture, no sign—to know more about the narrative function or to delve deeper into the psychological makeup of the woman from the box office. Her stare exceeds our understanding; it resists reading and remains inscrutable. While viewers (contrary to realist expectations) might contemplate the image as image, there is nothing for them (contrary to Bellour's thought) to add to the image and activate their interpretative desire. Nothing in what we see here allows us to decide whether we witness the woman in a state of pensiveness or brooding, being absent-minded or melancholic, focused and self-absorbed or deeply distracted. The image might fascinate, but this fascination only reinforces the categorical unintelligibility, the unsettling nontransparency, of the world framed for our view. Its meaning is simply in how it invites to retune our experience of time, in how we tune in (and out) of its nonteleological temporality.

Compare the contemplative stillness of this shot to the representation of movement and enraptured looking in what is arguably the climactic moment of *Werckmeister Harmonies*.

Figure 16. Tsai Ming-liang, *Goodbye, Dragon Inn*, 2003. Screenshot.

After a long frontal take showing a crowd marching with great furor toward the town's hospital, we cut to a shot of a door frame, everything around its edges pitch dark, its opening allowing us to see straight into the interior, where there is a starkly lit hallway. The ensuing take will last for about eight minutes, and the complexity of its choreography matches that of the film's opening shot. It commences with the camera slowly moving forward, approaching the door frame and thus pulling the viewer along (Figure 17). But it might be more accurate to say that the camera pushes us into the hallway, as if door and screen functioned like revolving doors or portals, enabling the viewer to enter diegetic space. Before the camera is fully inside, however, the men of the previous shot will overtake the camera's pathway and populate the frame from left and right, striding forward with great resolution, leaving the camera and us behind as mere witnesses of the action to follow. Throughout the next five minutes or so, we turn into mobile bystanders of a violent frenzy: we see men moving from one hospital room to the next as they silently destroy the building's furniture and, without any reasons given, pull patients out of their beds and beat them up. No words are spoken and no glances exchanged between the perpetrators. Eventually the camera comes to rest on the backs of two men as they tear down a white curtain and suddenly halt their destructive course midstride, their gaze arrested by something the camera will only show a few seconds later after it has carefully tracked around these men from behind: the sight of a naked elderly man. His body is not much more than skin and bones, his fragile physique brutally illuminated by the clinical light of his surroundings. He is located inside a dilapidated bathtub, leaning against the white tiles of the rear wall. While his gaze is directed at the floor, his body faces the intruders frontally, the two men in the front of the shot— now motionless—serving as internal frames for the camera's and our act of looking at him. For some seconds, everything comes to a pause before we see the men and their companions withdraw speechlessly from the room, the hallway, and the hospital. The camera follows them toward the door for some

time, but then veers to the right around another corner, only to finally come to rest in an unexpected close-up of János's face, his eyes staring directly into the camera for almost a minute. Did János witness what we just witnessed? Did he try to hide from it? Did he simply imagine it? None of these questions will receive conclusive answers before Tarr finally cuts away from the hospital's interior and shows us the crowd marching off, anger gone after encountering the miraculous image of the old man.

"In the long, contemplative glance," writes Theodor W. Adorno in *Minima Moralia*, "the urge towards the object is always deflected, reflected. Contemplation without violence, the source of all the joy of truth, presupposes that he

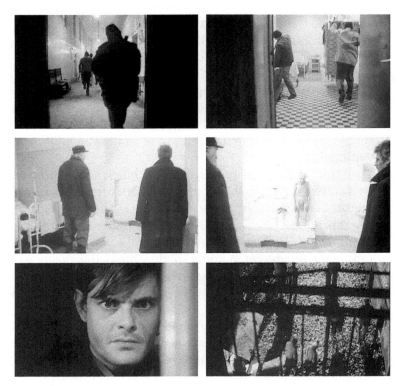

Figure 17. Béla Tarr, *Werckmeister Harmonies*, 2000. Screenshots.

who contemplates does not absorb the object into himself: a distanced nearness."[14] Both the rebels' wondrous gaze and János's enigmatic stare at the camera at the end of the hospital sequence suggest the experience of simultaneous proximity and distance. In both instances, states of contemplativeness result in a letting go of the object, in the case of the rebels a halting of the cruel objectification of elderly hospital patients in the form of random violence and in János's case a certain distantiation from the camera and its mobility to which he entertains a special affinity throughout the rest of the film. In both instances, however, the distant nearness of contemplation is marked not as a mere withdrawal into mindless passivity but as an active intervention, a dynamic deflection and reflection of the seemingly automatic course of events. Similar to the image of the box office woman staring at the wall in *Goodbye, Dragon Inn*, Tarr's long take fails to offer the viewer conclusive psychological motivation and causation. Both sequences conclude in a quasi-photographic cessation of cinematic motion. Yet in both instances, we end up seeing images that cause us to question the intelligibility of the depicted world—images that are a far cry from any realist desire to map the world in a way commensurate with the mandates of reason, rationality, and intentionality.

As it immobilizes the protagonists' as much as the viewers' urge toward the object, the long take in both films thus allows something enigmatic and mysterious to emerge from the spaces of the mundane. Tsai's and Tarr's extended shot durations systematically exhaust the possibilities of reading or understanding the image, yet in doing so, they break the violence of willfulness and automatized behavior. We have no idea exactly what it is we are seeing, but at the same time we are invited not to fear these states of not knowing—to open our senses, aesthetically, as it were, toward what exceeds the instrumental reason and self-management of the everyday without directly engaging massive perceptual or psychological safeguards.

Wonder, writes Ian Bogost, emerges whenever we allow the strange and unfamiliar to speak to us in all its strangeness and

unfamiliarity. It results when human observers acknowledge what is alien in the object; it also suspends how regular perception subjects the world to the templates of human intentionality and willfulness: "To wonder is to suspend all trust in one's own logics, be they religion, science, philosophy, custom, or opinion, and to become subsumed entirely in the uniqueness of an object's native logics—flour granule, firearm, civil justice system, longship, fondant."[15] Wonder is what happens when objects allow us to encounter them as if we were objects ourselves. Yet this is not done in order to cause—as some older type of critical theory might surmise—reification to reign triumphant. On the contrary, it is done to unleash the aesthetic and epistemic power that, unbeknownst to the world of subjective intentionality, resides in the realms of objects—their materiality, their surfaces, their textures. Tsai's and Tarr's long takes often picture the world as if it could grant space to practice such alien phenomenology. Their images of the everyday remain as profoundly alien as our own way of looking at what we see. They detach us, the viewers, from ordinary logic and meaning, invite us to see and sense the world as if we were an ambient element of the world's environments, and precisely thus make us wonder about what resists understanding, not least of all the alien in us.

Thresholds of Touch

"What happens," Maurice Blanchot once asked, "when what you see, even though from a distance, seems to touch you with a grasping contact, when the manner of seeing is a sort of touch, when seeing is a *contact* at a distance?"[16] Blanchot's question recalled lines of inquiry developed around 1900 in Germany and Austria in the context of so-called empathy theory and its effort to distinguish between merely optical modes of seeing and modes of visuality that feel for and feel themselves into objects in all their three-dimensional plasticity.[17] Art historian Aloïs Riegl's concept of haptic seeing figured central in these efforts. True to the original Greek meaning of the word (*haptein*,

"to fasten"), Riegl's notion wanted to describe a fastening of the gaze to the physical surface of an object that differed both from a purely optical look and from a literal touching of the object. Haptic looking established contact at a distance. It envisioned the viewer as a sentient agent in the very production of space, and it favored forms of knowledge and pleasure the embodied character of which had the power to energize the disinterested coldness of a merely optical encounter with the world.[18]

Though it was to develop in various directions, the emergence of haptic theory coincided with nothing other than the invention of cinema in the late nineteenth century, with how the medium of film—in Erwin Panofsky's terms—offered a fundamentally new way of temporalizing space and spatializing time, and thus invited the viewer—in Hugo Münsterberg's terms—to endow the screen's physical flatness with perceptions of actual depth.[19] In Tsai Ming-liang's and Béla Tarr's work, the long take becomes a means to recall and re-inscribe the promises of haptic seeing at the other end of film history, the presumed end of celluloid cinema. To be sure, as we have seen in the preceding pages, both directors operate within categorically different traditions of art cinema and its methods of framing space and time. Tsai presents the diegetic world in utterly static shots taken by what appears to be a fundamentally disinterested and automatized camera; Tarr promotes the camera to be an agent in the unfolding of narrative events, asking us to probe how much we can fasten our gaze to the slow, albeit carefully choreographed, movements of the recording apparatus. Yet despite these differences, long takes in the work of both directors end up destabilizing the modes of spectatorship typically associated with these kinds of aesthetic strategies. Extremely rigorous in their pursuit of formal consistency, both filmmakers embrace the long take as a means to unravel what at first might be seen as an aesthetic of realist observation or of immersive absorption respectively. Extended shot durations here do not simply deflate narrative temporality but also transform image and screen into objects of an at once lingering and hesitant gaze—a gaze that oscillates

between different modalities of looking, that inches toward yet reflects on the possibility of establishing sensory contact across distance. In both cases, long-take cinematography encourages the viewer to perform a mode of seeing that, following Blanchot's terminology, is "a sort of touch." It asks us to attach our gaze to the surface, the materiality, and the texture of what is shown on screen without considering the image as something we could or should literally touch upon. Time is both subject and object, form and content of what long-take filmmaking in Tsai and Tarr seeks to accomplish. However different in nature and design, Tsai's and Tarr's unyielding shot durations invite us to touch upon the wondrous possibilities of haptic visuality and thereby envision screens that exceed the conventional dimensions of rectangular framing and assume the status of a screenic ecology.

It is easy to see *Goodbye, Dragon Inn* and *Werckmeister Harmonies* as suffused with apocalyptic negativity. Both films surely mark the disappearance of a world, a certain atmosphere, a sense of community; both resist the speeding trains of progress in the name of something that remains mostly unspoken. Tsai's film ends with the woman from the box office and the projectionist vacating the Fu Ho Theatre after its last screening, drenching rain inundating the final images with pervasive doom. Tarr's film concludes with images of János, confined to a hospital room after a failed escape attempt, before we cut to a long take following composer Eszter as he approaches the exposed whale on the town's central square, stares at close range right into the giant's enormous eye, and then walks off frame, leaving us with a final extraterrestrial image of the whale shrouded in mist. One might think that things could not be more dismal. Both films commence with images evoking a twilight of the gods, including the gods of cinema, whose vanishing seemingly bequeaths filmmakers and audiences with nothing much to look at anymore. Yet in their very efforts to transform frame and screen into media and environments of haptic seeing, in their very efforts to negotiate the difference between Adorno's distanced nearness and Blanchot's contact

at distance, both filmmakers leave little doubt that the last word about the art of moving images and screenic culture has not been spoken. Both remind the viewer of some of the early promises and wonders of cinematic experience so as to make us thirst for more and different ways of probing and inhabiting the cinematic image.

"It's still not over," János claims when the barkeeper wants to shut down his performance of planetary motion in the opening sequence of *Werckmeister Harmonies*. Tsai's and Tarr's art of the long take is meant to persuade the viewer that there is plenty of time and space to keep going, keep probing, keep engaging the human sensorium in all its complexity. Rather than merely attesting to the brokenness of the modern world, the melancholia of the long take here insists on the fact that neither cinema nor any other medium will ever succeed in arresting time within the frame of a self-contained image. Planets keep spinning; rain keeps falling. Old movie palaces might close; communities might disintegrate without really knowing why. But the history of moving images, of picturing motion and capturing time, is by no means finished and done with yet. Let us think of Tsai's and Tarr's melancholic long takes as messages in a bottle. As they redefine art cinema as a cinema of thresholds and hesitant waiting, what they communicate to an unknown future is that our present—contrary to dominant self-perceptions—has plenty of time to experiment with different models of framing and unframing the dimensions of aesthetic experience. Exactly what to do with all that time will remain these films' and their long takes' open question. Attention eventually will always fail us, so we must learn how to fail better.

THE LONG GOODBYE

The Pleasures of Self-Directed Viewing

The classical theatrical setting of film projection, including the one reserved for twentieth-century art cinema, at once encouraged and enforced formal strategies administering seemingly boundless control over the viewers' attention. Once seated and surrounded by darkness and spectatorial silence, you had pretty much agreed to submit your own sense of time and attentiveness to how the camera and editing shaped temporal flows on screen. Pleasure, in fact, largely resulted from allowing screen time to suspend and manage viewer time. The Antonionis, Tarkovskys, and Wenderses of international art cinema delayed the speed of narrative time toward a minimum well aware that they could reckon with and virtually owned the viewer's attention once the lights were out; the Spielbergs, Woos, and Bays of global entertainment cinemas accelerated the action so as to make sure not to lose less patient viewers along the way. Even the most disappointing or aesthetically most challenging films rarely witnessed huge crowds of viewers reclaiming their time and striding out of the cinema's darkness in the middle of the film. You paid for the ticket, but in doing so, you sold your time to how filmmakers promised to confront you with or submerge you into other times not of your own making.

In spite of the massive changes in image recording, storage, and display over the last two decades, much of our thinking about moving images and their spectators continues to rest

on this paradigm. It presupposes the existence of spectators perfectly able and happy to abandon the multiplicity of mobile viewing devices and ambient screens in contemporary urban environments for the sake of training their eyes on one frame alone and allowing one single film and narrative to take hold of their attention. The frantic cutting patterns, nervous camera motions, hectic rack zooms, and splintered narratives of today's mainstream filmmaking are clear signs that Hollywood itself no longer trusts its former spectators and the dark cube's disciplinary force. Most films are shot with viewers in mind who will watch moving images on small screens, in discontinuous settings, and in "broad daylight."[1] Each shot screams, wants to prickle, trades in hyperbole, and extends endless exclamation marks, not simply to beg for the viewer's time and attention but also to respond to and feed into conditions in which various screens are with and around us at all times. Cinema has lost its monopoly over our consumption of moving images.

Critics of Tsai's and Tarr's glacial slowness might come to the conclusion that these filmmakers simply seek to reinstate cinema's former power over images in motion, their long takes advocating a straight return to the normative presuppositions of mid-twentieth-century auteurism. Tsai and Tarr, these critics might add, ignore what Hollywood itself has known for some time. They envision spectators no longer in existence and thereby define art cinema as a truly reactionary exercise of arresting cinema in time. A more generous reading of their work, however, should come to a different assessment. At least two different arguments could and should be made. First of all, what Tsai's and Tarr's long takes aspire is to build worlds in which cinema, as a one-screen moving image environment, invites contemporary viewers to probe their very temporal commitments to pictures in motion. Rather than taking a fully attentive viewer simply for granted, these directors claim the durational as a means to explore today's structures and domains of attentiveness in the first place. Second, what Tsai and Tarr do to cinema today is similar to what painters did to their canvases once the coming of photography had liberated them from the dogmas of realism. The long take's task here is neither to reinstate the past nor to please

spectators who are completely out of touch with the exigencies of the day. It instead is to explore a new type of cinema liberated from former pressures and expectations, a cinema in no further need to confront commercial or vernacular practices because these no longer approach cinema as a norm for encountering moving images in the first place. Whether we pursue the first or the second argument, we should conclude that Tarr's and Tsai's long takes push cinema to new twenty-first-century frontiers precisely because their films reckon with spectators who view films primarily in broad daylight and because their long takes seek to retune today's demands of being in full control over the temporal terms of our viewing.

Questions about spectatorial autonomy, participatory agency, and self-guided control have been at the center of debates about the proliferation of screen-based installation art over the last two decades. To simplify matters, one set of critics has celebrated the mushrooming of multimedia installations in contemporary gallery spaces as a welcome sign of spectatorial empowerment, enabling museum visitors to engage with time-based art on their own terms and escape the disciplinary regimes of the traditional cinematic auditorium. As they invite their viewers simultaneously to look at and through different screens, screen-based installations—these critics have argued—foreground the materiality of the viewing experience, encourage viewers to enter moving images as spatial or sculptural configurations, and thus liberate the spectator from cinema's bullying mechanisms of temporal and spatial consumption. Screen-based installations, by allowing perambulating viewers to develop durational strategies at odds with the duration of images on display, critique the linearity built into the hardware of more conventional film screenings. As Peter Osborne summarizes, "The marked spatiality of the modes of display of film and video in art spaces . . . and crucially, the movement of the viewer through gallery space, undercuts the false absolutization of time to which cinema is prone."[2]

Another set of critics has argued that the durational investments of today's gallery viewers are not that different from the highly distracted and noncommittal viewing practices of

channel zappers and window shoppers in suburban malls. Screen-based installations, in the name of emancipating the spectator from how both classical museums and cinematic dark cubes manage the viewers' attention, simply replicate the user-friendly templates of commercial consumer culture. They allow people to dip in and out of display spaces at their own will and leisure; they encourage attitudes of mere browsing and screen hopping; they reinforce rather than work against the systematic production of attention deficits as principal media of neoliberal capitalism. Most video installations today antici- pate viewers who are no longer expected to witness the whole work. Viewers may simply abandon the display space after a time of their choosing, no matter whether this work may simply entail an eight minute loop, an entire screenic environment, or a presentation whose extraordinary length defies any continu- ous viewing to begin with. In Dominique Païni's words, "The renewed physical freedom is no doubt only an illusion, since in one way it is very much the correlative of the emphasis on the individual as consumer of advertising and art."[3]

Debates about the costs and merits of self-directed viewing often provoke grand theoretical gestures and normative inter- ventions, with the roaming spectator either heralded as a para- digm of participatory agency or as a death knell to sustained aesthetic experience. It is tempting to look for the truth some- where in the middle. Yet such a search for compromise runs the risk of ignoring the extent to which screen-based installations today urge us—as indicated already in chapter 1—to reconsider the entire vocabulary critics have used for many decades to as- sess the cultural and political value of spectatorship. It would seek to identify some middle ground between concepts of active and passive, absorbed and distracted, critical and consump- tive modes of viewing, whereas the true challenge today is to move beyond such oppositions and to see these juxtapositions as remnants of a past that sought to conceptualize spectatorial practices as if they were causal effects of a particular work and its conditions of display. The point, in other words, cannot be to proclaim that self-directed viewers are per se more (or less)

active, participatory, and critical than consumers of more conventional cinematic fare. It instead must be to recognize how today's many modes of viewing moving images unsettle the very understanding of spectatorship as shaped by the template of cinema's dark auditorium.

What, then, is the exact place of the long take in our age of screen-based media installations? How do we identify and approach extended shot durations once gallery spaces invite spectators to enter films as environment and no longer really determine the length of a viewer's time of reception? What's the point of incorporating long takes at the level of form if today's roaming viewers might no longer see them as such? And how can moving-image artists appeal to modes of wondrous looking in a time of viewing screens in broad daylight, without nostalgically considering fifty years of moving image production—the period from roughly the 1920s to the 1970s—as a period authoritatively defining whatever can be said and thought about the meaning of filmic images and their durational properties?

The following pages profile three different screen-based works in order to develop a spectrum of possible answers to these questions. These will be tentative in nature, to be returned to and further unfolded later in this book. What they suggest, however, is that today's realities of perambulatory viewing open rich opportunities to rethink the durational in our encounter with moving images; and that contemporary art's nostalgic references to the history of cinema do not automatically translate into preservative projects, and may in fact allow us to experience the cinematic in a new key.

Seeing Beyond Seeing

The shot lasts for about two and a half minutes, the camera being absolutely immobile while recording the last moments of a setting sun over the Mozambique Channel as seen from a beach at the west coast of Madagascar. The film starts exactly when the lower edge of the sun hits the ocean's horizon; it ends a few seconds after the sun's complete disappearance. Barely

any clouds litter the sky; pleasantly warm colors dominate the image. Water and sky meet exactly in the middle of the frame. Soon after the beginning of the film, a gentle voice prepares us for what we are about to see: the optical phenomenon of a brief flash of green light, produced by the refraction of the setting sun's last rays under rare weather conditions, visible only for viewers who are situated in front of vast stretches of open water. Few have ever seen the green ray. Some chase it around the globe but never hit the right conditions. Others miss its decisive occurrence because of last-second distractions, or they fake its appearance with the help of special effects. According to the voice-over, however, the indexical qualities of analog filmmaking and the documentary properties of extended shot durations provide the ideal tool not only to record but in fact to see the elusiveness of a green ray. The soundtrack's voice concludes while the sun is dipping behind the horizon:

> The evening I filmed the green ray, I was not alone. On the beach beside me were two others with a video camera pointed at the sun, infected by my enthusiasm for this elusive phenomenon. They didn't see it that night, and their video documentation was watched as evidence to prove that I hadn't seen it either. But when my film fragment was later processed in England, there, unmistakably, defying solid representation on a single frame of celluloid, but existent in the fleeting movement of film frames, was the green ray, having proved itself too elusive for the pixelation of the digital world. So looking for the green ray became about the act of looking itself, about faith and belief in what you see. This film is a document; it has become about the very fabric, material and manufacture of film itself.

The voice we hear is that of Tacita Dean, an English installation artist and experimental filmmaker who during the early stages of her career was associated with the Young British Artists. First exhibited in 2001, we find *The Green Ray* typically installed in a walkable gallery space in whose middle a 16mm projector

projects the film onto one of the room's empty walls while the noise of sprockets transporting the strip of film forward will fill the entire room (Figure 18). Film, in Dean's understanding, can reveal and redeem the fleetingness of the material world whenever it probes and puts to work its own materiality. Our contemporary world of pixels is one of discreteness, fragmentation, and mere aggregation—a world whose video cameras not only fail to capture mysterious events such as the green ray but also distract viewers and camera operators from witnessing them in the first place. Yet classical film stock and recording technologies, as well as film's ability to produce impressions of movement across the mummifying logic of individual cells, hold the power to overturn the blindness of both algorithmic and nonconcentrated modes of relating to the world. Film's fabric simultaneously sharpens the eye and reveals the world's visual unconscious, the world's inner fabric, that which resists the willfulness of organic vision. The medium of film, in Dean's view, is part of the world of human consciousness and intentionality: an assembly of techniques and technologies with which humans can record and refine the process of vision and communicate expressive potentials. But the medium of film, as a result of its very materiality, is also part of the world of nature—the very kind of nature it records—because film, at least in its predigital form, is matter itself. It not only provides embodied forms of engaging with inner and outer nature but also offers models of seeing the world that stress what is incommensurable and hence nondiscursive about human intuition, spontaneity, and sensory experience.[4]

Dean's ruminations about the evidentiary materiality of celluloid film appear suffused with nostalgia for analog culture's stress on continuity and contiguity. Such rays of nostalgia, one might want to add, have energized much of Dean's work over the last decade, including her celebrated 2011 show in the Turbine Hall of the Tate Modern in London, plainly entitled *Film*. A virtuoso product of in-camera editing and analog montage, *Film* celebrated the visual creativity of predigital methods of

Figure 18. Tacita Dean (b. 1965, Canterbury, England), *The Green Ray,* 2001. 16mm color film, silent, 2 minutes, 30 seconds. Dimensions variable. Courtesy of the artist, Marian Goodman Gallery, New York/Paris and Frith Street Gallery, London. As installed in *The Dying of the Light: Film as Medium and Metaphor,* MASS MoCA, 2014. Photograph by Arthur Evans.

film manipulation. It showcased the power of manual interventions, the joys of working with the sheer materiality of the traditional strip of film, yet in flipping the projected image to the vertical and providing images that resonated with the architectural properties of the Turbine Hall, the film at the same time hoped to remind the viewer of the embodied materiality of viewing film itself, our own joy as spectators when encountering images that—as a result of their indexical qualities—had once literally been in touch by what they show. Though *Film*'s salvo of nonnarrative montage images by no means aimed at representational realism, one of its ambitions was—similar to the earlier *The Green Ray*—to praise celluloid's material connection to the real, its association with a world of manual labor, of making things rather than faking them. Much to the delight of many a cinephile, film's twentieth-century past was here played out against the pixelated distractions of the present, our faith of beholding the real against the dematerialization of the

world in the wake of the digital. Yet things might be more complicated, and projects such as *The Green Ray* might do much more than merely uphold the claims of a (nearly) lost past against the speedy transformations of the present.

Consider, first of all, that Dean presents the indexical and durational qualities of analog film not simply as a means to capture the world most accurately but also as a medium sharpening the viewer's view for what might exceed organic perception. For Dean, the unedited shot durations of film are the real deal because they define film's nature as a blueprint or promissory note for wondrous encounters with the material world of objects. The medium of film matters not because the indexical and durational provide perfect analogs of how humans perceive the material world but because a filmmaker's relation to the nature of her medium might teach us a thing or two about how to relate to the physical world. Consider, second, that *The Green Ray* is today mostly encountered not in gallery settings but online at sites such as YouTube and Vimeo, including a longer public Vimeo production about Dean officially produced by Tate Media and directed by Zara Hayes (Figure 19).[5] Needless to say, the film's digital display involves computational interventions that—according to Dean—make any successful representations of the film's subject matter impossible. Prompted by Dean's voice, viewers as a result either imagine witnessing what defies display or accept the absence of what is promised as proof of Dean's thesis. In either case, the evidentiary force of the image is fundamentally called into question as it only conveys what it is meant to convey in response to the words Dean herself speaks over the image. We either see *what* we don't see, or we see *that* we don't see, but in both cases, the reflexive or ironic elements of watching the film cannot but push the viewer beyond the brink of a purely nostalgic position. The aesthetic pleasures and epistemological advantages of analog filmmaking are thus marked as clear products of the digital age's imagination: the truths of film as an index of passing time become visible only because of, and in the moment of, celluloid's very disappearance.

Figure 19. Tacita Dean, *The Green Ray*, 2001. Vimeo screenshot.

The digital image, writes musician Neil Young about Tacita Dean's *Film*, "is only a rebuilding of an image from average sections gathered. Each section is monotone. In the analogue reflection, no matter how small of a section you look at, it possesses a universe of possibilities, like a perfect mirror. In the digital rebuilt image, each section of monotone, like looking through a screen, only one colour can be seen through each tiny opening."[6] Young's musings offer intriguing insights about Dean's embrace of film as an index of the durational, for one of the decisive aspects of experiencing moving images in the broader light of gallery settings is the fact that roaming viewers encounter the screen not merely as a window onto the world but as a physical object in its own right. We at once look at and look through the screen; we simultaneously engage with something material and virtual, a strange mix of presence and absence full of ambivalence, multiplicity . . . and emergence and possibility. Thus, even if witnessed in some digital format, Dean's *The Green Ray* will nevertheless engage the viewer in an intricate and ambivalent negotiation of digital and analog properties. As we peruse the long take of Dean's setting sun, the viewer's gaze will have ample time to look through the screen

as if it were a window onto the world; simultaneously, by looking at the screen and attending to Dean's voice-over, the viewer will come to explore the extent to which screens—all screens—screen out and block the viewer's access to the world and its profilmic spaces. Not seeing the green ray therefore extends an open invitation to activate one's imagination and see what exceeds representation; it urges the viewer to take time to complicate any Manichean juxtaposition of the digital and the analog, the indexical and the simulated. Dean's long take of the Madagascan sun thus cannot but make us wonder about the blind spots inherent in any form of representation. Far from solely bathing the visitors in the warm light of nostalgia, the extended duration of *The Green Ray*—whether seen in a gallery setting or on a computer screen—instead asks the viewer to embrace such blind spots as creative opportunities and sites of critical insight. They are what makes moving images tick.

Seeing on the Move

"There is," Charles Baudelaire wrote famously in the 1860s, "nothing more profound, more mysterious, more fertile, more sinister, or more dazzling, than a window, lighted by a candle. What we can see in the sunlight is always less interesting than what transpires behind the panes of a window. In that dark or luminous hole, life lives, life dreams, life suffers."[7] For Baudelaire, windows provided sites of fantasy production; they energized stories about the world and visions of alternative realities. Like poetry, windows elicited empathy and identification; they awakened the viewer's projective energies, our yearning to infuse visible objects with our own soul and corporeality.

In today's age of ubiquitous screens and digital windows, Baudelaire's candles have largely gone out of business. The window's former luminosity has largely been replaced not only by the dull shimmer of our computer screens but also by our ability to conjure endless images at will with the touch of our fingers. Yet as we have seen already with Dean's *The Green Ray*, there is no need to think that the advent of the digital

has completely erased the possibility of poetic enchantment, imaginative displacement, and wonder, or that the roaming spectators of screen-reliant video installations, even when being on the move and facing multiple screens, have no access to the joy Baudelaire experienced in front of the conventional window frame. On the contrary. Consider Iñigo Manglano-Ovalle's video installation *Le Baiser/The Kiss,* first presented in 1999 at the Institute of Visual Arts in Madison, Wisconsin, and later restaged at sites as diverse as the Whitney Museum of American Art in New York (2000) and the Mildred Lane Kemper Art Museum at Washington University in St. Louis (2007) (Figure 20). Born in 1961 in Madrid, Spain, Manglano-Ovalle's work since the 1980s has involved different media while recurrently engaging different traditions of the cinematic and efforts to expand cinema beyond its twentieth-century domains. And so does *Le Baiser/The Kiss.* Even though its projected images do not really rely on extended short durations, the installation as a whole situates viewers and their bodies as cameras in their own rights whose roaming movements through the entire space of the installation enables the viewer to experience the images on screen as if they were long takes after all. Whereas critics and pundits often claim that contemporary screen culture has made us lose our sense for the line between lived and mediated experience, between the intimacy of material presence and the abstraction of mere "screenness,"[8] *Le Baiser/The Kiss* asks us to problematize such oppositions and in turn explore our own mobility as a medium to infuse screenic images with extended duration and affective intensity, with soul and corporeality.

The video that is at the center of Manglano-Ovalle's *Le Baiser/The Kiss* was shot in 1999 at Mies van der Rohe's Farnsworth House in Plano, Illinois, an iconic exemplar of modernist architecture and its various attempts to redefine our places of dwelling as media capturing shifting views of our environments.[9] The title of the installation recalls one of the first films ever shot, an 1896 Edison release with a run time of roughly one minute showing nothing other than a couple kissing. Projected on both sides of a screen, Manglano-Ovalle's video opens with

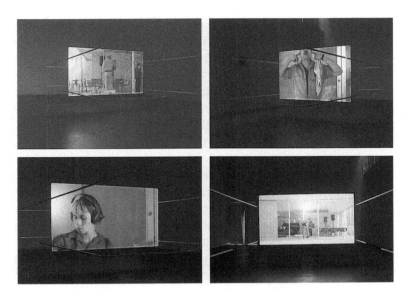

Figure 20. Iñigo Manglano-Ovalle, *Le Baiser/The Kiss*, 1999. Collection of the Museum of Contemporary Art Chicago, restricted gift of the Sara Lee Corporation, 1999.56. Installation view from *Window | Interface* at the Mildred Lane Kemper Art Museum, Washington University in St. Louis (August 31–November 5, 2007).

a spectacularly beautiful view of an autumn scene as seen through the glass walls of the Farnsworth House. Soon we witness a window washer (played by the artist himself) as he cleans the house's wide expanse of exterior glass while we also see a person inside, dressed all in red, wearing headphones and manipulating portable DJ equipment. Though window washer and home dweller are quite close to each other, separated only by the transparent glass, each fails to acknowledge the presence of the other. Both are locked into different perceptual orders, both held by incongruent class positions. Chilling silence accompanies the parts shot from inside the house, while we hear the sounds of crackling leaves, the window washer's squeegee, and nondiegetic guitar music (played by The Kiss) when the camera is outside. Cinematic conventions cause us to expect something extraordinary to happen—an act of seduction or violent

transgression, a moment of epiphanic recognition or sudden role reversal. Yet no such rupture ever occurs. No matter how close they are to each other, window washer and DJ will remain encapsulated in their separate worlds, and the window, instead of enabling some kind of contact, will continue to screen out unwanted or uninvited connections. Whereas the window washer eagerly restores the building's emphasis on breathtaking sight, the home dweller has chosen to live in an alternative and solipsistic universe of sound, one that does not allow for the two protagonists to even briefly touch each other's life.

Yet while the projected images and sounds of *Le Baiser/The Kiss* eternally delay what the title of Manglano-Ovalle's work promises, the installation's spatial setup allows the viewer some sense of contact and proximity after all. Manglano-Ovalle's double-sided screen is surrounded and framed by a suspended aluminum structure that mimics the modernist interplay of windows and walls in the Farnsworth House. Contrary to the film's image of the architectural window as an impassable and hence restrictive divide between solitary individuals, the installation invites us to traverse its defining boundaries: to enter the structure on one side and behold the projection; to move around the aluminum frame and look at the video—from outside the frame—from the other side; to test out and inhabit different relationships to the window screen and thus render permeable what in the video appears confined to static positions. We will certainly not be able, by changing our distance and viewing angle, to change the narrative trajectory of the film and somehow compel our two protagonists to recognize each other. What we do succeed in, however, is emancipating our own act of viewing from the logic of sensory enclosure staged in the video itself, its embargo on polysensory perception and trajective practice. As we move in and out, toward and away, along and around the frame that surrounds the installation's screen, we come to take in this screen not as a device screening out unwanted interactions but as a potential surface of contact and passage. The modern and postmodern reconfiguration of the window may no longer allow us to perceive space

as homogenous, systematic, and lodged in one dominant point of view. It may instead strike us as heterogeneous and aggregate, an inconclusive sum of incongruent aspects, planes, and zones of visibility. But as we slowly traverse Manglano-Ovalle's installation in ever-different directions and—unlike the film's protagonists—situate ourselves on either side of the screen, we seem to recuperate some aspects of Baudelaire's nineteenth-century vision of the window for our own time and future.

As it transfers the long take from the cinematic apparatus to the perceptual and physical movements of the viewer, *Le Baiser/The Kiss* probes the conditions of the possibility of attentive looking amid the swell of mobile spectatorship today. Moving through the installation, the viewer experiences his or her body as an active participant in endowing the images on screen with movement and affect. Our own mobility rubs against the film's representation of stasis and sensory isolation, such that we become painfully aware of what is lacking in the protagonists' life on screen. In beholding the image—like an extended tracking shot—from ever-different angles and distances, we experience our act of looking as being contingent on our sense of kinesthesia and proprioception as well as being a highly versatile technique of perception that constantly develops different models to fill the gap between flat and deep space, the three- and the two-dimensional, the self and the other, the near and the distant. Neither the viewer's physical motion nor the frame's undisguised visibility, neither the publicity of our own viewing nor the installation's acknowledgment of the viewer's presence, here stands in opposition to attentive and curious looking. Quite the contrary: what is theatrical about the whole setup and experience—the way in which the installation encourages the viewer to take time to explore various relationships with its mediated images and its frames of mediation—provides the basis for what it might mean to contemplate moving images today and for what allows us to investigate our own threshold between proximity and distance.

Manglano-Ovalle teaches the roaming viewer of contemporary installation art that we can still dream, live, and suffer

even when we perceive images while being in motion and are fully aware of the technological windows that mediate these images. The problem with contemporary screen culture is not that screens tend to dominate our environments with moving images, nor that new media have come to render our acts of viewing as often extremely mobile. The true problem is instead that most products and institutions of moving image culture today deny viewers the experience of extended and open temporalities so critical to the aesthetics of wondrous movement in Manglano-Ovalle's project. Whether digital or not, any kind of screen or screenscape can dazzle, engross, and fill us with wonder as long as it grants viewers the time and space to probe different bodily relationships to the materiality of the medium and the flow of its mediated images, and thus to explore the role of our own bodies in making, stretching, and holding time.

Moving Beyond Seeing

During the heyday of classical studio filmmaking, Erwin Panofsky famously spoke of cinema as a medium able to spatialize time and dynamize space. Like the theater patron, the movie spectator occupies a fixed seat in the auditorium, but to experience a film aesthetically is to transcend such experiences of physical fixity: "Aesthetically, he is in permanent motion as his eye identifies itself with the lens of the camera, which permanently shifts in distance and direction. And as movable as the spectator is, as movable is, for the same reason, the space presented to him. Not only bodies move in space, but space itself does, approaching, receding, turning, dissolving and recrystallizing as it appears through the controlled locomotion and focusing of the camera and through the cutting and editing of the various shots."[10]

After briefly stopping in front of *The Green Ray* and then roaming through *Le Baiser/The Kiss*, let's return once more to the kind of position Panofsky considered the anchor of experiencing motion pictures aesthetically. Our focus is on a single-channel video projection, *Single Wide* (2002), by the Irish American–Swiss artist duo Teresa Hubbard and Alexander

Birchler, whose collaborative work since the 1990s has consistently experimented with different models of narrating stories across time and space. The setting of *Single Wide* is, one might say at first, utterly static: an isolated trailer house, situated somewhere in a bleak countryside, the sign of an old (American) dream of mobility that no longer masks its underlying structure of poverty. We have been here many times before, courtesy of Hollywood cinema. We know it as a site likely to attack the viewer's eyes with monstrous returns of the repressed: violence, depravation, horror, hidden corpses, deranged killers. But no camera has ever attempted to show what we are about to see. It travels thrice around and through the trailer in one continuous, almost manically steady and slow move, for a little more than six minutes. In the end, we are where we were at the beginning, and we will repeat the circling without pause and hesitation, but it is impossible to figure out how we got there because a whole number of things have happened in the meantime and have filled time with narrative trajectories and possibilities, such that a second viewing of the triple loop cannot but make us wonder about how the initial circumnavigations fooled our sense of temporality and disengaged ordinary expectations about the identity of space in time.

The camera's circling begins—if that word really makes sense in this case—at the front of the trailer (Figure 21). We see a woman, a bag under her arm, leaving the door and walking up to a pickup truck, seemingly ready for immanent departure. The camera moves steadily to the right, though, and then passes effortlessly, and much to our surprise, through the trailer's exterior sidewall so as to show us in one extended lateral tracking shot the interior of its rooms, cut open to the eye of the camera like a Hollywood studio set. We see a child's bedroom, a living room, a kitchen, a bathroom, and a master bedroom. The camera remains unmoved by what it sees; it traverses this scene of ordered domesticity similar to a viewer on the move, determined never to pause or blink, no matter what she may encounter along the way. Eventually the camera progresses through the other exterior wall again, circles toward the front of the trailer and—revealing some unexpected responsiveness

to the events in the visual field—approaches the truck. Still situated behind the steering wheel, the woman is crying now, her earlier resolve replaced by despair and agony. The camera circles once around the entire truck and thereby allows us to see the face of the woman in a medium close-up, a cut over her left eye making us curious about events in the past of which we have no knowledge. We hear and see her curse, and as the camera—as if anticipating things to come—pulls away from the car to begin its second circumnavigation, the woman slams the truck right into the trailer, the crash itself for now mostly communicated via the soundtrack. Once again gliding through the sidewall, the camera now witnesses an interior quite different from the one we saw during the first passage. The layout and furniture of the rooms remain the same, but what in the early traveling shot represented a scene of quiet and simple comfort has now turned into a site of utter mayhem. Kitchen, living, and dining rooms have transformed into a disaster area, with the wall torn wide open, half a truck stuck inside the trailer, its driver locked into the driver's cabin, and furniture and appliances heaped up in piles of debris. Unblinkingly, however, the camera continues its now-familiar path. It moves outside again, passes the wreckage on the outside and shows the woman as she desperately tries to exit the truck, then hovers inside again in order to reveal the interior. Just as the camera reaches the kitchen, the woman manages to free herself from the truck; the big bag is under her arm, the cut still on her forehead. She walks around the steaming car's hood in what was once her kitchen toward the family bedroom; the camera exactly matches her speed and direction of movement. She inspects the wound in a mirror, sits down to rearrange her hair, then grabs the bag. The camera keeps traveling outside, only to return us to the beginning of the first circumnavigation: the sight of the woman leaving the door of the trailer with a bag under her arm.

Although it is difficult to recount by means of linear sentences even the most basic plotline of *Single Wide*, from the outset, it is clear that Hubbard and Birchler's work is about the literal deconstruction of stable borders between private and public, domestic and natural spaces, interiority and exteriority.

Figure 21. Teresa Hubbard and Alexander Birchler, *Single Wide*, 2002. High-definition video with sound, 6 minutes, 7 seconds, loop. Courtesy of the artists and Tanya Bonakdar Gallery, New York. Originally published by Teresa Hubbard and Alexander Birchler; copyright 2002.

Similar to the way in which *Single Wide* unsettles spatial notions of entrance and exits and quite literally tears existing walls open, so does the film's triple narrative loop cast into question how we may enter or exit certain stories in temporal terms, how we consider or identify beginnings and endings. In *Single Wide*, spatial loops allegorize temporal iterations as much as repetitions in time serve as allegories of spatial movements. The result is perplexing, to say the least, as the viewer is encouraged to see motion and stasis, progression and circularity, as moments of one and the same dynamic. Like the film viewer in Panofsky's famous description, we become witness to a situation in which

everything is in permanent motion while at the same time being stationary. Space here appears truly dynamic as a result of the locomotion of the camera, yet what the work's roaming camera reveals is nothing other than the extent to which things for the protagonist are in a desperate state of fixity—things have literally gotten stuck. Time, on the other hand, emerges as something spatial, but it does not allow for passages into the open and contingent. In the end, movement produces stasis just as much as fixity anchors and authorizes ongoing locomotion.

One of the decisive ironies of *Single Wide* is that this video installation, precisely by allegorizing within its own diegesis what Panofsky understood as the perceptual conditions of watching film aesthetically, manages to hold the attention of roaming gallery viewers for the film's entire duration. We see and sense what it means to see aesthetically, and it is for this reason that we are likely to grant Hubbard and Birchler's camera time to conclude its three circumnavigations, perhaps even linger on for some more time so as to gain some traction amid the work's wondrous, Möbius-like long take. To be sure, there might be good reasons to read *Single Wide* as a critical comment on our sense of loss and isolation amid a time emphasizing self-management, self-reliance, and ceaseless mobility. The temporal and spatial experience of the nameless protagonist of *Single Wide*, we might want to add, reveals the effects of how neoliberalism over the last few decades has come to disintegrate the social fabric: we rush and rush, yet we make no substantial progress; we accelerate our movements, only to sense standstill; all kinds of media and vehicles of transport breach former borders between the intimate and the public, but all we end up with is greater solitude and seclusion. Yet all things told, *Single Wide*'s most remarkable accomplishment lies in how its social or political intervention is essentially played out at the level of form, namely in how Hubbard and Birchler develop the loop as a seemingly endless long take and the long take as a multivalent loop, and thus precisely pose the question of contemporary subjectivity as a question of the durational, of temporality.

The structure of the loop, folding three circumnavigations

THE LONG GOODBYE ▶ **133**

of a trailer home into one continuous long take, is at once form and content of Hubbard and Birchler's *Single Wide*. What is critical about Hubbard and Birchler's reflexive use of the loop, however, is the fact that its triple nature defines the circular not as a mere iteration of the same but as a performative repetition with a difference—a repetition of difference. Because the video's roaming camera presents time as a fissure of space as much as it pictures space as a dynamic site full of loose ends and stories to be told, *Single Wide* asks the viewer to experience circular time as something never as closed and self-contained as it may appear at first—as something open to surprise, change, curiosity, and wonder. *Single Wide* is typically shown in a darkened gallery setting, encouraging visitors to pause their trajectory through regular exhibition spaces and inviting the viewer to enter *Single Wide* at any time during its six minutes (Figure 22). Once we, the viewers, have come to witness at least one of the camera's circumnavigations, however, we will find it difficult to exit again, not only because we cannot but attach our gaze to the camera's steady motion but also because the film's narrative showcases within its very fabric the impossibility of any clean break in time and space, of tidy narrative beginnings and definite endings, of entrance and exit. The longer we watch, the less we seem to know for certain and the more we get absorbed into what unfolds in front of our eyes. Does the woman depart the house only to get stuck in the truck? Or does she exit the truck for the sake of starting all over again? Do we surrender our gaze as viewers to the camera because it entertains us with a dynamic sense of forward motion? Or do we linger on because each return of the camera to an earlier position asks more questions than it can and wants to answer? Does Hubbard and Birchler's long take present the viewer with one extended traveling shot? Or does it stage the birth of the long take from the spirit of a loop—a loop never quite able to repeat what it just showed because time and space do not exist independent of each other?

We could go on and on piling up questions about the paradoxical structure of *Single Wide*. Some may throw up their arms

in desperation about the absence of clear answers. Others may embrace the film's ambivalence, its refusal to provide definite beginnings and exits, as the very ground of experiencing the images and sounds of *Single Wide* aesthetically—of allowing the film to displace stable perceptions of space in time and invite us, in Panofsky's terms, to virtual forms of travel. Whether we circumnavigate the trailer once or thrice or even more often, however, the most remarkable aspect of *Single Wide* is how this installation manages to out-roam the roaming spectators of contemporary gallery exhibition spaces. It precisely thus aspires to reconstruct what neither cinema itself nor screen-reliant installation art today is often no longer believed to achieve: viewing conditions that engage the viewer's curiosity for the durational and do not naively purchase spectatorial

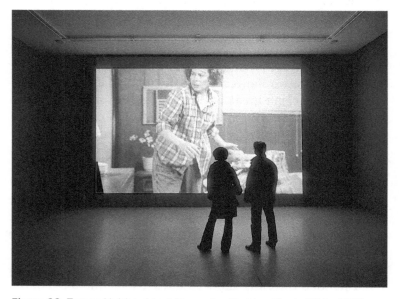

Figure 22. Teresa Hubbard and Alexander Birchler, *Single Wide*, 2002. Installation view, Modern Art Museum Fort Worth. Courtesy of the artists and Tanya Bonakdar Gallery, New York. Originally published in *No Room to Answer*, extended version, exhibition catalogue text by Madeline Schuppli, Andrea Karnes, Iris Dressler, and Sara Arrhenius (Aarau, Switzerland: Aargauer Kunsthaus, 2009); copyright 2009.

autonomy for the mere price of a radical fragmentation of time. *Singe Wide* is one of the shortest, but also the longest possible, narrative films ever shot. Similar to how Gordon Matta-Clark breached the fixity of architectural spaces, so does *Single Wide* slice openings into the (dis)orders of contemporary attention and time management. Six minutes of rotating around a trailer extend nothing less than an image of the profound and endless productivity of time in the form of a promise. These six minutes allow us to attend to durational extensions as if today's culture of reckless speed and neoliberal self-organization no longer made us feel ashamed about savoring the durational, the aesthetic ecstasy of suspending the restless clocks of self-interest and instrumental reason.

The Politics of Duration

In a 2004 essay, Peter Osborne returned the reader to a number of well-familiar modernist categories in order to discuss the politics of engaging with screen-based installation art. Central to his argument is Walter Benjamin's concept of distraction, originally developed in order to describe postauratic forms of film viewership and meant to endorse emancipatory, non-absorptive modes of viewing film—that is, structures of criticality and activity able to displace the bourgeois cult of art and its quest to subject the viewer to contemplative stillness and self-denial: "The temporality of reception," writes Osborne,

> will be a product of [the] temporality of the work and the other temporalities at play in the field of the viewer—temporalities that are embodied articulations of spatial relations. Each work makes its own time, in relation to its space, and hence to other times; but it can only succeed in doing so by taking into account in advance the spatiotemporal conditions—the dialectic of attention and distraction—characteristic of its prevailing reception. The work of art is in a deep sense "contextual." It necessarily incorporates some projected sense of its conditions of reception into the logic of its production.[11]

Osborne's comments are useful, first, in order to warn us not to heroize self-guided viewership in the broader daylight of today's screen-based installation spaces as an automatic good while demonizing immobile viewing arrangements and more absorptive modes of reception as necessarily bad and regressive. As we have seen with the use or redefinition of the long take in the projects of Tacita Dean, Iñigo Manglano-Ovalle, and Teresa Hubbard and Alexander Birchler, video artists of the twenty-first century actively anticipate, address, and recalibrate different temporal commitments of roaming spectators within the very structures of their respective works. They reckon with different attention spans and levels of focus; they experiment with various narrative hooks and spatiotemporal choreographies to make us probe the durational amid our culture of fast-paced data streams and multiscreen diversions. We'd be mistaken to consider a viewer's temporal autonomy as a principal measure of a work's aesthetic success. It would be equally erroneous, though, to reproach any effort to take hold of the viewers' attention and modulate their sense of time as a regressive rerun of classical Hollywood cinema within the postclassical space of the gallery. The meaning of time and the durational in screen-based art and installation art is deeply contextual, a matter of contingent factors and individual negotiations that defy theoretical predictions and dogmatic assessments.

Second, what Osborne calls installation art's dialectic of attention and distraction, at a more conceptual level, asks us to revise some of the most cherished tropes of modernist art discourse and critical theory of the postwar period. Benjamin famously celebrated cinema as an agent of modern distraction. Unlike the classical museum and theater, cinema—if appropriately used—fostered a decentering of perceptual processes, Benjamin argued in "The Work of Art in the Age of Its Technical Reproducibility."[12] With its discontinuous cuts and ongoing reframing of the visible world, film engaged the haptic aspects of seeing and precisely thus empowered at once politically and aesthetically progressive modes of reception—aesthetically

progressive because distracted forms of viewing freed the spectator from traditional categories such as beauty, originality, empathy, and identification, and politically progressive because distraction undercut the use of outmoded aesthetic principles in the media spectacles of Nazi totalitarianism. Modeled on Bertolt Brecht's theory of alienation and distantiation, Benjamin's ideal film viewer was one enabled and conditioned by the medium itself not to submit to the emotional (and temporal) pull of motion pictures on screen. Considered active rather than passive, reflexively aware of the work of the apparatus rather than duped by its illusionism, Benjamin's distracted spectator dodged the repressive aura of traditional art, reclaimed authority over his or her structures of attention, and in this way converted the cinematic auditorium into a space of individual and collective empowerment.

I will have more to say later about the fact that Benjamin's account of spectatorship significantly exceeds the image of the distracted viewer eager to parry the shocks of cinematic montage and precisely thus able not to fall prey to filmic illusionism. As we will see in the conclusion of this book, Benjamin's often forgotten efforts to understand the habitus of navigating architectural spaces as a model of film spectatorship continues to offer an intriguing approach to discuss viewing practices in our age of ambient screens and mobile display devices. For now, let me simply point out that Benjamin's distracted spectator, enabled by the apparatus itself not to submit to the apparatus, has served many generations of critics as a normative model of aesthetic criticality. This model censured more contemplative forms of visual reception as merely passive, consumptive, and hence politically regressive, while it privileged viewers who understood how to translate certain viewing conditions into self-reflexive acts of looking and critical modes of interaction. It additionally endorsed strategies of reading art that considered a work's formal structure or institutional settings as a comprehensive blueprint for this work's aesthetic and political effects.

The contingencies of viewing screen-based installation art provide many good reasons to rethink this older critical matrix.

We cannot uphold the loaded older opposition between the active and the passive spectator once viewers roam gallery spaces; nor does it make sense to consider a viewer's sense of fixity or mobility, of distracted or contemplative viewing, as an automatic key to a work's meaning and politics. The self-guided spectators of contemporary installation art are certainly active and mobile, but none of these attributes really tells us anything about the specific work or situation they experience. Attention may be something deeply embattled amid the fast-paced streams of 24/7 digital culture, but to think that distracted or durational viewing per se carry a political index, or that certain display media or viewing situations in themselves bear normative meaning, betrays the very criticality such positions claim for themselves. It is the function of the long take in the projects of Dean, Manglano-Ovalle, and Hubbard and Birchler to cast light on the extent to which screen-based installation art inhabits a realm of unprecedented contingencies. Rather than nostalgically yearning for the good old days, when critics could rely on clear maps of progressive viewership and bad consumption, their respective projects urge us to think beyond the modernist binaries of criticality. What these experiments with extended temporalities accomplish is nothing less than the deflation of the very weight of normative binaries such as the active and the passive, the reflexive and the absorbed spectator. They invite the viewer to probe the validity of meanings and experiences in face of the contingencies that mark the contemporary moment. Rather than mourning the vanishing of cinema as we once knew it, the long take in these projects bids farewell to a culture of criticism whose concepts have become far too narrow to assess the meanings, pleasures, and wonders of engaging with moving images today. This goodbye has been a long time in the making, but it may have needed the vagaries of screen-based installation art in order to bring it to the consciousness of itself and fully recognize what it will leave behind.

▶ five

FUNNY TAKES?

The Ethics of Duration

Recent writing on contemporary speed tends to present slowness not simply as a portal to deep pleasure and meaning but also as a well of ethical integrity and sustainable structures of mutual care amid the mind-numbing data streams of the present.[1] Too much speed and stimulation, it is argued, refracts our ability to commit to the force of moral imperatives, whereas a certain slowing down of our seeing, sensing, and thinking might do wonders in letting us reorganize our lives according to ethical principles. In the eyes of slow media scholars such as Matthew Flanagan, recent art cinema's exploration of extended shot durations is ideally suited to serve this moral cause. What he calls the "aesthetic of slow refrains from disturbing the spatial and temporal unity inherent in pro-filmic reality."[2] It reinstates a phenomenological sense of the real, and it precisely thus rehabilitates the viewer's care for worldly matters. Slow media and cinema, following this understanding, formulate a critical injunction against the kind of violence that contemporary visual culture administers to our experience of time. They clear a space for calming the nerves and reconstitute the possibility of ethical orientations.

Jonathan Crary's 24/7: *Late Capitalism and the Ends of Sleep* has added another dimension to this argument. For Crary, visual culture in the age of both continuous screen interactions and neoliberal self-management erases older boundaries

between work and nonwork, private and public, the everyday and organized institutional environments. Any act of viewing today, Crary argues, "is layered with the option of simultaneous and interruptive actions, choices, and feedback. The idea of long blocks of time spent exclusively as a spectator is outmoded. This time is far too valuable not to be leveraged with plural sources of solicitation and choices that maximize possibilities of monetization and that allow the continuous accumulation of information about the user."[3] To watch a show on TV today involves various activities through social media that comment, evaluate, rate, and thereby promote what's on screen. There is no open browser window today whose embedded hyperlinks do not seek to sell related or unrelated objects and information, no smartphone whose streams of information will not be tracked by various agents to utilize the user's actions for future advertising strategies. In Cray's trenchant perspective, today's regime of 24/7 not only eliminates the very possibility of qualitative experiences of time but also obstructs the foundations of community and mutual care. The more we use screenic interfaces to connect to the world at all times, the more isolated we become, locked into the confines of highly instrumentalist and reified forms of subjectivity. As it couples its heroization of strategic agency to the abolishing of sleep, 24/7 does away with what defines the ethical substructure of nightly slumber, namely our trust that no one will harm us during periods of diminished perception and receptivity to the world. Sleep's increasing disappearance in a culture of compulsory connectivity erodes what is at the heart of the ethical—the promissory assurance to care for others and be cared for by others in states of vulnerability, nonstrategic inaction, drift, dream, and wonder. Neoliberalism's vision of ceaseless self-management is the nightmare of what defines us as ethical beings.

The twenty-first-century long take often serves a role similar to that of Crary's sleep, which isn't to say that extended shot durations are designed to make viewers fall asleep (even though they very well might have that effect on many). On the contrary. What it means to say is that the long take, like sleep,

has the unique ability to open an aesthetic space-time that cannot easily be subsumed to the protocols of neoliberal self-organization and strategic screen interaction. Long takes want to situate viewers in positions of reduced awareness of their ordinary surroundings. They subject us to glacial movements of time not in order to overwhelm our perceptual systems but to invite the viewer to unregimented stretches of drift, of letting go and dissolving the hardened boundaries of instrumental subjectivity. As discussed in earlier chapters of this book, long-take projects intend to restore the nonintentional aspects of seeing and experiencing the world on screen. They ask us to explore or own vulnerability, to shut down our perceptual defense systems, and, unlike 24/7, to not embrace immediate responses and connections, all in order, in the form of an aesthetic experience, to suspend neoliberalism's regime of self-maintenance and restore the grounds for the ethical. If true sleep in Crary's perspective cannot exist without us presupposing the care of others, today's aesthetic of the long take often aspires to create viewing conditions in whose context the holding of attention over longer blocks of time retrains our ability to give ourselves over to the care of others and restores in us what makes us care for others. The long take's most important wonder is its promise of a state in which fear no longer existed and we no longer mistook 24/7's continuous acts of selection and interactivity as automatic signs of belonging, care, and freedom. At its most aesthetic, the long take's intervention is deeply ethical and political in nature, challenging how today's regime of 24/7 erases experiences of nonmonetized time and sociability.

Few international art-house filmmakers have enjoyed the label "ethical" more often in recent years than Austrian Michael Haneke. The rigor and slowness of his films are celebrated as an outcry against the manipulative work of Hollywood violence, speed, and genre conventions.[4] Born in Munich in 1942, Haneke's career as a director of films that sternly probe the moral infrastructure of modern media society did not commence until relatively late in his life. A handful of productions for Austrian television prepared what in the 1990s, with films

such as *The Seventh Continent* (1989), *Benny's Video* (1992), and *71 Fragments of a Chronology of Chance* (1994), emerged as a strikingly coherent body of cinematic work, and what after the turn of the century, with films such as *Code Unknown* (2000), *The Piano Teacher* (2001), *Cache* (2005), *The White Ribbon* (2009), and *Amour* (2012), coalesced into an ongoing provocation of dominant filmic practices and pleasures. Common wisdom ties Haneke's ethics directly to his modernist gestures of refusal and introspection and to his deliberate efforts to frustrate his viewers and reflexively investigate the effects of moving images. Haneke's often static framing, pondering shot lengths, and uncompromising editing are usually embraced as formal indices of the director's moral project. His most often discussed signature shot is no doubt the long take of the opening of *Cache*: a seemingly impassioned observation of a street scene lasting almost three minutes that, when its final seconds suddenly mark it as a surveillance video recording, casts the viewer into a disturbing position of retrospective complicity and reflexive caution about what might be to come. Discussing Haneke's general use of long takes, John David Rhodes writes, "Looking at people and things, especially if we are going to look at them for a long time, involves us, necessarily, in a three-fold process of interrogation: what do we think this means? Why does it matter? What do we do about it?"[5] In—or, better, at the end of—the opening shot of *Cache*, this triple interrogation into the ethics of looking necessarily asks us to stay on our toes throughout the rest of the film, for in Haneke's universe, even the most innocent shot of people passing by may secretly impose a deranged point of view onto our perception. Even the most distant and hence realist perspective, in the age of advanced media of recording and replay, may turn out to be an imaginary probing of our spectatorial resistance to diegetic fantasies of control, revenge, and murder.

Haneke's celebrated long takes, in the eyes of most of his critics, situate him as a director in whose hands the languages of both modernist and realist filmmaking interrogate what mediated images today do to us and what we should do with them.

Rather than absorb the viewer into the visible world on screen, Haneke's long takes want us to investigate our own seeing as much as they seek to inoculate us against today's culture industries. They make us question past assumptions and false identifications so as to develop more critical and less susceptible modes of viewing. In this respect, we can indeed think of the slowness of Haneke's work as part of a profoundly ethical project: it preserves the unity of the profilmic and precisely thus wants us to recalibrate our care for worldly things, including our relationship to the world's representation on film. Yet because some of Haneke's most celebrated long takes are designed like traps, pedagogical ladders we need to leave behind once we have climbed them, there are good reasons to question whether Haneke's extended temporalities really add to the aesthetics and ethics of wonder pursued in this book. Unlike Crary's sleeper, Haneke's viewers rarely experience perceptual drift and nonintentionality as an open invitation to suspend the pressing logic of 24/7. In fact, as they test our endurance as much as teach us a lesson about our follies, Haneke's long takes turn out to be a cinephile's ethical verso to neoliberalism's recto of ceaseless self-maintenance. They hang on to a modernist credo of criticality and reflexivity, and they reprimand viewers whenever these may fail to properly question and hold in check their receptive processes. Yet precisely in doing so they strangely mimic 24/7's systematic attack on substantive experiences of time, its heroization of perpetual self-control, and its flattening of what it might take to be wondrous.

The aim of this chapter is to flesh out this argument. The central object of discussion is Haneke's perhaps most provocative long take, a ten-minute tracking shot used in both the Austrian and the American version of *Funny Games* (1997, 2007), relentlessly capturing the pain and trauma that has come upon the films' middle-class vacationers. In exploring surprising complicities between Haneke's didactic modernism and advanced media society's logic of hyperactivism, the ambition is twofold: to complicate any possible assumption that long takes and slow cinematic temporality operate as automatic training grounds

for greater spectatorial freedom and self-determination, and to thereby more clearly define both the ethical and the political dimension of what I understand as wondrous spectatorship today.

The Pain of Others

The last image we see before Haneke cuts to *Funny Games*'s most excruciating take is that of a television set, its screen splattered with blood, its scan lines presenting agitated images of a car race. The following take shows the vacation house's living room from a slightly angular perspective (Figure 23). Its furniture is neatly arranged to accommodate casual guests and conversations. Its three windows stare into the darkness of the night. Its murky interior light suggests a sense of warmth and protected intimacy. Yet nothing could be more mistaken than to believe that this is a fortress of bourgeois coziness. We notice Anna (Susanne Lothar), sitting on the right, barely dressed. Her hands are tied behind her body, her hair disheveled, her face illuminated from below by a toppled lamp. We notice the slaughtered body of her son, Schorschi (Stefan Clapzynski), lying in a pool of blood to Anna's right, just below the television set of the previous shot. His legs are contorted. Haneke has spared us any previous images of the killing, and Anna tries hard not to look at her son, but his posture and all the blood leave no doubt about his being dead.

After some perusing of the unmoving frame, we will make out the lower parts of Georg's (Ulrich Mühe) legs on the left as they stick out between the sofa and love seat. It will take the camera almost two minutes before it will do anything. As if prompted by Anna's own action—she gets up in spite of her being cuffed, hobbles awkwardly around her dead son, and shuts off the television set—the camera will first pan slightly to the right and thus recenter our attention on Anna. We then see Anna hopping to the left toward the kitchen to get a knife, as she tells Georg, who raises his upper body just before Anna is about to leave the frame on the left. At this point we are already four minutes into the take. Because the camera has slightly panned

Figure 23. Michael Haneke, *Funny Games*, 1997. Screenshots.

to the left during Anna's movement, we now find Georg in the center of the frame; we have little else to look at when Anna returns from the kitchen and hugs Georg, then sits down next to him on the floor so as to discuss a possible escape plan. A good eight minutes into the take, after Schorschi's mutilated body has no longer been visible for some time, Anna helps Georg get up. The physical pain of his broken leg causes him to groan unbearably. Anna hauls Georg up and toward the camera, then drags him toward the door of the living room, with the camera

once more adjusting slightly to the left to follow their movements. However, as if to quash any hope in the viewer for the possibility of a redemptive exit once and for all, Haneke will cut to an exterior shot of the vacation home right before Anna and Georg are about to pass through the room's door frame. After more than ten minutes of continuous recording, this new shot brutally interrupts Anna and Georg's flight and thus re-emphasizes the house's status as a torture chamber rather than a sanctuary of domesticity. Whatever little movement has been accomplished over the past ten minutes will not suffice to break the logic of their captivity.

The narrative surrounding the events of this take is easily told, at least at first. Two well-dressed, well-educated young men—Peter (Frank Giering) and Paul (Arno Frisch)—enter the vacation house of an urban family; hold husband, wife, and son hostage; design (deadly) games they want to play with them; eventually kill the son, later the husband, and finally the wife as if the world existed in a complete vacuum of humanity; and then move on to the next vacation home, where they intend to restart their "game" with a different set of players. Throughout the film, the torturers engage in discussions about video games and television. They may act like members of the upper class, dressed all in white and speaking with considerable articulation and poise, even eerie tact and thoughtfulness. But they certainly are deeply familiar with the repertoires of the popular, of mediated pleasures and forms of consumption no different from those of young adults with different social backgrounds. During a crucial and oft-cited moment, one of the two invaders in fact rewinds the whole narrative of the film as if it were a video so as to undo the killing of his friend and continue the game as planned, thus establishing himself as the absolute master over what we see, a grand enunciator of the film's entire narrative and imaginary.

Haneke's work throughout the last two decades is well known for its sustained attack on the ubiquity of mass media and the templates of commercial genre cinema. "I am part of a generation," Haneke has described his upbringing, "which was

able to grow up without the continual presence of television. So I was therefore able to learn about the world directly, without any intermediary. Today, by contrast, children learn how to perceive reality through television screens, and reality on television is shown in one of two ways: on the one hand there are documentary shows, and on the other fiction. I think that the media has played a significant role in this loss of any sense of reality."[6] *Funny Games*'s Peter and Paul, as is clear at the outset, are meant to be seen as products of a society in which the continual presence of television screens has displaced any reliable sense of and for the real. They are monsters fed on and fostered by too much mediation. The logic of their games is one completely freed of any trace of substantive reason; it is one of strategic rationality emancipated from whatever could generate human reciprocity. Instead, what makes them tick are habits of thought and perception that are entirely shaped by what society has decided to put on screen—not in order to show and ponder but to displace the weight of reality and human interaction. Yet while it is tempting to go on at some length about the moral vacuity and televisual addiction of Peter and Paul, it will be of little use in bringing us any closer to understanding the primary agenda of Haneke's film, and in particular the function of the long take in the above-mentioned sequence. *Funny Games* is at heart not about Peter and Paul's violence or amorality; nor is the film about the question whether Anna and Georg's torture serves as a cinematic punishment for their bourgeois naïveté and idealism. Rather, the film is first and foremost about the spectator itself—about us. It is about us watching the action on screen and about us being directly addressed and drawn into the actions of the torturers and thus becoming complicit with their violence. It is about the question whether we may flinch or not flinch while horrendous things happen in front of our eyes. It is about our ability to resist what we see, our failure not to walk out the very door that Haneke's long take at once promises and refuses as a possible exit from the pain of others.

It appears, Susan Sontag wrote in *Regarding the Pain of Others*,

that the appetite for pictures showing bodies in pain is as
keen, almost, as the desire for ones that show bodies naked.
For many centuries, in Christian art, depictions of hell
offered both of these elemental satisfactions. . . . There was
also the repertoire of hard-to-look-at cruelties from classical
antiquity—the pagan myths, even more than the Christian
stories, offer something for every taste. No moral charge
attached to the representation of these cruelties. Just the
provocation: can you look at this? There is the satisfaction
of being able to look at the image without flinching. There
is the pleasure of flinching.[7]

The modernist drive of Haneke's overall work at first suggests
that the long take of *Funny Games* offers no less than a reflexive
version of this kind of provocation. The viewer is asked to attend
to the effects of extreme violence so as to probe the pleasures
we derive from watching the gore of mainstream films. Rather
than encoding violence through frenetic cutaways, accelerated
editing, and CGI bravura, Haneke's long take holds on for much
longer than viewers would ever ask for in the hope of restoring
the real against the grain of its cinematic mediation. There is
no hiding of what violence has done to Anna's, Georg's, and
Schorschi's bodies in Haneke's excruciating long take. We see
both parents maneuver their tortured limbs and bones across
the room, utterly reduced to what Giorgio Agamben and Eric
Santner might call the creaturely—that is to say, a state of bare
life from which any power to signify or be signified has been
stripped away.[8] We witness the slaughtered son in the corner
of the room, his body splayed as if he had been subjected to a
ritual killing before the altar of television, and yet his bloody
appearance leaves us with nothing but the impression of man-
gled flesh, a dead object amid the other inanimate objects that
populate the living room. We hear Anna's and Georg's groans
for minutes on end—devastating sounds no longer produced by
anything resembling human intentionality or deliberate articu-
lation. All this will without fail provoke the viewers' act of view-
ing, for throughout the shot's ten minutes we will desire nothing

so much than for the shot to be over, for us to be delivered from our position of helpless witnessing. As he presents the suffering of violated creatures in real time, Haneke's long take stages a violent return of contemporary action cinema's repressed. He profoundly challenges our ability to watch without flinching and to continue watching without feeling deeply unsettled about us watching this at all, ashamed that our very watching causes Peter and Paul to do what they do in the first place.

This, of course, describes the central aim of Haneke's pedagogy of the long take: to expose viewers who consume the creaturely pain of others while knowing all too well that they should have left the auditorium long ago to break the obvious circle of complicity. In contrast to the case of Sontag's painters of bodies in pain, for Haneke, the question is no longer, "Can you look at this, and if so, will you take pleasure in not flinching in spite of what you see?" Instead, the question is, "Why do you watch this in the first place if you know that these images have no pleasure to offer? Why do you keep watching if you perfectly know that my film violates its characters solely because your watching asks and authorizes me to do so?" Peter and Paul might control the action and choreograph its representation. But Haneke's long take gives us pause to recognize them as our avatars within the film's diegesis, administering what we, by watching, empower them to do. We could at this point easily finish their run, but in all likelihood we will fail to do so. We will keep watching because twentieth-century art-house cinema has trained us to sit through even the most challenging images and sounds. The function of Haneke's long take is thus much more ambitious than simply revealing the conventions of horror filmmaking and denouncing the perverse pleasures of genre cinema. It is to situate the viewer as an active producer of cinematic time as much as it is to deride the extent to which modernist criticality does not provide foolproof immunizations against cinema's cathartic promises and seductions. Contrary to much of what has been written about *Funny Games*, Haneke's long take in the end is neither about the question of whether we flinch in face of screenic violence nor about whether horror

films produce sadistic or masochistic pleasures that desensitize spectators and prepare the ground for violent action outside of the theater. What the film wants to do instead is to play tricks on sophisticated art-house viewers and make them responsible for what happens to Anna, Georg, and Schorschi. What it accomplishes is to shame the viewer about not following his or her voice of knowledge, reason, and morality, about not abandoning acts of unpleasurable looking in spite of their better judgment and all our pronouncements of criticality.

In the wake of World War II, European art-house and new wave cinemas were certainly already known for similar scenarios of displeasure and spectatorial punishment.[9] Whether or not they embraced long-take cinematography, the auteurs of the 1960s and 1970s largely withheld or refused generic pleasures; they defied affective narratives and psychologically coherent characters; they resisted user-friendly images and sounds. In so many of its celebrated products, twentieth-century art cinema in fact set out to challenge the viewer's perceptual system and probe the audience's patience so as to make viewers reflexively aware of the operations of the mainstream. It exposed the apparatus of cinematic production in order to emancipate the viewer from Pavlovian responses and activate the viewer's freedom and participation. Yet such pressures on the contracts of commercial film viewing of course also rested on various contracts, not least of all the assumption that art-house screenings could rely on the prolonged commitment of their viewers—that art cinema could count on the viewer's attention in the theater's black box even when it sought to disturb or repel it the most. Art cinema had little to fear about its viewer's endurance and attentiveness. It could presuppose the presence of receptive viewers, and it could violate common expectations because its viewers had largely already agreed to abandon dominant templates in search for something new and different. Whether postwar auteurs lured viewers into deeply undesirable spectatorial positions (as in the films of Hitchcock or Lang), or whether new wave filmmakers in the name of true art and/or politics declared war on the mechanisms of plea-

surable viewing and consumption (e.g., Tarkovsky, Godard), the art of art cinema largely rested on the effort to rebuke the merely pleasurable and, for the sake of critical and participatory viewing, unleash what defies easy comfort.

Though often praised as a direct heir to modernist, new wave, or simply "difficult" postwar filmmakers such as Robert Bresson, Michael Haneke's work clearly inhabits a position different than the one of postwar auteurism. Haneke's work addresses viewers no longer in need of education about the generic pleasures of commercial cinema and popular television culture. If films such as *Funny Games* simply aimed to reveal the violent mechanisms of the horror genre, Haneke would no doubt do nothing else but to preach to the converted. Unpleasurable looking in Haneke's cinema therefore no longer seeks to frustrate expectations so as to make us see our own seeing and become impervious to the pull of narrative cinema. The project of Haneke's long take in *Funny Games* is instead to play games with the viewers' presumed criticality itself—to punish viewers for not acting on their supposed moral superiority even though they were granted all the time in the world to draw a line between what is seen and their own enlightened principles as viewers. What is truly unpleasurable about Haneke's extended shot durations is what they do long after the screening to viewers trained by the legacy of cinematic modernism—namely, to make us feel humiliated about our own capitulation, to make us admit to ourselves that we disgraced our critical standards, that we disgraced cinema in general, when by watching the pain of others we knowingly produced it ourselves.

The point of Haneke's long take, then, is at once to picture and condemn a world in which neither self-reflexive distance nor pondering slowness protects us from acting as perpetrators of violence. Haneke's long take defines art cinema as one of radical disenchantment. In feeling ashamed about our continued and seemingly stoic looking, we are asked to understand that modernism's language of criticality is no less a myth and chimera as the pleasurable illusions of commercial cinema that cinematic modernism once ventured to destroy.

Antiwonder

How, then, does Haneke's use of the long take fit with the aesthetics of wonder explored in this book? How does his moralism square with the work of other contemporary moving image practitioners whose hope is to rekindle the very possibility of aesthetic experience vis-à-vis the ceaseless flow of mediated images and the neoliberal mandates of self-management?

Wonder enables and allows us to entertain reciprocal relationships between perception and thought, fascination and knowledge. Unthinkable without the very experience of durational time it seeks to interrupt, wonder initiates forms of curiosity whose subsequent quest for rational explanation may threaten wonder's moment of enchantment. Yet wonder may also instigate forms of engagement with the world that exceed the rhetoric of closure and finality so often associated with dominant modes of explaining worldly matters. In depicting wonder as the origin of philosophy and the primary driver of all passions, Socrates and Descartes associated wonder with the freshness, originality, and buoyancy of the youthful. Wonder disrupted the fabric of the ordinary, inspired by the unexpected, by that for which the perceiving subject has no conceptual matrix at hand. Wonder's impatience with routine and repetition, however, did not define it as necessarily outside of any moral framework—on the contrary. In particular in Socrates's conceptualization, wonder's task was to challenge the negativity of stoic indifference, its demand not to admire anything and to find meaning and orientation solely in what can be solidly expected: "Stoicism in its battle against the passions insisted on the reality of repetition within experience, thus ruling out unique 'first' experiences. At the same time it invented a training that amounted to a kind of practice that would prepare us so that, in effect, there could never be a sudden experience, a moment of surprise, a moment of the unexpected. Stoicism could be called a training in expectation."[10]

Stoicism privileged iterability over the freshness of unruly passions in order to safeguard reliable frameworks of human

interaction. It endorsed repetition because it mistrusted the youthful, and it hoped to emancipate us from the messiness of our emotions so as to pave the way toward being responsible for the lives of others. Yet in advocating rigorous affect control as a precondition for leading a moral life, stoicism at the same time threatened to erase the very ground of moral thought and action: the variances of human experience. Training the subject in emotional indifference, stoicism in the end had little to say why the moral good should matter in the first place, both for the individual and his or her community. Wonder's charge was in no small way to rekindle passion for the passions, and in doing so to restore the legitimacy of experience in all its unpredictability as a base of moral existence. Wonder provided a training ground for making and marking differences. It was affiliated with newness and creativity, not for the sheer sake of the unexpected and the not-boring but because sudden shifts in perspective and routinized discipline are essential to maintaining our intellectual and moral agility. To experience wonder, for both Socrates and Descartes, was to find oneself in an unexpected state of suspension in which the perceiving subject could readjust existing maps of what may matter and what may not. Rather than silencing the individual with mind-numbing astonishment, wonder sparked curiosity about the world as much as it renewed people's care for material, spiritual, and human affairs. To experience wonder is to reinvigorate what it takes to experience things in the first place. Similar to our daily sleeping and dreaming, wonder occurs in states of liminality in whose context we not only suspend ordinary mechanisms of self-management and self-preservation, but—vulnerable as we might be in experiencing a sudden shutdown of our ordinary mechanisms of perceptual, emotional, and cognitive protection—come to presuppose and give us over to the care of others. To experience wonder is to experience the world as if no fear about what is around and within us were necessary. Like sleep, wonder involves states of unguarded nonintentionality that revitalize the promise of a world governed by mutual care and noncoercive relationships.

Contemporary long-take work is often perceived as an exercise in stoicism, as a cinematic endurance test that not only probes our patience beyond its limits but that also trains viewers to become indifferent toward their emotions, passions, and desires. Sit still, expect little, admire nothing, keep your emotions in check, just watch and watch yourself watching—isn't this what the glacial camera work of a Kiarostami, Tarr, Tsai, or Weerasethakul, similar to the earlier cinema of Angelopoulos, Antonioni, or Tarkovsky, communicates to the contemporary viewer? This book argues that nothing could be more wrong than to make this association. For far from resuscitating stoic attitudes toward the world, the contemporary aesthetic of the long take—whether it takes place in a cinema's dark auditorium or describes our moves through a half-illuminated gallery space—is deeply committed to reconstructing the very possibility of passionate responses to the image spaces of the present. It invites us to experience the world on screen, the world of screens, with open eyes and wondrous senses as if there was no need to fear we could be harmed during prolonged states of perceptual defenselessness. To relax one's guards vis-à-vis shots that give us time to pause is not to turn into a stoic but to suspend the automatism and strategic reason we are called on to administer in a neoliberal world of screenic overstimulation. It is to unhinge the agitated indifference that 24/7 forces on the so-called user in order to both protect his or her perceptual systems and to feed the networks with ceaseless streams of feedback, information, and purchase orders.

Haneke's stretching of cinematic temporality inhabits a curious place in all of this. His excruciating long take in *Funny Games* wants to persuade the viewer to question the very stoicism we seem to assume when witnessing ten uncut minutes of suffering without being able to intervene. Stoic distance, in Haneke's view, is never as distant as it pretends to be. It sustains and vindicates the very cruelty it seeks to hold at bay. Yet in playing games with the viewer's criticality and self-reflexivity, Haneke's project at the same time is to shame us for not being on guard enough; for our underlying hope that things might

turn out all right in spite of all signs to the contrary; for our folding of sadistic and masochistic impulses into each other instead of staying indifferent to the generic logic of commercial cinema; for us not leaving the theater when critical reason called upon us to do so. To watch *Funny Games* is to enroll in a seminar you cannot but fail. It is to submit oneself to a no-win situation. To be sure, Haneke's long take might convince some viewers that the passivity of stoic attitudes, of us holding out in front of images of extreme displeasure, is of as little use to challenge the operations of commercial cinema as the thrill of the horror genre addict. Yet in shaming the spectator for being a spectator, Haneke's long take at the same time couldn't be further away from the aesthetics of wonder and its underlying ethics of sociability, of lowering perceptual guards while presuming the care of others, explored in most of the other projects in this book. If you stay, you prove to have been fooled by Haneke in spite of your critical training as a student of art cinema. If you leave, you reveal your ignorance of modernist art cinema and how it has come to define itself around scenarios of displeasurable looking.

Shame, Immanuel Kant argued, is what we feel when we have failed to live up to our humanity. It results in feelings of "self-contempt and inner abhorrence."[11] When feeling ashamed, we find ourselves in a self-conscious state of being split as we see our own presumed failures through the castigating eyes of the other. Unlike feelings of guilt and embarrassment, shame fragments the subject without giving the subject a public stage to play out supposed shortcomings. Shame is a deeply atomizing emotion. It casts us onto ourselves; it makes us internalize conflicting values and actions and thereby breaks social bonds. Like Kafka's protagonists, the subject of shame is one unable to trust or contribute to the care of others. His slack posture and downcast eyes, her blushing and feeling of disgrace—these signify a profound breakdown of human reciprocity that is often far more serious than the alleged violation of certain codes that caused it to begin with. Shame's interiorization of social facts in the form of contemptuous self-observation is fundamentally

hostile to the freshness and profound curiosity experienced in the state of wonder. The shamed subject is one wanting to shut down perception and experience to protect the self from further fragmentation, and at its heart, it seeks to drop out of any social network so as to discontinue how shame makes us look at our human failures through the (imagined) eyes of others. The wondrous subject, by contrast, not only allows for the possibility of being struck by something unexpected as a path toward thought but also is driven by a desire for experience—a kind of experience that liberates the self from the exigencies of willful intentionality, of self-directed action, of ceaseless self-management. If shame begins with something that makes us turn inward and sets us aside from others, then wonder begins with something initially imposed on us but that causes us to become curious and turn outward to the world, including to the perceptions, thoughts, emotions, and lives of others.

Haneke's long take is thus an exercise in antiwonder. It systematically depletes what could empower the viewer to experience something new and curious with youthful attention. Rather than give way to pause and thought, Haneke's long take reckons with viewers deeply familiar with the ceaseless self-vigilance that 24/7 imposes on us. In Haneke's universe, similar to the one of neoliberalist self-organization, every man at all times turns out to be a wolf to his fellow man. Neither trust nor hope in the other will ever be rewarded. Nothing new is ever likely to happen. Though we cannot rely on our own desires and impulses, the self, in all its internal fragmentation, is all we have. Shore it up, Haneke tells us. Don't allow focus and attention to slip for a second. Anticipate radical evil at every corner, most of all as it may emerge from inside yourself. By no means dare to drift. Fear nothing so much as sleep, for it is during periods of diminished consciousness that some damage will come over us and punish our naive belief in the possible goodness of others. Yet in the disparaging eyes of Haneke, even when we are at our most reflexive and vigilant, we cannot but fail to live up to the agendas of criticality, to our presumed humanity. Disgraced by our stubborn hope for

something wondrous to interrupt the flow of violence on display, we find ourselves in utter loneliness in front of the screen, our shame exhausting whatever could connect us to the experience of other viewers. In speechless contempt with ourselves about our own presumed failures as spectators, as Haneke's viewers, we—in radical contrast to experiencing long takes as a promise of the wondrous—evidence an absence of human sociability that is no different from neoliberalism's logic of atomized individualism, that logic of self-management that Haneke's film, in the eyes of many well-meaning critics, seems to challenge.

Long-take work in the hands of twentieth-century auteurs such as Antonioni and Tarkovsky often rested on a quasi-theological dialectic of the visible and the off. Whatever you saw indexed no less than the presence of an absence. While refusing to cut, the camera defined the off as a space potentially able to redeem a shot from its desolation and lack of meaning. The twenty-first-century long take at once expands and secularizes the logic of this promise. It extends the off from diegetic space and cinematic frame to the entire environment of the viewing experience—the space of exhibition, the milieu of moving image interaction. Its central aim is not to kindle our desire for redemption but to probe and remodulate our sense of time and attentiveness—that is, to recalibrate the temporal relationships of screenic representation, exhibition space, and the space of the perceiving body in such a way that the off's very location becomes deeply ambivalent. Haneke wants it both ways: he wants to replay the political theology of modernism and reshape the ecology of moving images. All things told, however, his long takes are exercises in negative theology. Coupled to a didactic politics of shame, Haneke's films tend to erode the central ambition of the twenty-first-century long take: to make us investigate our durational receptivity as a precondition for establishing fresh and caring relations to the world, including those who cohabit the space of our viewing in that ambivalent and semipublic zone between on and off. Haneke's fully disenchanted world of modernity radiates disaster triumphant.

After Dark

Radical art in the twentieth century, Theodor W. Adorno wrote shortly before his death, is dark art; its background is black in color.[12] Though holding on to the promise of a better life, Adorno's preferred artistic work refused to restore wholeness to the world. In its effort to resist the protocols of the culture industry, it turned entirely toward itself and thus defied any desire for easy consumption, pleasure, and delight. No less a moralist than Adorno, Haneke's aesthetic program communicates a similar negativity to Adorno's late philosophy of art. "My films," Haneke has said, "should provide a countermodel to the typically American style of total production to be found in contemporary popular cinema, which, in its hermetically sealed illusion of an ultimately intact reality, deprives the spectator of any possibility of critical participation and interaction and condemns him from the outset to the role of a simple consumer."[13] Haneke's films are exercises in blackness. In their relentless perspective, colorful entertainment commits treachery against the dead and the suffering of the living. Commercial filmmaking floods the auditorium with shining spectacles; television entertains its viewers amid the brightness of their living room. Haneke's cinema, on the other hand, emerges from and explores the muted darkness of the auditorium as the only ground of legitimate aesthetic communication. Its images are deliberately set against the background of the auditorium's blackness, denying our childish delight in color as much as the luminous abundance promised by the culture industry.

Haneke's repeated statements about the vacuity of genre cinema and televisual entertainment seem to situate him as a stalwart cinephile, were it not for those many moments in his work that, like the long take of suffering in *Funny Games*, tend to renounce cinema altogether and/or push viewers into agonizing positions of self-contempt. Haneke's ethics of art cinema rests on the idea of a viewer able to attend critically and without disruption to the images on screen. For him, the auditorium's blackness serves not as the condition for the possibility

of forgetting oneself and submitting one's own sense of time to the narrative drive of the projected film, but rather to reflect on one's viewing, guard it against possible manipulation, and become an active participant in the film's meaning. This prospect of spectatorial activity essentially relies on us, the viewers, submitting to the blackness of the auditorium, to our own stillness and isolation, to our unconditional commitment to focus and not be sidetracked by other images, screens, sounds, and activities around us. But how do we watch Haneke once his films are detached from the atomizing darkness of the auditorium and, like most films today, viewed as DVD or streaming video on a home screen? What happens to Haneke's moralism if we, remote control in hand and under the living room's bright lights, no longer need to submit to the disciplining *dispositif* of the cinema? What happens to the politics of Haneke's long take if viewers, free to use their digital controls, simply decide to speed up the action and replicate how Peter and Paul themselves manipulate the viewer's process of looking, be it intradiegetically (making us watch car races on the television set) or metadiegetically (rewinding the whole film in order to alter its narrative order)?

Catherine Wheatley has asked similar questions about the role of television and domesticity in Haneke's overall work, and in exploring some tentative answers, she mainly points to Haneke's general ambivalence about the digital.[14] While Haneke's work has used digital techniques during the production process, most of what we see in his films at the narrative level, Wheatley argues, still feature analog technologies, with the rewind sequence in the 2007 version of *Funny Games* being the sole exception as the images on screen imitate the rewinding process of a DVD recording rather than of a magnetic tape (as in the 1997 version). Wheatley is certainly right to question the curious mismatch between production aspects and the diegetic in Haneke's work. In the end, however, she shies away from addressing the elephant in the room: the question of whether watching Haneke on any screen other than the one of classical cinematic projection at once betrays the director's

aesthetic of blackness and transforms us into the very kind of viewer Haneke warns us about all along. What happens to Haneke's politics of shame if we, as roaming spectators and digital interventionists, play games with the slowness of his images of violence rather than allow the film to play games on us?

Laura Mulvey's *Death 24× a Second: Stillness and the Moving Image* offers a good starting point to answer this question. Digital spectatorship, for Mulvey, places critical pressure on a film's narrative order and temporal flow. It situates the viewer as an active participant in the flow of cinematic time. Contrary to the templates of classical spectatorship, including the one associated with auteur cinema, digital spectators can willfully affect "the internal pattern of narrative: sequences can be easily skipped or repeated, overturning hierarchies of privilege, and setting up unexpected links that displace the chain of meaning."[15] Like the roaming viewers of contemporary video installations, digital spectators are expert poachers and samplers. They have little respect for the temporal integrity of moving image products and are eager to imprint their own sense of time onto screening images. They accelerate or slow down screenic representation, perhaps even halt it altogether, so as to assimilate moving images to their own aesthetic expectations: to bathe in the frozen image of their star; to follow chains of action in analytical detail; to replay one's favorite scene at the expense of all others; or simply to skip beyond what may contain a source of boredom. If auteur cinema's task was once—in Andrey Tarkovsky's view—to imprint time onto film and thereby sculpt it,[16] Mulvey's digital spectators use advanced technologies to become temporal sculptors in their own rights. As digital spectators, we animate the dead and arrest the living. We create new gray zones between movement and stillness, whether to satisfy our fetishistic impulses, please our fickle attention spans, or simply indulge in the very creativity of shaping time. Digital culture, in Mulvey's perspective, liberates the maker in all of us. It does not—as many would argue—lead to an automatic flattening of meaning and accel-

eration of temporal streams. It primarily allows the viewer to define autonomous durational commitments, customize and destabilize the authority of the filmic text, and thereby emancipate our own temporal horizons from the push and pull of pregiven narrative patterns.

One may rightly question—as I did already in the opening of this book—whether Mulvey's vision of spectatorial activity secretly depletes the very resources of the aesthetic. Called on to sculpt our own time at each and every moment, we may lose what it means to experience moving images aesthetically, namely that playful hovering between the sensory and the cognitive, intentionality and nonintentionality, that cannot do without a certain subjecting of oneself to the force of the other. However, as we have already seen, long-take aesthetics and digital spectatorship are not necessarily incompatible—quite the contrary. As much as the roaming spectators of contemporary video installations can partake of the wondrous as long as they are prepared to consider their own perceptual activities as a mode of long-take cinematography, so too can Mulvey's digital poachers and gamers experience extended durations aesthetically. The rise of the digital did not kill the long take. It has inspired many filmmakers working with analog film to redefine what long-take cinematography was once considered to be all about. It has also enabled people using digital media to redefine the very meaning of both the "long" and the "take," thereby asking us to rethink the possibility of durational experiences beyond their former association with the auteur's sculpting of time and the darkness of the classical auditorium.

Though groundbreaking and important, the problem with Mulvey's approach is that it simply relocates some of the central values of modernist cinema—criticality, reflexiveness, autonomy, participation—from the hands of the former auteur to the adroit fingertips of the digital spectator. To be sure, as she transfers modes of critical judgment from older to newer media, Mulvey avoids any nostalgic attachment to the good objects of previous generations of critics. Yet the true challenge, of course, would be to ask whether new means of capturing,

storing, distributing, and displaying moving images have changed the very parameters according to which we approach and assess images in the first place, including their ability to rework our experience of time, memory, and anticipation, and their power to rub against the dominant organization of temporality in late capitalism. Shouldn't we rather question the very value of participatory viewership—that is, the ideal of spectators customizing their own film according to personal preference, if neoliberalism today asks us to do the very same in all branches of contemporary life and at the cost of destroying communities of care and sociability? Shouldn't we rather dismiss the entire modernist mantra of active and critical distance if restless interactivity and dispassionate multitasking are the central building blocks of today's economy of digital attention?

Long takes in contemporary moving image culture can serve as privileged objects to think with Mulvey beyond her. In all its different analog and digital manifestations, they not only index desires for alternative temporalities and visual pleasures but also formulate ethical and political interventions to reconstruct the very condition of aesthetic experience against neoliberalism's increasing colonization of time. Yet no matter where we want to take Mulvey's thoughts on digital spectatorship and intentionality, they illuminate what is deeply wanting in Haneke's modernism and ethics of time: his fundamental reluctance to think about spectatorship beyond the template of the dark theatrical auditorium, his stern refusal to find value in anything that may involve home screens and digital technologies of time shifting. Consider the rewind sequence in both versions of *Funny Games* (Figure 24). When Anna manages to shoot one of her captors, Paul grabs the living room's remote control, and much to the initial confusion of the spectator, he simply rewinds the entire film to a point before Anna's desperate act, thus not only undoing her action but allowing the narrative to unfold in a different direction. When read through the lens of Mulvey's writing, Paul's use of the remote administers what Mulvey considers the emancipatory promise of digital spectatorship. It takes active hold over the flow of cinematic time,

Figure 24. Michael Haneke, *Funny Games*, 2007. Screenshots.

customizes narrative order and logic, and thereby—godlike, as it were—invites the dead to reenter the realm of the living. Paul, in Mulvey's terms, is a possessive spectator: he is a fetishist who uses living room technologies to "wound(s) the film object in the process of love and fascination," but also to "reinvent its relations of desire and discovery."[17] He wants to own the film, to convert life into film, so as to arrest the entropy of time and—outperforming's cinema's ability to mummify change[18]—beat death at its own game.

Haneke's own agenda for staging this crucial scene is doubtless less generous. As much as domesticity against the backdrop of Haneke's aesthetic of blackness belies its own historical rhetoric of interiority and protectiveness, so does digital spectatorship pervert modernist criticality. It violates the body of film in the false name of liberating the spectator from prefabricated pleasures. Dead bodies in film, Lesley Stern has written in a different context, have the ability to interrupt and suspend cinematic temporality; they pause the flow of images and temporarily fill screenic space with a slowed-down sense of time, a certain sense of stillness.[19] Paul's willful use of modern media—as seen through Haneke's optics—has no patience

for such experiences of slowness. He rewinds the film not simply to reawaken his friend from the dead but also to escape the possibility of encountering time as something uncertain and ambivalent—something that might exceed his own sense of control and intentionality. Paul's act of time shifting evacuates one dead body from the screen, only to produce more in what is to follow. His intervention thus echoes and allegorizes what in Haneke's view may happen when moving images move from theater to electronic screens and filmmakers no longer control the temporal terms of cinematic representation. Free to assemble narrative elements according to their own will and liking, digital spectatorship in Haneke's view is a blueprint, an open invitation, for random acts of violence, and for violence as the purest expression of the random and nondetermined.

In both versions of *Funny Games*, Haneke's discontent with domestic and digital time shifting is directly imprinted onto the viewer—on us. To watch the film somewhere other than a theater's dark auditorium is to become complicit with Paul's effort to collapse the difference between violence and auteurism, between representation and the real. Similar to how we endorsed the film's violence when we—in spite of our better judgment—allowed Haneke's long take seemingly to take forever, so do we conform to Peter and Paul's identification of media control and random murder if we end up watching *Funny Games* on our domestic or mobile viewing devices and dare to reassemble the film's order and rhythm of time. Once again, Haneke heaps shame on the viewer. Once again, Haneke's ethics make us crawl into ourselves and, charged with self-contempt, feel mortified about our own susceptibility. Once again, Haneke tells us to keep our guard up at all times, not to drift, let go, or trust in the possible care of others. Once again Haneke seeks to teach us that neither cinema nor digital spectatorship has anything wondrous to offer—anything that in the mode of aesthetic experience would allow us to think beyond the present's regime of strategic reason and atomizing self-management.

Haneke's rigorous ethic of the long take, all things told, formulates no less and no more than a mere negative to Mulvey's positive. If Mulvey places too much trust in the democratizing powers of digital technologies while hanging on to some of the central credos of modernist film theory, Haneke in the very name of modernism associates postcinema with violence and mind-numbing consumption, the mass-cultural leveling of difference, sense, and sensibility. What both jointly uphold, however, is the vision of the viewer as an active, ceaselessly attentive, and interventionist participant, an autonomous manager of meanings and pleasures, whereas the true challenge today—amid a neoliberal culture of 24/7 screen interactions—would be to rethink spectatorship beyond paradigms that have come to feed on and into the very culture it once sought to defy. Both Haneke (overtly) and Mulvey (tacitly) continue to think about contemporary visual culture and its proliferation of screens and images from the normative standpoint of the classical cinematic auditorium. Their thoughts about the politics of spectatorship remain loyal to a time when cinema had a monopoly over moving images, when the darkness of the auditorium allowed critical filmmakers to develop disruptive forms of visual engagement—a didactic and often affectless aesthetic of negativity meant to challenge the spectacles of commercial cinema. Mulvey's and Haneke's viewers, expected to be vigilant at all times, have little left to remind them of the freshness and disruptive force of the wondrous. These viewers' surfeit of intentionality and willfulness not only causes them to encounter moving images as if they no longer had the capacity to surprise the human eye but also precludes them from what the extended durations of long-take work in most of the other projects discussed in this book are all about: to unlock spaces of perceptual drift and roaming that—like sleep—remind us of our reliance on the care of others, our urge for sociability; and that—like nightly slumber—cannot be fully mobilized for the sake of late capitalism's logic of self-management and its disruptive demands for incessant actions, choices, and feedback.

THE WONDERS OF BEING STUCK

Pendulum Aesthetics

The camera holds steady for almost thirty minutes—video recording technology allows one seamless take. What we see is a dirt road that, after an initial decline, leads up to a ridge perhaps 200 yards away from the camera. A few gray houses hug the slope to the left and right; some cars are parked in front of these dwellings. We are unable to tell where the road will lead beyond the ridge, so are we unable to anticipate what may happen if one used a small turnoff to the right at the bottom of the hollow. Though emphasizing passage and mobility, the visual field is severely limited—boxed in, as it were. An abandoned car seat is sitting on the road, awaiting a pedestrian to take a rest or a playing child to turn the world into an object of the gaze. Various power and telephone lines crisscross the upper half of the image yet do not make us think much about what may reside beyond the nearby horizon.

We will notice and explore all of this, however, only upon second look. For what will bond our attention first is the sight of a red VW Beetle, the kind from the early 1970s and built in Mexico with little modification all the way through the 1990s. Though perhaps one of the most robust passenger vehicles ever constructed, this red Beetle does something strange and surprising: it first climbs the slope on the far side of the road's depression, then suddenly loses its speed and simply rolls back down the slope again toward the camera. It even uses its kinetic

energy to roll—with idle motor—up the hill on the near side of the camera before the driver eventually reengages the clutch and repeats the entire process, a curious dialectic of mobility and standstill, effort and failure.

The shot's static frame and extended duration offer the viewer ample time to search for some kind of logic behind the Beetle's seemingly erratic movements, its indulgence in repetition, its performance of nonachievement. Twentieth-century futurists once celebrated the car as a prime symbol of modern speed. Automobile culture was to liberate the weary bourgeois subject from the burdens of the past and usher them into a new era of exhilarating progress.[1] Little of this modernist excitement is left when it comes to the red Beetle, its driver causing it to play the role of a pendulum. It won't take too long, though, for the viewer to understand that the car's failure to live up to modernist expectations of mobility is by no means caused by a weakness of the engine. Instead, the car's swings follow a precise choreography, a protocol communicated to the driver through a diegetic tape recording to which the audience is privy in the form of the video's nondiegetic soundtrack. What we hear is a brass band's rehearsal session. Whenever the musicians play to perfect their *danzón*, the car driver presses the gas pedal so as to drive forward and climb the hill; whenever the musicians pause or trip out of synchronicity, the car will come to a stop; whenever the musicians tune their instruments or simply pause to chat, the driver decompresses all pedals and allows the car to roll freely downhill along the dirt road. With the entire musical piece never played in one continuous take, failure is thus built into the car's path of progress. As they rehearse yet never complete the Creole, Cuban, and Mexican version of a contra dance, the musicians (unknowingly) force the car to suspend its journey—to remain stuck in the hollow, forever swinging back and forth, never crossing the ridge and thereby fulfilling our most intuitive expectations.

Long-take cinematography has often been associated with a certain realism of the acoustical. Extended shot durations are to gather the sounds of the profilmic like a magnet attracting

everything metallic around it. While the visual frame itself might be static, the classical long take has been hostile toward choreographed, subjective, or meticulously shaped sounds. Its ears are wide open to whatever sonic event may enter, traverse, remain outside, or emanate from within the visual frame. Time is given to the free travel and multidirectional nature of the acoustical, while little space is granted to allow diegetic or non-diegetic sound to destabilize the image or set up an entirely in-dependent stream of signification. Few examples come to mind using long takes to experiment with dialectical sound. Even acrobatic long takes, like the opening shot of Orson Welles's *Touch of Evil* (1958), submit the auditory field to whatever may be seen on or rendered invisible by the screen—that is, to nes-tle even stray sounds, mechanically recorded sounds, and off sounds (what Michel Chion calls the acousmatic[2]) back into the long take's extended exploration of the visual field. It's the bombs ticking that, though mostly invisible, at once anchors and is being anchored within what we see when Welles's cam-era approaches the Mexican–American border.

The video's red Beetle is close to but will never reach the same border whose authority caused Welles to unchain his camera and design one the most famous moving shots of cinema history. The artist's use of sound clearly upsets what we know and expect from the acoustical repertoire of twentieth-century long-take filmmaking, for sound here, far from merely being witnessed, gathered, contained, or authorized by the frame of the image, literally occupies the long take's driver's seat. Whatever moves, moves because audio—played through the car's tape recorder and via the video's soundtrack to us—demands and controls it. Whatever will attract our attention in the image only does so because sound here breathes life into it, even if it withholds any triumphant disappearance of the car from the visual field. Sound in the video's long take is genera-tive. It produces the visible. It calls forth space and time. It de-fines space-time as a realm of suspension and the iterative, of arrested development, rather than of trajectorial passage and teleological progress.

Rehearsal I (El Ensayo) (1999–2001) (Figure 25) is one of various interventions by Francis Alÿs that interrogate the uneven temporalities of modernization: the hopes and disappointments as they emerge when Latin American countries try to remake themselves in the image of their wealthy North American neighbors. Born in Belgium in 1958, Alÿs lived and worked in Mexico City since the mid-1980s. He is best known for performances that challenge the organization of urban space and redraw the contours of social encounters across given borders and divisions. In *Paradox of Praxis 1 (Sometimes Doing Something Leads to Nothing)* (1997), Alÿs pushed an ice block through Mexico City until it melted away, commenting on the hardships of unproductive labor while at the same time questioning the austerity of minimalist objects. In *When Faith Moves a Mountain* (2002), Alÿs mobilized about 500 volunteers in the outskirts of Peru's capital, Lima, not only to shovel a sand dune by a few inches but also to create a whole new network of collaborations and stories to be told. In 2004, Alÿs walked a leaking can of green paint along the demarcations that divide Jerusalem into Jewish and Palestinian quarters, thereby exploding the act of painting into political space as much as probing how things political may take on poetic qualities. And in *Don't Cross the Bridge before You Get to the River* (2008), Alÿs asked dozens of kids, model sailboats in hand, to form a line into the waters from either side of the Straight of Gibraltar, intimating interchanges between different cultures and continents blocked by existing political mandates.

What is remarkable about Alÿs work is the fact that his interrogation of place, space, labor, and community never fails to inquire into the very medium used to carry out his interventions. While toying with the durational qualities of the walk as an artistic practice, *Paradox of Praxis 1* questions minimalism's investments into the authority of objecthood, its association with the metropolitan, wealthy, and powerful centers of the global art trade. As he walked his can of paint through politically contested geographies, Alÿs made us think about the very act of painting and drawing, about how to expand marks and lines

Figure 25. Francis Alÿs, *Rehearsal I (El Ensayo)*, Tijuana, 1999–2001, in collaboration with Rafael Ortega. Video, 29 minutes, 25 seconds. Courtesy of David Zwirner, New York/London.

beyond canvas, studio, gallery, and museum. Never shy to put his own body and physical well-being on the line, Alÿs's work explores the contours of time art in both senses of the word: it enfolds the power of time and flux, and of often conflicting temporalities, into whatever you might want to call the artistic work; it examines, stages, and/or debunks art's very location in time, be it the contentious time of the political or the time of the finite body.

The relentless long take of *Rehearsal I*, as it invites us to shift our attention ever more from what we see to what we may hear, and, as Alÿs put it himself, "from the finality of the action to the act itself,"[3] certainly reflects Alÿs's ongoing concerns with the temporality of the aesthetic, with art's staging of time in space. *Rehearsal I* echoes and anticipates other work carried out with the help of a VW Beetle. In *Game Over* (2011), Alÿs crashes a VW Beetle at considerable speed into a tree before

exiting the car and, dazed, walking away from the site of his aborted journey. In *VW Beetle* (2003), he pushes a car through the city of Wolfsburg, Volkswagen's German world headquarters, disrupting regular traffic patterns while exposing people's unwillingness to lend him a hand. *Rehearsal I*'s true companion piece, however, is another thirty-minute video entitled *Politics of Rehearsal* (2004), which offers a number of critical terms to illuminate the staging of arrested development in *Rehearsal I* and thereby the interlocking of political and aesthetic temporalities. Filmed in New York, the video captures the rehearsal of Schubert's "Nur wer die Sehnsucht kennt" (Only he who knows what yearning is), with Russian soprano Viktoria Kurbatskaya and pianist Alexander Rovang taking up the back area of small stage while a stripper, Bella Yao, takes off her clothes in the foreground whenever the musicians perform in unison and redresses whenever they discuss individual aspects of their recital. The film opens with the 1949 inaugural address of Harry Truman, in which he famously introduced the notion of underdevelopment so as to define normative templates of industrial modernization in a world of cold war tensions. Throughout most of the film, we hear critic and curator Cuauhtémoc Medina's voice as he ponders curious similarities between dominant notions of modernization and a stripper's at once arousing and delaying choreography of time.

According to *Politics of Rehearsal*, the promise of modernization, as it has been communicated to "underdeveloped" nations ever since Truman's cold war speech, resembles the logic of pornography. It stirs desire but will never grant fulfillment. It accelerates the present in the name of progress, yet it does everything at its disposal to transfix the subject in utter dependency and postpone whatever could approximate true gratification. Like a stripper's time, the temporality of modernization—as experienced by less developed nations—is deeply ambiguous and ambivalent, a Freudian game of *fort-da*, a permanent state of agitated suspension. Look, but don't touch. Yearn for what is to come, but hold on to what you have because you do not want the show to end. Or, in the words of the desperate lover of Goethe's

poem that subtends Schubert's song: "Oh! the one who loves and knows me, / Is far away. / I feel dizzy, and it burns / my insides. / Only one who knows longing / Understands what I suffer!" Like Goethe's lyrical subject desiring a dead lover, and like the spectator of a stripper at once awaiting and dreading the end of the show, the subject of underdevelopment is one who sacrifices experience and presentness to a deceptive concept of linear time, progress, and anticipated plenitude, well aware of the fact that his very yearning for future fulfillment burns the present and blocks any path to substantial transformation.

The VW's pendulum swings in *Rehearsal I* pursue a similar goal. Set near the border to the United States, they allegorize what "underdeveloped" subjects in this region experience on a daily basis: a certain suspension of experience caused by the ambivalent temporalities of modernization, by impossible yearning for the ideological specter of progress. Whatever may lure on the other side of the hill is no different from what the stripper promises, yet never extends, to the viewer. It arouses but also permanently delays fulfillment. Sometimes doing something, as the subtitle of Alÿs's pushing ice through Mexico City had it, indeed seems to lead to nothing. Yet because Alÿs's long take does not simply invite the viewer to explore the unexpected relationships between the visual and the acoustical but also defines a durational framework in whose context sound activates the visible, doing almost nothing leads to something after all. To remain stuck in the hollow opens a pocket of creativity and autonomy, of at once resisting and debunking the myth of linear progress and speed developed nations impose on "underdeveloped" ones to shape their imagination and desire. Alÿs's long take unravels how the West has come to sell wealth, progress, and development like pornographic material. It redefines space as the intersection of various temporalities, and not just as a point from which to draw straight vectors into the future. The car's suspension, then, doesn't simply stage a painful failure to live up to normative Western models of progress. Instead it articulates noncompliance with the existing templates of social growth and urges the viewer to envision al-

ternative models of development—models that resist the stripper's politics of arousal and delay; models that approach space as more than a mere container for forward passage and time as more complex than merely measuring one's pace toward the future; models that understand the present as a site charged with unforeseen connections, unpredictable relationships, and unexpected wonders independent of what dominant ideologies of progress might expect. Similar to Sisyphus in Albert Camus's famous reading, we must imagine Alÿs's car and driver as instantiations of happiness. They are in revolt. As absurd as their struggle with road, hill, music, and expectations of progress might seem, what they do is reclaim the durational as a space of creativity, as a strategy of presentness and contemporaneity that produces rather than denies experience and life, that reconstructs the possibilities of unconditional wonder.

Reel Aesthetics

"Cinema is something I don't know at all. I adore it, but it's not my language," Alÿs declared in 2013.[4] Resisting closure and completion, Alÿs's work wants to engage his audiences in open-ended conversations. It often eschews interpretation, and although it crosses different mediums and platforms, it tends to reckon with its own transience, its vanishing, the impossibility of capturing its poetic energies and political ambitions within a time-proof container. In Alÿs's perspective, the language of narrative cinema is hostile to what is speculative, probing, and ephemeral about his work. Cinema freezes and disciplines rather than sets free unruly emotions and forces. Cinema structures time and mummifies change rather than producing them in the first place. Cinema is about watching, not doing. We may adore it, but it is of little use to mark, unsettle, tear down, or reconstruct the physical architectures of the everyday.

Or at least so it seems. For with his 2011 piece, *Reel/Unreel* (Figure 26), Alÿs clearly entered the domain of narrative cinema, not only showing that there is more than one language to cinema today but also exploring an alternative notion of the

long take, one that belongs to the profilmic world rather than to how cameras may capture ongoing events for extended durations, so as to give—to quote Jacques Rancière's words about Béla Tarr—"the visible the time to produce its special effects."[5] A boy, using a wire with great skill, rolls a discarded bicycle tire along a dusty road at the edge of contemporary Kabul, Afghanistan, until it escapes down the hill. A helicopter flies by, and another boy, shown in close-up, frames it with his fingers like an experienced cinematographer. Almost three minutes into the film, we cut to a third boy—like the others dressed in traditional attire—running down the road. His hands propel a red film reel and make it roll with impressive smoothness right beside him. As the boy rotates the reel, he causes 35mm film to unreel from the spool, thus leaving a continuous trace along his path. We see other boys following the runner with great enthusiasm and noise. We see the strip of film sliding across the road, horses and mules almost stepping on it. We cut to yet another boy, all dressed in black. He is almost as adept in rolling his powder-blue film roll as the boy in white. He too is followed by a crowd of kids. After a few seconds, however, we come to realize that his task is the reverse of the earlier boy's: to spool 35mm film onto a reel. Crosscutting between both boys, the respective throngs of followers, the sight of the road and neighborhood, and the image of the moving image film strip itself, Alÿs's film will take some time before fully confirming what we suspect all along: the boys' race revolves around the same unbroken strip of film. What the boy in white unreels, the boy in black is to respool, the first boy's greater adeptness allowing him not only to gain ground but the trace of strip of film to grow in length before it will be removed again by the second boy's action. Thus, for more than fifteen minutes, we follow the two boys' game through various streets and markets in the outskirts of Kabul as they mark and unmark space, as they map and unmap a city whose everyday life appears remarkably ordinary in spite of its relative poverty and the political pressures indicated by the military helicopter in the film's opening passage.

In stark contrast to *Rehearsal I, Reel/Unreel* involves considerable efforts of staging, editing, and postproduction to

Figure 26. Francis Alÿs, *Reel/Unreel,* 2011, in collaboration with Julien Devaux and Ajmal Maiwandi. Screenshots from public domain video available at http://francisalys.com/reel-unreel/.

dramatize what we see on screen. The film relies on many takes (and probably even more retakes), none of which lasts any longer than what we know from conventional cinematic fare today, while all of them reveal considerable familiarity with constructing—like mainstream cinema—spatial and temporal continuity, causality, and orientation. In a strict sense, then, *Reel/Unreel* has no place in any consideration of the long take as a mode of contemporary art cinema. *Reel/Unreel* does not delay cuts and probe the viewers' attention; nor does Alÿs's film give us any reason to believe that both boys race a piece of film strip through Kabul that contains some unusually long shot durations. Yet what the boys' seemingly absurd game is all about is nothing other than, with the help of the materiality of film, generating durational experiences—a playful sense of connectedness and continuity, of sociability and temporal boundlessness, that folds circular and linear notions of time into one dynamic unity. As they simultaneously unreel and respool a continuous strip of celluloid, these boys use film as a medium to generate the potential infinity of a Möbius strip. Just as important, their production of looped time goes hand in hand with unlocking a path through the city, one in which repetition and difference figure as two sides of the same coin. Repetition in fact generates difference, as much as the boys' incredible speed here enables a sense of open-ended suspension, of association rather than rupture, of slowness as a strategy of intensifying perception. Alÿs films the boys as if camera and editing were infected by the boys' physical velocity. What the boys establish with their game, however, is a different regime of temporality: a type of time that prioritizes the non- or multi-directional duration of play over the strategic temporality associated with both the causal drive of narrative cinema and the exigencies of self-preservation and self-maintenance.

The long take's location in *Reel/Unreel*, then, resides not in the act of filming but in the strip of film itself, the way in which the objecthood of the 35mm film helps stretch time across a variety of spaces and stitch together a multitude of different perspectives. Unlike long takes meant primarily to showcase

the ingenuity of the filming process, *Reel/Unreel* defines the durational less as an experience reserved for and to be consumed by the viewer than as something that emerges from the spaces of the profilmic, the lives, practices, and interventions of his protagonists. Consider, by contrast, Alexander Sokurov's *Russian Ark* (2002), which travels through 300 years of Russian history as the camera steadily drifts through the Hermitage in Saint Petersburg. Recorded onto a hard drive rather than with conventional film stock, Sokurov's ninety-six-minute take necessitated a meticulous choreography of over 2,000 actors and three orchestras to synchronize the movements of the camera with the slices of Russian history to be reenacted in thirty-three different halls of the palace. Sokurov thus lined up historical characters and events like beads on a string, but the viewer's astonishment has less to do with the protagonists' own being in time than with the auteur's colossal effort to synthesize what resists synchronization. "How did they possibly do it and succeed with this?" is the viewer's primary expression of curiosity when watching *Russian Ark*, dazed by how the camera manages to absorb different epochs into a single stream, and in awe about the massive work it must have taken to carry out all this without resorting to special effects. The awe we feel about Sokurov's acrobatic camera work lets us forget that every act of filming and diegetic staging is of course as much of a special effect as the expert use of postproduction tools. *Reel/Unreel*'s agenda could not be more different. Alÿs's project is to show us how his protagonists embrace the materiality of film to engage the durational in the face of considerable pressures to do otherwise. The efforts and pleasures of the durational are all theirs, not ours, to be consumed from a self-effacing distance. Time is on their side, not, as in Sokurov's heroic auteurist project, ours.

Yet even the infinity of looped time in Alÿs's work doesn't run forever. The camera shows a fire by the roadside. When Boy One passes by, the strip of film is drawn through the flames. Boy Two arrives too late to avoid the film's catching fire; it melts down in the middle and separates into two, which effectively ends the race and game. For some of the other boys who earlier

chased our two contenders, however, the real fun seems to begin now. Once the credits have finished, we see them sitting next to the road, perusing individual frames of the damaged film: "Here all these people are locked up," they repeatedly shout, amused by cinema's mummification of movement, the fact that individual frames do not add up to cinema's illusion of motion. "Here a man is standing and the rest is scratched, half remains blank," one boy comments after carefully inspecting the material in front of him. Reversing the wonder of early cinema's viewers who indulged in the apparatus's ability to set images into motion, the boys' astonishment is directed at no less than the discrepancy between our knowing of film as an art of movement and the objecthood of film, its base in separate frames and cells that seem to lock mobility. Cinema is a special effect, no matter what happens behind or in front of the camera. We marvel at how projectors endow the screen with life, but we may as well marvel at how a strip of film seems to be able to freeze movement and speed, and thus deliver images of bodies in time in unexpected ways to our curiosity.

The story of *Reel/Unreel*, and Alÿs's foray into the foreign land of cinema, however, remains incomplete without any reference to what is communicated in the form of white Arabic letters against a black screen during the film's final title sequence: "On the 5th of September 2001, the Taliban confiscated thousands of reels of film from the Afghan Film Archive and burned them on the outskirts of Kabul. People say the fire lasted 15 days. But the Taliban didn't know they were mostly given film print copies, which can be replaced, and not the original negatives, which cannot." Deeply steeped in dogmatic thought, the fundamentalists of the Taliban revolution erroneously grafted the legacy of auratic art onto the scenes of technological reproducibility. As a result, they took copies for originals and treated the objecthood of film as if it were everything cinema was all about. The kids of Kabul know better. They may play with film as if it were in no need of projection. But in doing so, they poke fun at all those who take the objecthood of film as film's sole mode of existence—as an object whose sheer physical being

could produce blasphemous effects. For the kids of Kabul, there is something wondrous about seeing bodies being stuck in individual film frames when everyone knows that cinema is about setting images into motion. For them, the wonders of cinema emerge from in between what we touch and what we see, what we know and what we believe to see. In its very zeal to discipline people's imaginations, fundamentalist doctrine misreads what every kid knows all too well: the wondrous and hence the unpredictable happen not when objects take hold over our imagination, but when we start to drift within and beyond the given orders of time.

Miracles on Dirt Roads

"Cinema," André Bazin famously claimed in the early 1950s, "is in itself already a miracle"[6]—only to then go on to celebrate cinema's catholic powers to engage the viewer's faith and belief, not purely in what we see on screen but in how cinematic images may relate to the world they render visible. For Bazin, the wonders of cinema emerged from the unique ability of modern machinery to make us discover unexpected aspects of the visible world as if no mediating subjectivity existed. Cinema approached theology because it had the potential to make viewers at once witness and believe in the distinct and incommensurable objectivity of the world before the camera. As Monica Dall'Asta writes, "Unlike any other of the visual arts, cinema, under certain conditions, can make the spectator aware of the original unrepeatability that rests at the core of reproducibility itself, encouraging the perception of the uniqueness of the events reproduced and the re-presented on the screen."[7] One aside other techniques of cinema to accomplish this was the use of the long take: a sequence shot that constructed an event in front of the camera while respecting its spatiotemporal coherence and unity. Sequence shots, in Bazin's understanding, invited spectators to explore the authenticity of what is seen on screen. As they equated the duration of the actual event with the duration of its representation, sequence

shots encouraged an aesthetic of discovery, a curiosity about the singularity of the event powered by the belief that we can climb on the ladder of the image beyond it.

Alÿs's use of the long take at once references and moves beyond Bazin's theology of the cinematic image. Whether he pictures a VW oscillating up and down a hill or Afghani kids propelling film reels through Kabul, Alÿs makes us think of the long take today as something no longer merely meant, in the name of realism, to communicate the singularity and present-ness of a certain event—its aura, as it were—through the channels of technological reproduction. The durational here instead serves as a medium to explore and, yes, embrace the complexities, the layeredness and multiplicity, the copresence of linear and circular models of time under conditions of "underdevelopment," poverty, and political repression. Long takes picture a world in which dominant ideas of progress have eradicated the auratic, but which continues to promote the promise of abundant presentness as an ideological tool to keep the disempowered in states of disempowerment. Alÿs's long takes are miraculous not because they make us believe in film's ability to transcend worldly immanence but because they reclaim time from those who in the name of development and fundamentalist reform take time away from us. Long takes here offer models of the world in which we can think of repetition and difference, the linear and the recursive, as part of a single dynamic. They display space as a playful meeting ground for multiple temporalities and speeds, memories and expectations, as a site that not only needs to shed but also actually has the very power to suspend chimeras of teleological progress. Cinema is a language. Today, however, it speaks in different tongues than those who once wanted it to picture life as if seen through the eyes of God. Cinema is miraculous whenever it unlocks time in all its diversity from the hold—the frames—of control and ideology, the asymmetries of power in today's globalized world.

(UN)TIMELY MEDITATIONS

Framing Space and Time

Asked about his iconic use of extended shot durations, Thai director Apichatpong Weerasethakul ruminated in 2008, "They are not really long for me. When I watch my films during editing, I like the pace like that. But when I watch long takes in others' films, especially Asian ones, I get impatient! I keep dreaming about other angles. So maybe that's the trick, to make the audience dream."[1] Far more than a mere tool of observational realism, long takes—according to Weerasethakul—energize attitudes of drift and dreaming. They play with the viewer's desire to see the world from a different perspective and make us wonder about alternative representations of the real: parallel worlds, double lives, and second chances. However static a long take might be, it probes cinema's very authority of framing. It draws our attention to the screen's function as a window onto the world as much as it activates our curiosity about a screen's ability to conjure the sensible while blocking other possible perceptions. As mediums of active dreaming, Weerasethakul's long takes do what all good art does: they teach us new ways of seeing the world. If montage cinema once placed its bets on the space in between individual shots to mobilize the audience, long-take cinematography engages the viewer's imagination by simultaneously drawing on and pushing against the defining power of the frame, its ability to set boundaries as much as its capacity of carrying viewers to other times and places.

Recall one of the early shots of Weerasethakul's 2006 *Syndromes of a Century*, eventually used as a backdrop for the film's title roll (Figure 27). After we first witness a rather curious indoor conversation between a female doctor, a male doctor interviewing for a hospital job, and a shy man wooing the female protagonist, the camera now shows us a green tropical landscape as seen through a glassless window. As we hear the voices of the film's protagonists in the background—they are about to have lunch—the camera slowly pulls forward until the architectural framing recedes from the picture and all that is left is the stark geometry of the landscape: a narrow band of trees separating the sky from a green field; a small house on the left; a path cutting through the field, adding another almost horizontal line to the composition. The shot lasts for almost three minutes. We listen to the voices in the off as they will eventually abandon their diegetic roles and—much to our astonishment—slip into what amounts to a conversation among actors discussing their current film project. In the final stretches of this long take, we witness the film's titles printed in white on top of the image in such a way that the writing becomes yet another aspect of the landscape's delicate composition. The path's line in the field is used to set names and functions apart; the typography neatly inhabits the left portions of the field; the words perfectly align themselves with the edge of the house in the background. In spite of its static frame, Weerasethakul's long take thus blurs the line between the diegetic and the nondiegetic, between interior and exterior spaces, between nature and civilization, between the cognitive and the affective. His frame produces the conditions for the possibility of displaying the world as an array of sensible things as much as it offers us ample time to question this frame's very role in defining the lines between what is on and what is off, what is near and what is far, what is in motion and what appears to be still, the found and the created.

"I regard sound as being very important, more essential than pictures," Iranian filmmaker Abbas Kiarostami once mused, much to the surprise of those who celebrate the photographic

Figure 27. Apichatpong Weerasethakul, *Syndromes of a Century*, 2006. Screenshots.

compositions and painterly qualities of his long takes. "A two-dimensional flat image is all you can achieve with your camera, whatever you may do. It's the sound that gives depth as the third dimension to that image. Sound, in fact, makes up for this shortcoming of pictures. Compare architecture and painting. The former deals with space while all you have in painting in surface."[2] In Kiarostami's perspective, extended shot durations straddle the line between the photographic and the filmic, between two-dimensional flatness and impressions of spatial depth. Sound inscribes the off in what each frame defines as the visible. In doing so, it does not simply remind us of what we do not see or allow us to speculate about what might be to come, but also encourages us to explore what is truly architectural about the cinematic experience—its ability, by engaging multiple sensory systems at once, to situate viewers in three-dimensional environments. According to Kiarostami, sound renders substantial what Christian Metz once called the subtle aspects of the photographic off.[3] It invites us to see the visible world as one of ongoing connections, stories, transformations, and blockages. Sound defines the cinematic frame as a medium to produce unsettling perceptions of presence and absence, here and there, now and then. It defines space as something neither a film's characters nor their viewers can ever fully own, inhabit, or master—something that exceeds our control and that is charged with multiple temporalities and stories to be told.

Though often sparse in sound and known for their long stretches of silence, Kiarostami's films since the mid-1990s have consistently enlisted the acoustical to probe the borders of the cinematic frame and complicate our relationship to the geographies of the everyday. Nowhere has this perhaps been done more rigorously, and with greater reliance on extended shot durations, than in Kiarostami's 1999 *The Wind Will Carry Us* (Figure 28). The film tells the story of a director who is trying to make a film about the burial rites in an Iranian village and whose unsuccessful waiting for the anticipated death of an old villager is repeatedly interrupted by impatient cell phone conversations with his Tehran-based producer. Throughout

the film, Kiarostami systematically rejects the dominant language of narrative cinema: he refrains from shot/countershot techniques as much as he avoids point-of-view perspectives and conventional reaction shots. While each shot is carefully composed, the sound of unknown voices repeatedly enters the frame from the off, only to simultaneously destabilize and dynamize the visual field. A man digging a hole will speak with our director without ever being seen. We witness various conversations between the protagonist and his team through car windows, but at no point do we actually see the team members' faces. Verbal exchanges across patios and rooftops take place between the urban visitor and various local dwellers without us ever being able to integrate the film's diegetic space. The camera follows the protagonist during repeated cell phone conversations as he rushes to an area of viable reception, his hearing tied to sounds that originate in some unknown elsewhere, his body unaware of what may happen directly around him. The film's tensions between the rural and the metropolitan, the modern and the premodern, are thus played out by sound's unique ability to place pressure on the integrity of the cinematic frame. To the extent to which Kiarostami again and again delays the cut, the film's sounds enable the off to hover between the subtle and the substantial, and in this way to allegorize the logic of displacement, uneven modernization, and temporal incongruence that structures the film's overall narrative.

This chapter argues that long takes have taken on a crucial role in contemporary screen practice to investigate the intermingling of different temporalities and incongruous spaces often associated with recent processes of globalization. Drawing our attention to film's framing of the sensory field, extended shot durations explore the transactions between and mutual implications of the local and the global in our twenty-first century of accelerated flows, be they of goods, bodies, data, technologies, ideologies, or meanings. It would certainly be tempting to discuss the work of directors such as Angela Schanelec (*Marseille*, 2004), Jia Zhangke (*Still Life*, 2006), Lisandro Alonso (*Liverpool*, 2008), and Nuri Bilge Ceylan

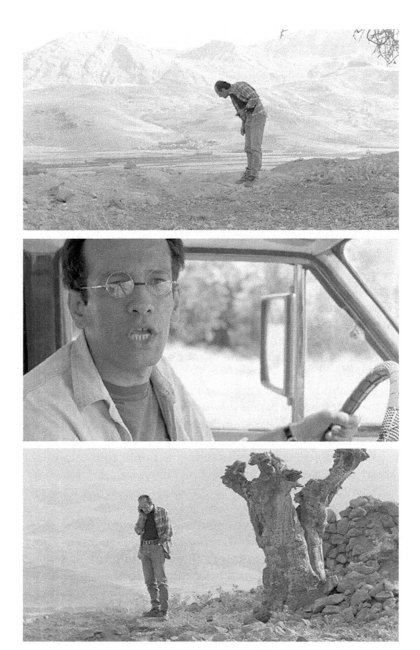

Figure 28. Abbas Kiarostami, *The Wind Will Carry Us,* 1999. Screenshots.

(*Once Upon a Time in Anatolia*, 2011; *Winter Sleep*, 2014) to carry out this argument. The particular and often challenging slowness of their films provides ample material to situate the long take as a medium to reframe and recalibrate the drive of global speeds and technological transformations. Yet the aim of what follows is more ambitious. My focus will be on various works by Apichatpong Weerasethakul and Abbas Kiarostami, not simply because both directors uniquely use extended strategies of framing space and time to engage our sense of curiosity and wonder about what remains beyond the frame, but because their work asks profound questions about what we want to consider a long take today in the first place. While Weerasethakul's and Kiarostami's long takes encode at the level of form contemporary tensions between the local and the global, what is of crucial interest here is the fact that both filmmakers map our global now as a moment that unmoors the very home and ontology of the traditional long take. In Weerasethakul's and Kiarostami's work, long takes serve as aesthetic strategies of the contemporary precisely because they travel across different media platforms and assume various shapes and sizes beyond the regimes of twentieth-century spectatorship.

Degrees of Complexity

In "The Virtues and Limits of Montage," André Bazin famously endorsed long-take cinematography because it aligned the duration of certain shots with the duration of the diegetic action and in so doing produced impressions of the real. As they warranted the spatial and temporal unity of the action, Orson Welles's or Robert Flaherty's sequence shots situated the viewer not simply in front of projected images but as part of events, as if they had presented themselves in time to the camera itself. Long takes privileged continuity over rupture, with the effect of sharpening the viewer's observational attentiveness and desire for discovery. Yet for Bazin, to argue for durational camera work meant neither to abandon fiction for the sake of documentary modes of filmmaking nor to flatten the complexity of moving

images so as to invite meditative acts of viewing. On the contrary. "What is imaginary on the screen," Bazin wrote, "must have the spatial density of something real."[4] Done properly, as for instance in the seal sequence of *Nanook of the North* (1922), long-take cinematography had the unique power to record reality as a force field of individual elements—an interplay of diverse activities, trajectories, and settings whose interdependence defined the uniqueness of what may count as an event in the first place. Rather than reduce complexity, sequence shots effectively framed the world as a site of intricate interactions. They allowed us to witness and enter imaginary worlds because they displayed the complexities of ordinary life.

Bazin's call for a diegetization of complexity neatly outlined what many European auteurs of the late 1950s and 1960s aspired to when slowing down the drive of narrative time and questioning the normativity of modernist concepts of montage aesthetic. According to David Campany, to be slow in the postwar period was to challenge the disasters that modern speed and mass distraction had authorized in the first half of the twentieth century: "To be radical in this new situation was to be *slow*. A stubborn resistance to the pace of spectacle and money-driven modernization seemed the only creative option and it came to characterize the landmarks of art and film in the latter decades of the last century."[5] To be sure, the slowness of Antonioni's long takes may have sought to frame nothing less than the presence of painful absences. Think, for instance, of the extended search for someone never to be found in *L'Avventura* (1960) or the final shots of *L'Eclisse* (1962), mapping the empty space of a date both protagonists decide to forfeit. And Miklós Jancsó's often "rhapsodic camera,"[6] as it endlessly traveled through diegetic space and tended to open up often surprising portals for characters to enter the frame from the off, may have aimed to reveal the extent to which the density of diegetic space resulted from and was an effect of the work of the camera itself, a special effect rather than a property of the real. But Bazin's stress on the durational as a critical frame for complexity, an antidote pitting the sensibilities of national art

cinemas against the speed of Hollywood's global spectacle and distraction, remained central to these postwar masters of the long take, even or precisely when they—like Antonioni—were eager to depict modern alienation as the event of an absence, a nonevent uniquely located in the continuity of space and time.

As much as European film festivals have been essential since the 1990s to promote Asian filmmakers such as Hou Hsiao-hsien, Edward Yang, Tsai Ming-liang, Kim Ki-Duk, Apichat-pong Weerasethakul, Jia Zhangke, and Abbas Kiarostami as auteurs of the global age, so have postwar concepts of European art-house cinema and Bazinian realism been deployed to present the slowness of their films as a continuation of what art cinema was once all about. Yet nothing could be more mistaken than to construct the formal rigor of their extended shot durations in terms of postwar auteurism. As Jean Ma and others have persuasively argued,[7] East Asian art cinema's experiments with the durational, rather than simply challenging the hegemony of Hollywood like Europe's postwar auteurs, register processes of uneven modernization and globalization across various national, regional, and cultural divides. If their auteur predecessors used long takes to interrogate the moral vacuum left after World War II, then extended shot durations after the end of the cold war capture the complexities of our global economy of flows, including the fact that what we have come to know as globalization since the early 1990s exceeds any assured effort to visualize the complex interplay of diverse forces, actions, causations, and movements across the borders of the nation-state. To go global is to live in multiple spaces and times at once. It is to encounter local spaces as reflexes of often invisible transnational dynamics, be they economic, social, or technological in nature; it is to experience the present as a multiplicity of incompatible temporalities, memories, and narratives; it is to encounter space as a nestled array of sensory and highly mediated data, a fold of various elsewheres amid the here and now. Bazin's charge for the long take as an armature of realism was to bridge possible gaps between life time and world time. As it hung onto the Aristotelian identity of place, time,

and action, the long take's mission was to map the present as a site of intricate yet readable complexity across time. Similar to how the bourgeois novel of the early twentieth century failed to capture the abstractions of industrial capitalism,[8] so does Bazin's observational long take today run up against certain limits when seeking to capture how global finance capitalism, with its accelerated and uneven temporalities of technological modernization, causes everything solid to melt into air, and how twenty-first-century globalization tends to abolish the human as a measure of worldly things and presents the desynchronization of life and world time, of space, place, and location, as the order of the new (neoliberal) day.

Well known for their rigorous attention to questions of framing movement across extended durations, the two filmmakers whose work is at the center of this chapter—Abbas Kiarostami and Apichatpong Weerasethakul—have played a central role in recent conversations about the locations of global (art) cinema. International film festivals and funding arrangements have established both directors as major presences amid the global circuits of contemporary cinema while their work has found less than enthusiastic recognition in their respective home countries. If we were to follow what defined national cinemas as national in the postwar period, we might be tempted to argue that labels such as Thai or Iranian, when used to modify their profession as filmmaker, are nothing other than international constructs used to define their place as art-house filmmakers; and that these directors' very focus on local textures echoes and feeds into their status as artists appealing to more universal audiences and critics. Yet what I argue in the pages to follow is, first, that both directors, in their use of the long take, pursue concepts of art cinema no longer attached to former concepts of the national and its presumed resistance to global cinemas of commerce and consumption; and second, that both directors, as they explore the long take as a medium to expand cinema beyond its traditional platforms, unframe cinema as we have known it and bring it into productive exchanges with other mediums of contemporary (moving) image culture.

However formal(ist) their role and design may be, Kiarostami's and Weerasethakul's long takes map space in time and install time in space, not simply to reveal the multiplicity of temporal streams that define our global now but also to explore complexities that exceed the cinematic frame—the frame of what we have come to call cinema. Though both directors choose quite different strategies, they investigate our state of contemporary globalization as one that redefines cinema's very ability to frame space and picture time. For both, twenty-first-century art cinema happens when moving image culture reflects on its own modes of framing time and investigates what it takes to look our historical moment of globalization straight in the face. In spite of their apparent untimeliness, Kiarostami's and Weerasethakul's long takes are nothing other than aesthetic strategies of the contemporary. They open up spaces to sense and reflect on the passing of time amid the 24/7 culture of global speeds that is all around us.

Still Moving

As mediums of transport and temporalization, both cars and cell phones play essential though opposing roles in Kiarostami's films. The former provide islands of privacy amid public spaces. They insert stillness into the heart of urban mobility, enabling conversation and thought within larger environments that at first appear fundamentally hostile to interaction and pensiveness. However fast they move, the interiors of Kiarostami's cars are sites of slowness and contemplation; and however much their seating arrangements resemble those of classical movie theaters, these cars' primary function is to encourage intimate reciprocity rather than voyeuristic consumption. When shown from the perspective of the passenger, Kiarostami's cars offer mobile frames onto a passing world; their rearview mirrors often invite us to witness multiple perspectives, trajectories, and temporalities within the same frame. Kiarostami's cell phones, on the other hand, insert other spaces and times into the integrity of the frame, thus marking the present as a site

of fractured attention and disorientation. Rather than successfully funneling verbal communication, mobile phones largely suspend conversation: our protagonists engage with answering machines or struggle with a lack of reception. Whereas automobiles in Kiarostami's films operate as agents of territorialization amid the flux of forward movement, mobile phones subtract their users from their physical surroundings, yet precisely in so doing fail to make them move effectively toward the future or recognize the passing of time to begin with. As mediums of accelerated viewing, Kiarostami's cars cause viewers to focus on the resonances of spoken language; as mediums of acoustical expansion, Kiarostami's cell phones ask us to explore the limits of the visual field.

No film engages this push and pull between automobile and mobile phone more effectively than Kiarostami's 2012 *Like Someone in Love*. Set in Tokyo, the film tracks a two-day affair between a young student and part-time prostitute, Akiko (Rin Takanashi), and a retired professor, translator, and widower, Takashi Watanabe (Tadashi Okuno). While it remains unclear whether they sleep with each other during the first night of their relationship, Takashi eagerly takes care of Akiko, not least of all to protect her from her abusive boyfriend, at whose hands Takashi will presumably die in the final shot, when a brick pierces the window frame of Takashi's apartment and hits the elderly academic. Yet the distance between the film's two central figure could not be bigger. He is a man of books, cherished memories, limited mobility, and cultivated privacy; she is a woman close to being a digital native, familiar with her technological devices, never shown in any space resembling a steady home, always on the move, with little attachments to the past and no real commitments to the future. Whatever both bring to the table of their encounter appears tied to fundamentally different times and spaces—or, if you wish, historical eras and even world ages. Whereas Takashi seems to live a timeless life of the mind and thrives on his deep knowledge of (the texts of) various histories, Akiko has her eyes on the speed of the passing present—so much so that she finds no time to respond

to her grandmother, who, during a visit from the countryside, wants to meet her grandchild and who leaves numerous messages about possible locations for a meeting on Akiko's mobile voice message system.

Shot as a series of pensive, at times starkly frontal, at times enigmatically angular long takes, *Like Someone in Love* relies heavily on cars and phones to stage the dynamic of and between these two worlds. Automobiles provide settings for emotional intensity, reflectiveness, and reciprocity, as well as the shedding of what makes us take on stylized identities in public life; mobile phones, on other hand, decenter the subject, unmoor body and mind as much as the cinematic frame itself, and invite other times and spaces to unsettle the here and now. In one of the film's most exquisite sequences, Kiarostami folds these two dynamics into each other, thus allegorizing the very effort of contemporary art cinema to serve as a strategy of the contemporary, a medium reflecting on the framing and unframing of time under the condition of global acceleration (Figure 29). The sequence in question, which is almost ten minutes long, shows Akiko in the rear seat of a limo, to be driven—against her initial will—toward her next job (which will turn out to be Takashi). The camera's close-up give us plenty of time to study her face and eyes as they peruse Tokyo's street life at night, while the shot's composition leaves enough space to witness what Akiko has just seen through parts of the rear and side window. We see, with a slight delay and in the reverse direction, what had initially captured her seeing; we thus see her seeing. Yet though her eyes actively track the passing reality, her mind is clearly focused on the voice of her grandmother, whose repeated messages Akiko, with earbuds in her ears, extracts from her voice mail system—acousmatic sounds in Michel Chion's sense,[9] whose presence on the diegetic soundtrack subtract Akiko from her physical surroundings as much as they encapsulate her in a perceptual cocoon within the frame of the shot. The experience of seeing Akiko listening, or of listening to Akiko seeing, is as disjunctive for the viewer as is Akiko's inhibition to call her grandmother for the protagonist herself. The

Figure 29. Abbas Kiarostami, *Like Someone in Love*, 2012. Screenshots.

tears that well up in her eyes index the price it takes to sever traditional family bonds for the sake of living the life of an urban contemporary.

At once static and mobile while capturing Akiko's torment in the car's interior, the camera will eventually direct its gaze outward with a prolonged point-of-view shot that circles around a public sculpture in front of the train station. Its true

to her grandmother, who, during a visit from the countryside, wants to meet her grandchild and who leaves numerous messages about possible locations for a meeting on Akiko's mobile voice message system.

Shot as a series of pensive, at times starkly frontal, at times enigmatically angular long takes, *Like Someone in Love* relies heavily on cars and phones to stage the dynamic of and between these two worlds. Automobiles provide settings for emotional intensity, reflectiveness, and reciprocity, as well as the shedding of what makes us take on stylized identities in public life; mobile phones, on other hand, decenter the subject, unmoor body and mind as much as the cinematic frame itself, and invite other times and spaces to unsettle the here and now. In one of the film's most exquisite sequences, Kiarostami folds these two dynamics into each other, thus allegorizing the very effort of contemporary art cinema to serve as a strategy of the contemporary, a medium reflecting on the framing and unframing of time under the condition of global acceleration (Figure 29). The sequence in question, which is almost ten minutes long, shows Akiko in the rear seat of a limo, to be driven—against her initial will—toward her next job (which will turn out to be Takashi). The camera's close-up give us plenty of time to study her face and eyes as they peruse Tokyo's street life at night, while the shot's composition leaves enough space to witness what Akiko has just seen through parts of the rear and side window. We see, with a slight delay and in the reverse direction, what had initially captured her seeing; we thus see her seeing. Yet though her eyes actively track the passing reality, her mind is clearly focused on the voice of her grandmother, whose repeated messages Akiko, with earbuds in her ears, extracts from her voice mail system—acousmatic sounds in Michel Chion's sense,[9] whose presence on the diegetic soundtrack subtract Akiko from her physical surroundings as much as they encapsulate her in a perceptual cocoon within the frame of the shot. The experience of seeing Akiko listening, or of listening to Akiko seeing, is as disjunctive for the viewer as is Akiko's inhibition to call her grandmother for the protagonist herself. The

Figure 29. Abbas Kiarostami, *Like Someone in Love*, 2012. Screenshots.

tears that well up in her eyes index the price it takes to sever tra-
ditional family bonds for the sake of living the life of an urban
contemporary.

At once static and mobile while capturing Akiko's torment
in the car's interior, the camera will eventually direct its gaze
outward with a prolonged point-of-view shot that circles
around a public sculpture in front of the train station. Its true

object, however, is the sight of what we presume to be Akiko's grandmother, stoically waiting for Akiko, a foreign body amid the city's pulsating rhythms, her view repeatedly obstructed by passing pedestrians, other cars, and reflections of neon lights on the limo's windowpane. After some circling through a roundabout, we eventually cut back to the image of Akiko looking toward what can no longer be seen, then to the limo driver, who observes in the rearview mirror Akiko's intent act of looking, then settles his gaze on what is in front of his vehicle to continue the trip. The scene's complex choreography of motion and immobility, of acoustical and visual perspectives, of perception, refraction, and reflection seeks to conjoin within one frame what withstands such conjoining. As an index of a different order of time and space, the grandmother in the end will have found some short-lived representation within the urban fabric of fleeting sights and sounds. Yet similar to the naked body of the old man in the hospital sequence of Tarr's *Werckmeister Harmonies* (chapter 3), the grandmother's sight here punctures the course of action: it confronts the viewer as something incommensurable, something we cannot fully align with the cosmopolitan relay of images and sounds, something wondrous. Kiarostami's use of the long take is essential to this sense of disjunction as it invites us to observe, through or on behalf of Akiko's eyes, what resists observation. It invites us to witness our own failure to witness. It marks the very dynamic of urban speed and commotion as one that simultaneously produces and obscures the grandmother as an object of Akiko's and our attention. The durational qualities of the shot may at first express some form of solidarity with the grandmother's traditional and slow existence. At the same time, however, they picture her life as one that cannot be integrated into the streams of Akiko's urbanity, as one that ultimately testifies to the extent to which the complexity of Tokyo's modernity challenges the very idea of synthesizing interdependencies within the unity of one common (cinematic) frame.

"Cinema," writes Chion to explain the role of the acousmatic, "has a frame, whose edges are visible; we can see where the

frame leaves off and offscreen space starts. In radio, we cannot perceive where things 'cut,' as sound itself has no frame."[10] As it folds the differential logic of transport enabled by mobile telephony and automobilism into one and the same shot, Kiarostami's long take inscribes the framelessness of sound into cinema's very need to separate the visible from offscreen space—that is, cinema's foundational need to cut through the realm of the sensible. Kiarostami first diegeticizes sound, only to then unframe the image and thereby signify what exceeds visualization. Old and new, urban and rural, traditional and hypermodern, movement and stasis appear in close proximity, one touching upon the other, one reflecting or even producing the other. Yet cinema as we know it no longer holds the power to contain all this within the unity of its frames and stories, to focalize all this as something we could call event and experience. What cinema can show, with the help of the long take, is that cinematic showing and framing no longer appear entirely capable of capturing the complexities of life across the landscapes of our expanded now. What Kiarostami's long takes communicate is that today's dynamic of accelerated speeds and global flows challenges how cinema combines images and sounds into meaningful stories as well as how that dynamic questions the very nature of cinema itself—its limits, its identity, its material base, its right to exist. Similar to the brick that breaks the frame of Takashi's window, our global now shows little respect for how cinema's frames once provided illusions of integrity and control. The point is no longer to categorically separate outside from inside but rather to explore the unsettling of stable frames of reference, of cinema's traditional rhetoric of mastery, as a new source of aesthetic experience and spectatorial wonder.

It should therefore come as no surprise that Kiarostami has repeatedly sought to expand his work beyond the domain of the cinematic frame and situation. Presented out of competition at the 2004 Cannes Film Festival, *Five: Dedicated to Ozu* reworked earlier plans for a video installation to be shown in Turin, Italy, in 2003, and even though the film—with a run time of about

seventy-five minutes—enjoyed a small theatrical and DVD re-
lease, its nonnarrative and poetic qualities make it a much bet-
ter fit for a museum's black box or even white cube. The work
entails five long takes, all captured at the Caspian Sea in the
summer 2002, each shot with a (digital) camera that refuses to
move, its frame completely agnostic about what may happen in
the larger visual field. We see driftwood at the seashore; people
walking along a promenade, stopping and going; dogs and then
ducks roaming up and down the beach; a pond at night with
frogs croaking somewhere in the distance (Figure 30). There is
virtually no narrative within or across these takes, no clue as to
why we see what we see, no symbolic hints and hence nothing
for the viewer to read or interpret. As Geoff Andrews remarks
about Kiarostami's five long takes, "What binds his work to-
gether [is] not so much the narrative or visual content . . . as the
contemplative quality of his gaze."[11] Like an installation piece,
Five can be entered at any moment. It's more of a sculpture
than a projection, not just a recording of the passing of time
but an act of active sculpting with and of light, a visual poem
that approximates the haiku Kiarostami has published over
the years.[12] Though not all that much happens in any of these
five takes, what they all feature are images of ongoing flux and
motion reduced to their most basic aspects. What they all share
is the effort to encourage contemplative seeing—not because
the camera's static frame effectively insulates the visible from
the off, but because the frame's very rigidity cannot but make us
wonder about whatever may enter the frame at any moment in
time. Exercises in lyrical abstraction and minimalist literalness,
Kiarostami's long takes ask their viewers not simply to recog-
nize that no frame will ever safeguard their perception from the
contingencies of the world but also to embrace this recognition
as a promise of a world in which we can safely relinquish our
desire for control and mastery in face of what is unexpected,
new, and wondrous. Instead—as it may first appear—of fleeing
from the ubiquity of moving images today and how they force
us to harness our perception, *Five* formulates an open invita-
tion to flee calmly into a world of ceaseless flows, to leave the

disciplinary templates of traditional cinema behind and precisely thus unsettle the sleepless time of 24/7 neoliberalist globalization. In Kiarostami's own words, "You know how annoyed some directors get on finding out that someone has fallen asleep while watching their film. I will not be annoyed at all. I can confidently say that you would not miss anything if you had a short nap. . . . I declare that you can nap during this film."[13]

Landscapes in Motion

To "cut back content," Susan Sontag wrote in 1964, enables us to "recover our senses. We must learn to *see* more, to *hear* more, to *feel* more."[14] An homage to the master of Japanese mid-twentieth-century cinema, *Five: Dedicated to Ozu* clearly aspires at once to cut back and expand cinema as we know it so as to allow viewers to see, hear, and feel more. Shown in 2007 at PS1 Contemporary Art Center in New York, the installation piece *Summer Afternoon* continued and intensified this ambition (Figure 31). What we see is the parallel projection of two windows, their lattices offering a gridded view of the world as seen from an unspecified interior. Shadows of bending trees and leaves dance across the semitransparent window

Figure 30. Abbas Kiarostami, *Five: Dedicated to Ozu,* 2004. Screenshots.

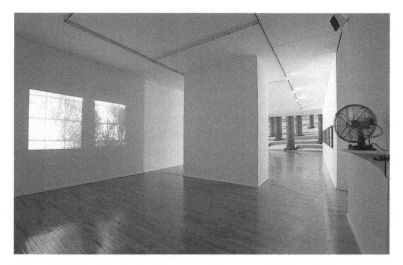

Figure 31. Abbas Kiarostami, *Summer Afternoon*, 2007. Installation view, PS1 Contemporary Art Center, New York, 2007. Photograph by Matthew Septimus, courtesy of MoMA PS1.

shades, captured in enduring long takes during this ten-minute video. Unlike the grid's role in aiding how Renaissance central perspective produced illusions of deep space, however, Kiarostami's gridded windows, as a result of the presence of the white shades, at first seem to collapse any impression of spatial volume onto two-dimensional flatness. True to the dual meaning of the word "screen," Kiarostami's windows simultaneously display views of the world while also blocking uninhibited access. They operate as mediums producing visibility as much as they offer apertures whose function is to cut back possible depth. Yet as both shades billow in what appears to be an ongoing breeze, they end up bending the trees' silhouettes, animating their projected flatness into plasticity and layering a second trajectory of motion onto how the same breeze stirs the trees beyond the window. Moreover, because Kiarostami decided to install a fan on the projection's opposite wall in such a way that viewers will feel a waft of wind on their necks while watching the screen up front, the video's play with motion and

stillness, with flat and sculptural space, extends into the very site of exhibition. Although once again not much happens in what we see in the image, Kiarostami's long takes in *Summer Afternoon* activate modes of spectatorship that exceed the optical and involve the viewer's entire sensory systems, including our sense of touch, kinesthesia, and proprioception. Just as important, similar to *Five: Dedicated to Ozu*, *Summer Afternoon* asks the viewer not simply to contemplate but also to actively explore the instability of any act of cinematic framing. As the installation blurs stable lines between the interior and the exterior, it allows us to investigate what it might mean to be in the image while also having the image in us or being an active producer of what we might want to call "image" in the first place. By cutting back on content, Kiarostami invites us to no less than recover our senses—to experience aesthetically a world in which the frames of visual media no longer offer stable, self-contained, and transparent impressions of place and space, however complex they may be.

Nowhere, however, does Kiarostami's ongoing investigation of what it means to frame the visible today become more poignant than in his photographic work, in particular his series Wind and Rain of 2006–7. Kiarostami: "The work method used in film differs from that of photography. With film, everything is prepared and organized ahead of time. Each shot, though independent, also depends upon the shots that precede and follow it. The filmmaker has an idea in his mind and, during the shooting, he endeavors to make the scene correspond to the vision he has imagined. This is not the case in photography, particularly landscape photography. Sometimes an isolated and abstract image upsets the continuity of the photographer's mind and invites him to pause, make a choice and release the shutter. Nothing is foreseeable in advance."[15] Photography, in Kiarostami's perspective, upholds the claims of the contingent, incommensurable, and unexpected. Precisely because it slices through existing chains of causality and continuity, precisely because it makes us pause and halt the flow of time, photography is able to suspend the kind of intentionality film can never entirely escape. Yet Kiarostami's photographic images

Figure 32. Abbas Kiarostami, landscape photography.

by no means lack compositional rigor, let alone assume the rhetoric of the everyday invested into the snapshot.[16] On the contrary, his landscape photography—whether its focus is on the delicate shadow of trees on snowy ground, dirt roads in hilly countrysides, or swarms of birds flying in front of majestic mountainscapes—relies on deliberate acts of framing light and shadow (Figure 32). What drives Kiarostami's photographic work is his effort to use the photographic frame in such a way that it indexes the off as a ground from whose openness the image itself borrows its formal unity. The image refuses to show the upper half of a tree, but its branches become visible as shadows on the ground; roads meander through the countryside, yet exit the image on the side and make us curious where they might lead; the diagonal shadows of trees dynamize wintry landscapes that at first seem entirely frozen in time; strategies of visual abstraction suggest that certain natural patterns could replicate forever and thus question the integrity of the frame as a stable container of the visible. Within the space of Kiarostami's images, everything appears to be fully under control of the photographer and thus correspond to its maker's vision. The willfulness of Kiarostami's frames, however, is performative: it nods toward what remains beyond the photographer's control and charges the image's apparent flatness and stillness with the motion of what escapes representation—that is to say, it moves the image to the very limit at which it cannot help but burst into a motion picture, a film, after all.

Wind and Rain is a series of photographs taken straight through the windshield of a car, its frame not visible, its glass covered with raindrops, the world behind the pane barely visible (Figure 33). In all of these images, the focus of Kiarostami's lens is consistently on the shapes of water on the windshield, such that the exterior world appears blurred and enigmatic. Trees seem to bend in the rainstorms; the profiles and lights of other cars appear as something ghostlike; roads and their edges are difficult to make out. The effect is disorienting. Kiarostami's images suspend the kind of seeing that automobilists usually take for granted to navigate traffic safely and speedily. Abstrac-

Figure 33. Abbas Kiarostami, Wind and Rain, 2007.

tion takes over as the spaces and temporalities of the exterior escape recognition and comprehension. Yet rather than simply frustrate the viewers' act of looking, visual blur in Kiarostami's images, writes Silke von Berswordt-Wallrabe, "makes us keenly aware of the process of seeing: the loss of control associated with our impeded outlook causes us to look even more attentively, to strive to understand what actually presents itself to our gaze."[17] Instead of not seeing anything at all, our gaze is thrown back onto what is most proximate, and hence onto itself. What it attends to is neither the shape of the raindrops themselves nor the effort of decoding the world without the rain's refraction, but how to see what is far and distant as a product of what is near and palpable, how to see our own seeing and not-seeing, how to at once look through and at the window, and thus practice what Roland Barthes—his eyes on the movie screen—once theorized as productively disjunctive forms of spectatorship that operated as if the viewer had "two bodies at the same time: a narcissistic body which gazes, lost, into the

engulfing mirror, and a perverse body, ready to fetishize not the image but precisely what exceeds it: the texture of the sound, the hall, the darkness, the obscure mass of the other bodies."[18]

For the speed addicts of early twentieth-century modernism, cars often symbolized a rejuvenating liberation from the burdens of past and present. Thrilled by the velocity of early automobiles, in 1931 Aldous Huxley famously pronounced, "Speed, it seems to me, provides the one genuinely modern pleasure."[19] In Kiarostami's Wind and Rain series, cars—and their windshields—figure as media to slow down the pace of time, to liquefy stable boundaries between motion and stasis, not simply in order to intensify the viewer's perception but also to allegorize what image making and vision in today's world of hypermobility can hope and strive for. We see the far vaguely refracted through the near, the near as something at once mediating and being thrown into relief by what is distant. We witness what is close by as screen and filter for the complexity and mobility of the world, and we experience what exists beyond our immediate surroundings as something that exceeds reliable representation. We thus see our own seeing as much as we see the very limitation of our seeing, a reminder of an image's insufficiency to frame space and time today. And we do all this not in a state of frustration but in a state of curiosity and wonder, eager to explore Kiarostami's image through prolonged acts of viewing and discovery. A logical extension of his cinematic projects, Kiarostami's photographic windshields offer open invitations to recover our senses in face of a world whose logic of globalization and 24/7 mobility tends to deny sensory indetermination. They impede or deflect our view, make us rub against their deliberate strategies of framing, so as to suspend our world's ongoing need for mastery and self-preservation and grant us space to look attentively.

The Contemporary

This book has argued so far that twenty-first-century long takes do not necessarily need to be five or twelve minutes in length. What they need to do is to enable durational experiences with

moving images as much as with images of motion that prepare the ground and clear a space for possible states of wonder. They permeate different technological platforms and display situations, opening a fold in the fabric of time in which viewers can entertain a curiosity for the unexpected and extraordinary, for moments of first encounter that do not administer shocks to viewers' perceptual and psychic systems. Just as important, the durational experience of the long take, rather than attaching us to the past, serves as a privileged medium to encounter our world of globalized connections and 24/7 mobility head-on, in the mode of a contemporary. It aspires to the durational and wondrous not by turning its back to a world of ceaseless connectivity and fast-paced flow but by looking straight into its eye. In Kiarostami's work, this contemporaneity articulates itself in how his images, their framing, and what they exclude from view vie for the audience's attention and reflection. Rather than—with the gesture of Brechtian criticality—pushing the viewer out of the picture, Kiarostami—as Andrew Uroskie has written in a different context—pulls us into the picture, but pulled "in different directions simultaneously [with] the effect of strengthening and loosening the grip of each in turn."[20] Durational experience in Kiarostami takes careful heed of the heterogeneous plurality of spatiotemporal vectors that mark our present, and precisely thus enables us to become contemporaries to our ever-more global moment.

It is time, finally, to pause and contemplate in more detail the concept of the contemporary, of what it means to be contemporaneous to one's age.[21] It is easy to mistake someone who is a contemporary with someone simply at the height of his or her time: the person tuned into the latest turn of the fashion industry, the most advanced gadgetry, the latest gossip, the most current book, film, or TV show. But Giorgio Agamben, reminding us of the work of Friedrich Nietzsche, has argued that to be contemporary means to think, see, and sense in face of what is present, which may include our willingness to formulate thoughts that may be timely and untimely at once. Contemporariness, he explains, "is *that relationship with time that adheres to it through a disjunction and an anachronism*. Those

who coincide too well with the epoch, those who are perfectly tied to it in every respect, are not contemporaries, precisely because they do not manage to see it; they are not able to firmly hold their gaze on it."[22] Because no present, Agamben continues, is ever transparent to itself, to be contemporary means to engage head-on with the obscurity of the present moment, including its overlay of different recollections as well as its structures of anticipation and becoming. Contemporariness in this sense describes a special attentiveness—not simply to what is ephemeral, but to what is not understood about the moment. To be contemporary means to push against the present in all its nontransparency, to explore the possibility of alternative presents and temporalities, of that which has been forgotten, the unlived and the not yet and perhaps never lived. To be contemporary is to experience and read the now in unforeseen ways, precisely because there is always more about this present than we may perceive at face value.

Victor Burgin has described our contemporary moment of globalized streams and transactions in terms of an unprecedented joining of multiple histories and trajectories: "the assembly of simultaneously present events, but whose separate origins and durations are out of phase, historically overlapping."[23] Contrary to common wisdom, what we call globalization today does not simply result in an acceleration of chronological time and an overwhelming sense of spatial shrinkage. It instead leads to conditions under which time no longer seems to follow one singular narrative or belong to specific spaces. The globalized subject lives, and is compelled to live, in multiple times and spatial orders at once, in competing temporal frameworks where time often seems to push and pull in various directions. In contrast to the modernist subject, for whom the arrow of time seemed to point decisively toward the future, and in contrast to the postmodern denizen, whose clocks seemed to suggest a certain evaporation of historical time altogether, time under the condition of contemporary globalization is often sensed as going forward, backward, and sidewise all in one; it might often be perceived as simultaneously chronological and

cosmic, geological and modern, local and global, evolutionary and ruptured.

To engage moving images as a strategy of the contemporary, then, cannot simply mean to immerse oneself into, or allow oneself to be washed over by, the multiplicity of streams and temporalities that mark our present. Instead, to become contemporary to our own time today means to look the fractured temporalities of our global now right in the eye and to think, sense, see, hear, and act in deliberate recognition of the fact that neither the arrows of time nor the vectors of space offer reliable strategies of containment or framing. It questions any frame that promises to offer self-sufficient views of the real; it is eager to explore that which we have never seen and to give voice to the not yet told. It pursues timely images that reckon with viewers for whom the flows and folds of the global now have become a condition of life; as much as it insists on what is untimely, wondrous, and incommensurable, shaping alternative structures of attention that do not easily give in to the demands of 24/7 hypervigilance, and brushing against how neoliberal visions of global culture today, sell ceaseless self-management as a sad stand-in for freedom, care, and autonomy.

The Life of Ghosts

Few contemporary filmmakers have paid more attention to the untimely and wondrous than Apichatpong Weerasethakul. Ghosts populate his films since the early 2000s almost as frequently as car drivers in Kiarostami's work use their vehicles to map a world in which reliable compasses no longer exist. Yet Weerasethakul's spectral presences do not haunt his protagonists like things that should have remained hidden. They are not uncanny in Freud's sense; they are not symptoms of a potentially violent return of the repressed. Instead, they enter his films as portals to different times and spaces, to altogether different orders of temporality. Weerasethakul's ghosts remind the living of the dead. They inscribe memory into the landscape of the present as much as they encourage the living to move

with the past into the future. Rather than unsettle the now, Weerasethakul's ghosts allegorize a quest for an expanded present, one in which past and present, dead and living, matter and spirit may coinhabit the same place without taking hold of each other or causing horror about what escapes predictable identity and reason. As Thai artist Rirkrit Tiravanija notes, "Unlike many narratives of the past, which were based on the architecture of fear, what we find today in the works and films of Apichatpong could be read, understood and interpreted as a narrative of difference. In the narratives of Apichatpong, the world of the living coexists with the world of the spirits, where ghosts are not a source of fear but of spiritual exchange, where difference and otherness can be better understood as nature and as living."[24] Weerasethakul's wondrous ghosts illuminate a passing present like the light of a distant star. They inscribe the cyclical into the chronological, structures of renewal and rebirth into what desires radical newness, not in order to affix the present to an unchanging mythical past but in order to insist that we—as much as cinema itself—require the light of memory, the memory of light, to move us in the first place.

Long takes, as essential elements of Weerasethakul's aesthetic, play a critical role in resurrecting the dead amid the living and thus mirror the timely and the untimely within each another. In *Uncle Boonmee Who Can Recall His Past Lives* (2010), the camera repeatedly observes natural or domestic interiors with seemingly static distance and for extended durations before the ghosts of the departed—the protagonist's deceased wife and his long-lost son—literally emerge on screen and help Boonmee face his own mortality. In the most memorable shot of *Syndromes and a Century*, the camera wanders for minutes in a hospital's utility room before it finally approaches the spectral sight of an air duct and allows our gaze to be swallowed by what seems to unhinge the order of ordinary time and Euclidian space. Like a form of incantation, extended shot durations in Weerasethakul are key to set the stage for other times to enter and push against the limits of the present, not as something that needs to be feared but as something that fills

protagonists and viewers alike with wonder. Weerasethakul's long takes open a space for the forgotten, concealed, and hidden so as to expand our notion of what it means to be alive and live in the present.

As friends of the long take, Weerasethakul's ghosts entertain curious relationships to the cinematic frame. Consider the strange first two appearances of Boonsong, the lost son of *Uncle Boonmee* (Figure 34). He (re)appears first at the end of a prolonged pretitle sequence in which we observe the efforts of a farmer pulling a cow through the forest. Eventually the camera will stop tracking these efforts, allow the farmer and cow to exit the frame, and then simply present for some time a slice of dark undergrowth. A nearly invisible cut eventually reveals a similar section of the forest. Two red dots glow on the left side of the frame, which we—after some more careful looking—can make out to be the eyes of a strange creature, staring between leaves and stems. Because this dweller of the woods directly faces the camera without any motion, it is easy to take this long last take before the film's title card as a photographic still image, were it not for some leaves on the right, whose ever so slight movement identify this shot as an image in time and invite us to invite what is strange into our viewing of what is to come. Consider a later sequence, in which Boonmee, his visiting sister Jen, Thong, and Roong sit around a dinner table on the house's veranda. It's nighttime. A long static take shows them involved in a calm conversation. Finally, however, their heads will turn to the camera and be drawn to Boonsong, whose red eyes and furry body await them seeing his seeing at the edge of the porch. Though first startled, the foursome soon invite Boonsong to join them—a transition once again pictured with the help of a prolonged shot, featuring the encounter of the familiar and strange as a scene of generous welcome and sociability. Though Boonsong's reincarnation clearly has the power to trouble his family's minds and our perception, in the end he enters the frame as if it provided an open portal to the untimely and as if no measure was needed to represent this encounter through the potentially traumatic rupture of a cut. The

Figure 34. Apichatpong Weerasethakul, *Uncle Boonmee Who Can Recall His Past Lives,* 2010. Screenshots. Courtesy of Kick the Machine Films.

sequence's durational qualities transform what might potentially strike diegetic and nondiegetic viewers alike with fear and terror into something that produces wonder and curiosity.

If in Kiarostami's work the long take indexes the complexities of what exceeds the frame and cannot but remain invisible, Weerasethakul's aesthetic of extended shot durations—the average shot length of *Uncle Boonmee* is no less than 34.1 seconds[25]—allows what is complex and challenging to emerge from within the frame itself. Frames here may limit the visible field, presenting self-contained slices of what could possibly be seen, heard, and sensed. Yet they also define the condition for the possibility of the unexpected and untimely to reveal themselves; of different times and ontological realities to enter into meaningful transactions; of the dead to resurface among the living and the living to accept their own death as a mere transition into a different form of life; and of the now absorbing and being absorbed by other times and places. Long takes in Weerasethakul's work situate frame and screen, not as something whose rigidity and solidity is meant to keep things out but as a membrane through which the unanticipated and incommensurable might pass. Long takes here undo what caused former theorists and practitioners to hail the cut—the rupture of montage—as the primary allegory of modern life: the view of modern existence as a ceaseless series of traumatic shocks and temporal displacements. Time and space, in the context of Weerasethakul's aesthetic of the long take, are on our side, not because we have learned how to master them in each and every moment but rather because Weerasethakul's long takes teach us the art of letting go, of approaching the visible with hospitality rather than fear, of experiencing the present as a complex relay station of often incompatible temporalities, spatialities, and stories to be told.

"I am fine," Weerasethakul noted in 2011, "when people say that they sleep through my movies. They wake up and can patch things up in their own way."[26] Weerasethakul's long takes offer exercises in the art of (historical) awakening. They extend open invitations to learn how to open our eyes and assimilate

the world of slumber and dreaming to whatever we may call the real. Yet rather than cast the waking subject into a realm of trepidation and trembling, Weerasethakul's long takes draw on our dreams to expand the depths and ranges of the cinematic image. These long takes enable us to open and use our eyes as if we did so for the first time after a long period of non-seeing. What they show is not a world to which we respond with feelings of shock and trauma but one in which even the most bewildering moments of displacement and temporal overlay can activate curiosity and wonder—a world that never exceeds the measures of our perception simply because the awaking dreamer has little respect for the limits and scales that structure the ordinary, and because Weerasethakul grants us (and his protagonists) ample time to patch things somehow together, to take in what is strange and learn how to move with it.

Reconstructing Hospitality

It is important to note in this context that Weerasethakul's efforts to expand the frame extends to his work as an installation artist as much as to his experiments with unconventional recording methods. *Uncle Boonmee* grew out of larger exhibition project, entitled *Primitive*, first shown in the United States in 2009 at the New Museum in New York (Figure 35). In a series of interrelated videos, the project—displayed as a multiscreen installation—investigates the dynamics of life in Nabua, a rural village in northeastern Thailand caught for years in a devastating struggle between communist farmers and the repressive Thai military regime. Each video in the show blends documentary and dreamlike images. All of them, though eager to pay tribute to the specificity of the local, leave little doubt that the here and now of village life can no longer be seen in isolation from the dynamics of larger political and historical forces; they also demonstrate that political activism cannot but take root in the local, the fabrics of sensory interaction, the dreams, visions, and ghosts we carry from the past to the future. "The idea of landscape," Weerasethakul ruminates about his relationship to

the region, "is not only physical, but also the landscape in other media—in movies, the movies and stories I grew up with. These landscapes are disappearing, from my memory and from social collective memory as well."[27] *Primitive* is an effort not simply to preserve the textures of these landscapes but also to build a new media landscape, an ecology of screens, in whose midst viewers experience a suspension of the onrush of time and, by mapping their own memories and dreams onto the images on screen, awaken to new life the dreamscapes of Nabua existence. To navigate *Primitive* is to expand the frame of the present so as to rub against how current mandates of power discipline, streamline, and contain the richness of local stories and temporalities. *Primitive* reimagines the extinguished dreams and memories of Nabua in the hope of restitching the broken fabrics of time and durational experience.

Advocates of what in realist cinema eludes the index, Weerasethakul's ghosts push cinema beyond its institutional traditions; in the name of memory and the durational, they even cause the filmmaker to abandon the use of conventional

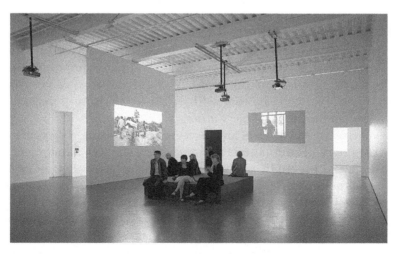

Figure 35. Apichatpong Weerasethakul, *Primitive*, 2009. Installation view, New Museum, 2009. Courtesy of New Museum, New York. Photograph by Benoit Pailley.

cameras and recording devices altogether. The spectral aspects of the cinematic image thus find remarkable companions in Weerasethakul's more recent efforts to discover ghosts in the very machines that make moving images possible. A 2012 project shot in collaboration with the online art-house cinema MUBI (https://mubi.com/), Weerasethakul's *Ashes* is exemplary in this regard (Figure 36). This twenty-minute film was recorded with the help of a handheld LomoKino MUBI Edition camera, which asks cinematographers to move the film manually and reduces exposure and focus options to a bare minimum. When cranked at full speed, the LomoKino can shoot no more than three to five frames per second, thus producing rather choppy impressions of movement, a nonindustrial picture of motion whose artisanal aspects are at the core of its aesthetic signature. No roll of film will enable takes that last longer than forty-eight seconds. Sound recording is not an option. "Be your own director," Lomography advertised its camera when it hit the market in 2011—not only to recall Kodak's famous slogan for its Brownie camera but also to introduce an inexpensive medium promising to return the roughness of the manual to a world governed by fast-paced and digitally altered images. The LomoKino is as spartan as mechanically possible, a device fueling the dreams of self-stylized auteurs who are no longer in need of technical crews and complex equipment, an apparatus approximating a zero degree of filmmaking, yet—as a result of the collaboration with MUBI—promising global distribution through online channels.

Avoiding the drive of any discernable narrative, *Ashes* gathers images of rural Thailand, apparently shot by a dog owner who walks his pet through streets and fields, along houses and farms, before we, for a brief interlude, cut to more urban setting. We see images of a protest against Thailand's repressive lèse-majesté law, which permits persecution of anyone who insults the nation's king; we see images of several people gathering for an outdoor meal; we see glimpses of conversations whose sounds must have been added during postproduction; we see the bright green of tropical leaves. We follow the interview of a

Figure 36. Apichatpong Weerasethakul, *Ashes*, 2012. Screenshots.
Courtesy of Kick the Machine Films.

man reporting his efforts to draw from memory the houses and streets of his distant hometown, the screen repeatedly turning black for some seconds during his description. In the last few minutes, we see images of some festivity, a fire and fireworks, clearly shot in digital video, while melancholic guitar sounds mix with the noise of cicadas and a diegetic spectator seeks to shoot the events and its onlookers with his cell phone camera.

This final transition to digital is less surprising than it may sound, given the fact that earlier scenes already put to work different film stock and aspect ratios and split the image horizontally into two, as if to prove—like Tacita Dean's 2011 installation *Film*—that analog technology has no less potential to empower creative experiments than cutting-edge digital devices.

With no single take lasting longer than about fifty seconds, and with the camera's reduced frame rate turning moving images into rather jerky affairs, one may wonder whether Weerasethakul's *Ashes* marks a radical departure from the meditative slowness of his earlier cinematic work. *Ashes* shuttles the viewer without pause from one place to another. In the absence of anything resembling establishing shots or transitional bridges, the experience for the viewer is disorienting and feverish, a far cry from the surreal stillness of *Uncle Boonmee* or *Syndromes of a Century*. Yet there are good reasons to insist that Weerasethakul's foray into Lomo cinematography closely follows the spirit of his earlier work. *Ashes* recalibrates the director's interest in ghosts as a paradoxical index of the durational for a time and technological universe that pretends to have little patience left for the indexical, the slow and lasting materiality of the trace. To decelerate the speed of film recording here allows cinema to recall the power of the index, of establishing tactile relationships between the filmic and the profilmic, no matter the extent to which later editing and distribution procedures draw on the malleability of the digital. Hand cranking a film at five frames a second may produce everything but impressions of slow motion. What it does, however, is to insert human measures into the making of motion pictures, and to feature the temporality of the human body in all its contingencies as an antidote to how contemporary screen culture tends to absorb human time ever more swiftly into machinic time. Moreover, inasmuch as decelerated frame rates destabilize any sense of continuity, *Ashes* systematically dismantles the conventional integrity of identifiable scenes, takes, and framing strategies. One set of images here seems to bleed into or jump to the next one. Sudden jumps in time or space do not strike

the viewer as potentially traumatic but rather as a quasi-logical product of how *Ashes* handles moving images in the first place. Present and past, memory and the observational, movement and stillness thus blend into one continuous flow, however fragmented it may be at heart. What we witness in *Ashes* are not images that document the nuances and excesses of the real but rather images that approximate the logic of a dream; we witness the protocol of a dream, an index of how dreams, in the shortest time imaginable, usher dreamers into radically expanded presents.

In Weerasethakul's work, including the experimental *Ashes*, the length of what we call a long take cannot be measured in terms of clock time or by pointing our fingers at what appears to be the beginning or ending of a particular sequence of images. Instead, long takes are long because they suspend the ordinary regime of chronological time; because they confront the orders of 24/7 with alternative temporalities in which present, past, and future enter into unpredictable relationships; because they upend a kind of thinking that wants to identify calculable units—be they minutes, episodes, sequences, or integrated narratives—and precisely thus destroy what it takes to tap into the durational. Similar to Weerasethakul's long takes in other filmic projects, the choppy fragments of *Ashes* suspend any metric, chronological, or teleological sense of time so as to lure the ghosts of other times to the surface. What makes them long is not the fact that they might last for extraordinary numbers of seconds but that they invite the viewer to encounter passing images with unabashed curiosity for what is surprising, unseen, unheard, and untimely. What makes them long is the fact that they allow viewers to dream with their eyes wide open.

The Politics of Patience

Globalization, as we have come to know it over the last two decades, is less about the mere mingling of different places and times within the space of the present than it is about the reconstruction of our sense of space under the impact of the

neoliberal logic of 24/7: its disciplining stress on ongoing com-
petitiveness, gain, and strategic survival; the circulation and
consumption of mediated images for the sake of maximizing
self-regulation; the blurring of any meaningful difference be-
tween work and nonwork, private and public spaces, the distant
and the near. Under the global rule of always being on, time is
and has no time at all. It allows for neither the timely nor the
untimely. It rules out the possibility of daydreaming, of drift,
of absent-mindedness and nonintentionality, of vacant or un-
structured periods, of reverie and wonder, all in the name of
efficiency and self-directed functionality, of connecting to and
networking with other places at all possible times.

Kiarostami's and Weerasethakul's probing of the durational
qualities of the cinematic frame—its spatial extensions, its
temporal depths—is no less than an effort to recuperate and
activate the powers of dream, sleep, and drift so as to gaze to-
day's logic of globalization straight into the eyes, to explore the
wonders of sustained attention in face of the age's principal in-
attentiveness or hyperattentiveness. The films and installations
of both image makers open up spaces of vacant time not to turn
their backs to how the global logic of 24/7 tends to dismantle
any viable concept of the frame but rather to draw our atten-
tion to the fact that the task of framing moving images matters
as never before in order to rub against the atrophy of patience
and sustained attention, and hence to warrant the conditions
for the possibility of the ethical and the political. Often seen
as an expression of heightened formalism and self-reflexive
rigor, Kiarostami's and Weerasethakul's use of the long take
at center formulates compelling responses to the flattening of
what it takes to act politically today. For both Kiarostami and
Weerasethakul, to explore the durational aspects of framing
moving images does not mean to yearn for a pretechnological
past or resist what drives us into the future. It simply means
to take the time to encounter the present, to comprehend this
present in all its obscurity—and hence to do exactly what we
according to Agamben require to be a contemporary: to be
able to be timely and untimely at once.

Consider, in closing, Weerasethakul's 2007 single-video installation *Morakot (Emerald)*, shot in an abandoned hotel in Bangkok and first exhibited in the United States in 2013 at the UC Berkeley Art Museum and Pacific Film Archive (Figure 37). A product of Thailand's economic boom in the late 1970s and early 1980s, the Morakot Hotel provided a harbor for Cambodian refugees who fled their country after Vietnam's violent invasion in 1978. In the wake of Thailand's economic breakdown in 1997, the hotel went out of business, and the building was left to itself, with no new tenant, for more than a decade. *Emerald* features a camera slowly hovering through various of the former hotel's abandoned rooms, hallways, and staircases, at times resting, at times quietly moving forward, at times gliding backward by a few meters to open up the visual field. Though flooded by harsh daylight, each room remains much darker than required to discern any details of their now derelict decoration. Clouds of dust obscure visibility, their presence amplified in various takes by digitally inserted dots and specks—white noise that floats across the foreground of the image as mysteriously as the camera itself drifts through the defunct building. Additionally, reminiscent of Kiarostami's fan in *Summer Afternoon*, viewers of *Emerald* will find a green light installed in the gallery that illuminates the space between screen and floor, less to remind us of our own seeing and of the screen's role as an artificial window than to extend what is puzzling about the hotel's abandoned spaces into the viewing space and situate the frame as a membrane of sensory and metaphysical transactions.

Emerald's camera navigates the hotel's spaces like a disembodied ghost returning to the present in order to both document and counteract the atrophy of time. Yet similar to *Uncle Boonmee*, Weerasethakul here does not hesitate to insert a few "real" specters into the film's diegesis as well: vague, semitransparent images of the hotel's former occupants who will testify (in Thai) to their traumatic experience as victims of political violence, recall happy moments of their past, and contemplate places to which (dead) lovers will return in the future. Weerasethakul's ghosts, introduced as Thong, Goh, and Jen, were initially

Figure 37. Apichatpong Weerasethakul, *Morakot (Emerald)*, 2007. Screenshot. Courtesy of Kick the Machine Films.

inspired by Karl Gjellerup's Buddhist novel *The Pilgrim Kamanita* (1906), an unconventional Danish novel recalling the path of an Indian merchant's son toward nirvana. Unlike Gjellerup's Indian tale of transcendence and reincarnation, however, the stories of Tong, Goh, and Jen are haunted by memories of exile and violence that speak up against the silencing of political repression. They weave forgotten pasts into the fabrics of the present so as to carry the memory of history's victims into the future—as something Thai society cannot afford to disremember in its (botched) efforts to be at once democratic and contemporary. "I dreamt of Kachanaburi," one of Weerasethakul's ghosts in Morakot recalls, referring to a town not in Cambodia but in western Thailand, which witnessed mass killings during World War II as well as government attacks on political protesters in the mid-1990s: "The soldiers dragged me out of bed and let the dogs chase us. All I could see were small green lights in the distance. So I floated that way. Turns out they were squid boats."[28] As if authored by some spectral reincarnation itself, the floating long takes of *Emerald* explore the present as a site

charged with heterogeneous stories to be told. As advocates of memory and the durational, Weerasethakul's ghosts—like Kiarostami's windshields—allegorize the director's signature use of the long take as much as they serve to remind the present of what it seeks to repress as it hopes to move into the future. Far more than a mere exercise in aesthetic formalism, long takes here provide a hospitable environment to make us see and listen with patience and care, to await our own turn to speak and act, to attend to the seemingly untimely so as to grasp and complicate what may count as timely. In an era ever less attuned to the textures of proximity and ever more stressing on-demand connectivity with distant places, we cannot overestimate the political import of the long take's evocation of patience and waiting, of sustained seeing and listening, of the nonintentional and wondrous, of its strategies of framing and unframing time so as to inhabit space as something whose complexity we can never fully map and comprehend, let alone own and master.

CONCLUSION

Screens without Frontiers

Beyond the Operative

Sleep today is no longer what it used to be when in 1963 Andy Warhol filmed the slumbering body of John Giorno for more than five hours. "*Sleep*'s radical duration," writes Andrew Uroskie, "far from remaining a formal feature of the *work*, must rather be understood as a transformation of the theatrical *site*."[1] Warhol's long takes of Giorno were meant to redefine the existing structures of theatrical spectatorship. Whereas classical Hollywood as much as postwar auteur cinema presupposed and produced viewers fully attentive to the entire cinematic product, Warhol's *Sleep* envisioned viewers perfectly happy to exit the screening for a while to do something else, to direct their attention to their neighbors rather than at the screen, or to enjoy a peaceful moment of slumber without violating the codes of proper viewership. To film sleep in excruciating long takes was to emancipate viewers from how narrative cinema had come to manage the spectator's temporality and subsume their entire sense of time to the rhythms projected onto screen. *Sleep*'s radical duration invited viewers to use the cinema as a place to hang out, to experience the pleasures of drift, and to take in moving images at their own pace. By screening a body fast asleep, Warhol hoped to reinject radical contingency into the heart of theatrical spectatorship, allowing viewers to "derive pleasure from components of a cinematic experience that have little to do with the film itself."[2] Neither the film's formal operations nor the screening's length was designed to condition the viewer's temporal commitment. Everything seemed possible and nothing could be predicted anymore, once you untied

the Gordian knot of temporal compression and encouraged the viewer to roam freely in face of sleep's logic of suspension.

Neoliberalism's logic of ceaseless time management has little patience left for those who sleep, let alone those who watch others sleep. 24/7's imperatives of always being on largely suspend sleep's power of suspension. Teenagers place their cell phones next to their pillows to check on social media during the night. Brokers continually run their gadgets so as not to miss out on market developments in other time zones. Binge watchers stream media content on twelve- to sixteen-hour cycles so as to devour a year's worth of broadcast material between work shifts. Restlessly clicking ourselves from one thing to another, ever fewer of us experience sleep as a space to cleanse the filters of perception and reopen our eyes to what may defy expectation and instant maneuverability. Yet the durational and strangely desubjectified gaze that Warhol's camera casts at Giorno's body finds its perhaps most important successor today in the mechanical images that surveillance cameras capture of night streets or that drones produce while observing landscapes that no human eye dares observe. In spite of the onslaught of fast-paced images we encounter everywhere and at all times, it is foolish to think that long takes have gone out of business. We often simply look for them in the wrong places; in most instances, extended shot durations today neither result from artful cinematographers nor address spectators eager to challenge classical cinematic conventions. Rather, they are products of complete mechanization; they offer moving images read by machines and rarely seen by human spectators at all.

Whether captured from 30,000 feet or delivered by rooftop cameras, the ubiquity of uncut surveillance footage today urges us to identify the specificity of durational images and experiences in contemporary moving image work. Similar to the restless users of electronic gadgets, surveillance cameras cannot afford to sleep. Even minimal discontinuities threaten their task, namely to produce records of ordinary time should ordinary time suddenly prove to become extraordinary. In most cases, surveillance cameras capture passing presents

not to shower possible viewers with surprise and wonder but to prepare different stakeholders for the effects of disruptive events. As witnessed by the mechanical eye of surveillance cameras, tears in the fabric of ordinary time thus do not really constitute tears at all. On the contrary, surveillance cameras do what they do because they follow the protocols of controlled expectation set against the background of what their operators anticipate might happen next, even if it may never occur in actuality. Drones capture 24/7 images to identify the paths of alleged terrorists before they might plan to strike their targets; street cameras track intersections to raise alarm should accidents halt desired traffic flows. Rather than decentering the present's attentional economies and promoting the promise of the wondrous, namely the promise of disruption and novelty encountered without fear, the mission of surveillance cameras is to manage fear by ruling out the very possibility of wonder. Precisely because surveillance cameras witness the real without cut or sleep, we may in the end consider their images to be neither long takes nor durational. To call any take a take requires recording procedures that begin and end somewhere, no matter how long that stretch might be. And to call images durational, to follow Henri Bergson, does not simply involve images that mechanically document the mere unspooling of time but includes viewers in whose consciousness present and past, perception and memory, enter processes void of totalization and conclusive representation. Surveillance footage assumes the qualities of a "take" and of the durational only once someone decides to interrupt the flow of observation, either because he or she wants to review what led up to a disruptive event or because he or she desires to intervene in the unfolding of time presented on screen, in which case these images no longer count as images of surveillance but become operative images—that is, images meant to shape strategies that alter time's very course.

With his eyes on advanced war technologies circa 2000, Harun Farocki once called operative images "images that do not represent an object, but rather are part of an operation":[3]

video images that guide automated warheads; visual tracking devices that help adjust a missile's deadly trajectory. Today, operative images far exceed the realm of combat and security. To the extent to which they enable us to communicate, shop, navigate, rate, or simply manipulate data, the interfaces of our laptop and desktop screens, of tablet computers and smartphones, of GPS systems and smart watches, all offer images primarily operative in nature—images that no longer simply present or represent but are part and parcel of real-time and often locomotive operations. In 2004, Farocki still limited the concept of the operative images to images "taken in order to monitor a process that, as a rule, cannot be observed by the human eye."[4] Various waves of technological innovation later, operative images today appear to be all around us, seen by human eyes at all times, used by human fingers or other body parts to affect both the world around us and how we see, sense, and navigate this world. Like surveillance footage, operative images today often include moving images that display extended periods of time without a blink, cut, or downtime; they may interface with other times and spaces as continuous chains of data and information. Operative images—images that stress doing over seeing, acting upon rather than merely representing the world—may be seen outside of the purview of the aesthetic. Deeply enmeshed in the logic of goal-oriented action and self-management, operative images rarely provide windows to what aesthetic experience might be all about. Whereas the aesthetic cannot do without a certain suspension of ordinary temporality, operative images want users to select, guide, readjust, arrest, or track in real time. Rarely do they seem to invite viewers to hover between the sensory and the cognitive, the playful and the nonintentional. In most cases, they instead prompt operators to act strategically, to calculate costs and effects of certain interventions, to map possible anticipations against factual outcomes. Yet there is no reason to assume that operative images and their media can have no place in time-based art at all, or that their constitutive logic of often impatient interactivity disqualifies them once and for all for artistic forays into the durational and

the wondrous. It is the task of this concluding chapter to witness aesthetic experiments with extended shot durations where we might expect them the least: among viewers who hold electronic gadgets in hand to navigate real and virtual spaces, to blur the differences between screenic and nonscreenic temporalities, and to act on what they see as image in the first place.

Operative images of the twenty-first century are part of our contemporary culture of the interface, with the latter understood as a technological artifact designed for seamless interaction between humans and computational devices, for rolling representation and functionality into user-friendly and largely self-effacing dynamics. The interface embodies "a cultural form with which we understand, act, sense and create our world. In other words, it does not only mediate between man and computer, but also between culture and technological materiality (data, algorithms, and networks). With this, the mediation affects the way cultural activities are perceived and performed."[5] Interfaces often wrap digital processes into analog surfaces as much as they draw on certain iconographic genres or acoustical conventions so as to engineer feedback loops seemingly as free of engineering as possible. Screens today continue to serve as our main interface with digital data production, dissemination, and storage—so much so that we have come to think of the screenic interface as the primary site to study our contemporary culture of computing. Though it is increasingly misleading to regard screens as exclusive metonymies of computational culture, they surely remain a key site to explore the visual codes and narrative tropes that embed bodies, spatial settings, and computational machines within each other, but also as a media platform able to transform operational images into something that may hold the potential for aesthetic experience in spite of these images' stress on functionality. In the concluding pages of this book, the focus will be on work done with handheld screens and video games. The aim is not simply to probe the extent to which we can locate the durational as a stage for the wondrous in technological environments whose emphasis on mobility is normally seen as hostile to contempla-

tive modes of perception, but in so doing I will define an expanded concept of contemporary art cinema—a polymorphic concept of art cinema centrally concerned with exploring the temporality of movement, of bodies and matter in motion, across different media today.

Physical Cinema

Initially, the image on screen shows little else but what you see right in front of your eyes as you peek over the edges of your handheld screen (Figure 38): the same tiled floor and elevated ceiling, the same glass facade in the back, the same shops on the left and right, selling goods to fickly travelers—in sum, the same arrival hall of a medium-size German train station. Fed to your ears via a connected headset, the sounds too seem to duplicate or blend into what you might hear already anyway: the same busy footsteps, the same mechanical voices of station announcers, the same distant rumbling of departing or arriving trains. Same and similar—but not identical. For what we see on screen and what will quite instantly direct our movements is the image of a previous recording, not the result of a live camera feed. We will note minute differences in visual detail, bodies moving toward us on screen that we cannot find anywhere near us. We will hear the artist's voice urging us to follow her footsteps and be fully aware that we are not copresent to her seeing and her hearing the space around us. Yet prompted by her voice and the screen's image, we will not hesitate to immerse ourselves into her previous seeing, hearing, and recording, and hence to embed her perception into our own perception of space and time, no matter how nonsynchronous they actually may be. In spite of the fact that the image on screen is no bigger than four inches and neatly fits into our hand, we as much accept this image to index our own visual field (and hence serve as a trustworthy guide for our steps) as we take on the recording of ambient sounds as if they were integral part of our own hearing.

Soon, however, things will get more complicated. We see a

Figure 38. Janet Cardiff and George Bures Miller, *Alter Bahnhof Video Walk,* 2012. Video walk, 26 minutes. Produced for dOCUMENTA 13, Kassel, Germany. Copyright Janet Cardiff and George Bures Miller. Courtesy of the artists and Luhring Augustine Gallery, New York.

woman in a red coat on screen, the soundtrack's voice commenting on the fact that she herself once owned one as well. Aligning, as prompted, our own gaze with the perspective of the screen, we are told that the hall's garbage cans have been moved, in spite of the fact that we see them both on and off screen in pretty much the same location. We are asked to look out for some musicians (whose brass music we have heard on the soundtrack for some time) as they emerge between some of the hall's pillars on screen, but not in real space. And yes, we will be asked to approach and follow them, moving our own bodies through space as if they indeed inhabited our physical surrounds. So we begin our twenty-six-minute walk through Kassel's old train station. We are asked to follow the image as we, following the two brass musicians, come across a ballerina on screen dancing in the hallway while being recorded by a camera team—a wondrous moment amid the triteness of the arrival hall off screen. The screen image lingers for a little on the dancer until a barking dog interrupts her and the filming; the voice prompts us to keep moving toward the actual train tracks, past a man who shares traumatic memories of World War II with another person (on screen and soundtrack): "Every house was burning. And the next morning bodies were lying on the street. Arms. Legs." We walk over to a public art installation, designed—as we learn from the voice-over—to commemorate the fate of Kassel's Jewish citizens during the Nazi period. We step up to the station's infamous track 13, used between December 1941 and September 1942 to deport 2,500 Jewish women, men, and children to the death camps in Majdanek and Theresienstadt. Historical images suddenly appear on screen, as much transporting us back to the horrors of deportation as stitching haunting memories into the fabric of the present. Eventually, the iPod touch will direct us back to the station's entrance area and invite the viewer to witness a choreographed dance performed by Laurie Young and Grayson Millwood. Their dance lacks the lightness of the ballerina's initial performance, yet in spite of its ongoing struggle with gravity, it radiates an eerie kind of beauty, in particular if we hold up the screen against the empty spot occupied by the performers

on screen while taking note of other video walkers in our vicinity doing the same (Figure 39). No one will share the same space-time when both watching this performance on screen and watching others watching, yet hardly any viewer will be able at this point not to be absorbed into what emerges as an unsettling audiovisual layering of multiple times and spaces.

Commissioned for the 2012 dOCUMENTA 13 in Kassel, Germany, *Alter Bahnhof Video Walk* was designed by Janet Cardiff and George Bures Miller, Canadian pioneers of sound and walking art since the early 1990s. Creators of deeply unsettling work such as *The Paradise Institute* (2001) and the Kafkaesque *The Killing Machine* (2007), they have no doubt left their greatest mark with their experimental audio walks: binaural recordings that guide listeners through at once real and virtual, extant and fictional soundscapes and thereby explore forms of expanded cinema in which physical and mental images as well as narra-

Figure 39. Bahnhof Kassel with *Alter Bahnhof Video Walk* in hand, 2012. Video walk. Duration: 26 minutes. Produced for dOCUMENTA 13, Kassel, Germany. Copyright Janet Cardiff and George Bures Miller. Photograph courtesy of the author.

tive and nonnarrative elements collapse into each other. In *On Slowness*, I argued that Cardiff and Miller's audio walks, as they nestle different auditory events into our own hearing and navigating of space, sharpen our senses for what is temporal and multiple about space, about possible disjunctures between the space we perceive and the space of the perceiving body. Cardiff and Miller, I added, make us slow down not to find plenitude and fullness but to explore what it might mean to listen and move in the first place.[6] In adding moving images to the previous use of layered sound alone, *Alter Bahnhof* recalibrates the stakes of their earlier audio walks. If the earlier work upset given orders of space, the addition of moving images disperses the presentness of sound, complicates the temporality of auditory and visual perception, and thereby makes us wonder about what it might mean to be in the present of something in the first place. The earlier audio walks rendered the past entirely present, relying on the user's visual imagination to charge the visual and haptic field with the invisible. Cardiff and Miller's video walk, by contrast, dissolves any stable concept of the present, not simply to invite us to experience the present as something structured by multiple narratives and stories to be told but as something in which the present's spatial configurations mask the past and/or deposit past realities into some kind of visual unconsciousness, the repressed of the present's seemingly complete visual field.

The experience of both physically carrying and being pulled by moving images on screen could not be more different than an immobile viewer's response to Béla Tarr's glacial long takes or to how Tsai Ming-liang's films approximate the look of still photography. We are literally on the move in order to partake of *Alter Bahnhof*, our motion through space at once energized by the images on screen and energizing how we want to see these images. To "watch" *Alter Bahnhof* is not a meditative exercise: there is no experience of minimalist reduction bordering the abstract, no probing of the boundaries of boredom, no fundamental challenge to our ability of staying attentive. Moreover, though much of what we see on screen is shot in extended takes

emulating a first-person perspective, Cardiff and Miller's video involves a number of fades and cuts, which act as punctuation marks that shuttle us to different times, while the audio track carries out a whole series of intricate editing maneuvers no matter how little listeners are actually able to think of audio cuts as cuts in the first place. Yet in spite of the fact that there might be many good arguments to consider *Alter Bahnhof* as antithetical to a cinematic practice of extended shot durations, I see many more good reasons to claim Cardiff and Miller's audio and video walks for the aesthetic of the contemporary long take. Like other practices discussed in this book, *Alter Bahnhof* places the viewer in the present of something that seems to eschew finality: the closure and death administered by cuts and narrative endings. We are absorbed into some profound sense of presentness less by what we see on screen itself than by how recorded images and sounds at once echo and overwrite, how they simultaneously contest and supplement the perceptual field. What qualifies *Alter Bahnhof* as an exemplar of the contemporary long take is not what this work pursues at the mere level of visual or auditory representation but in how it makes us experience film, cinema, and spectatorship as architectural media, as media engaging three-dimensional, haptic space in real time, and precisely thereby cues the viewer for the unexpected, that which escapes prior anticipation and classification.

It is time to pause and recall how one of the most important thinkers of twentieth-century cinema, Walter Benjamin, took recourse to architecture to discover the specificity of moving image spectatorship. Many will recall Benjamin's theory of cinematic viewing, as developed in his artwork essay, as principally unfit to come to terms with the durational images of today's screen-based art forms. After all, the central categories of Benjamin's account, the concepts of distraction and distracted attentiveness, were developed vis-à-vis the editing strategies of Russian montage cinema—that is, ballistic shocks that aimed at unhinging the authority of pensive, contemplative, or absorbed forms of looking. What is important about

Benjamin's conception of film viewing, however, is the fact that Benjamin's concept of distracted attentiveness described physiological and somatic responses to moving images much more so than it was meant to register a cognitive slackening of concentration. Cinema, in Benjamin's perspective, redefined seeing not as an immobile and purely optical event but as a haptic process, a reciprocal embedding of perceiver and perceived. Distracted attention registered at the level of the body what history in Benjamin's eyes in the mid-1930s required most urgently: the potential of cutting existing ties with the past and opening new paths into the future. More important for our context here, however, is Benjamin's effort to understand architecture as model of film analysis, of absorbing and being absorbed by moving images in a state of distraction. "Tactile reception," Benjamin writes, "comes about not so much by way of attention as by way of habit. The latter largely determines even the optical reception of architecture, which spontaneously takes the form of casual noticing, rather than attentive observation. Under certain circumstances, this form of reception shaped by architecture acquires canonical value. For the tasks which face the human apparatus of perception at historical turning points cannot be performed solely by optical means—that is, by way of contemplation. They are mastered gradually—taking their cue from tactile reception—through habit."[7] Architecture arranges distances and relations in space, calibrates movements and trajectories, and frames a user's attitudes, perceptions, and moods. In Benjamin's understanding, architecture denies distant, disembodied, synthetic, and totalizing modes of seeing; it produces or shapes the user's body as a body that may perceive in the first place and it is best appropriated not through structural contemplation or cognitive synthesis but by means of attuning the moving body to its volumes, shapes, rhythms, and passages. To inhabit something by habit is to encounter tasks, challenges, or obstacles without pursuing any sense of perceptual mastery or synthetic knowledge; it is to allow space to shape and modulate temporal perception and experience subjectivity as being constituted by and distributed across

different contexts. Though Benjamin's theory of film spectator-ship has often been read as a Brechtian exercise in criticality, its indebtedness to the model of architecture points us somewhere else: toward an understanding of time- and screen-based art as a sculptural and often hybrid medium, an environment whose primary task is to modulate, moderate, and reshuffle the body's sense of time in space, its rhythms, tempos, and temporalities, and to thereby produce viewers who join transformative politi-cal movements, not because the encounter with modern art persuades them to do so cognitively but because time-based art has the power to reshape our very sensing of time and his-tory, of anticipation and memory, of present and future.

In Cardiff and Miller's *Alter Bahnhof*, architectural space, screen space, and corporeal movement all fold into one open dynamic. The piece attunes the body of the user to both the pathways of architectural configurations and the rhythms of screen time as much as it allows the viewer to explore the hid-den heterogeneous narratives that energize what we call the space of the present. Cinema here happens neither solely on screen nor in the viewer's mind. It takes place in how various elements produce the moving body as a body that may per-ceive, and how architectural configurations conjoin moving images and perceptual movements into tactile experiences. Asked to inhabit space in all its temporal multiplicity rather than to observe it from a disembodied point of view, Car-diff and Miller transform Kassel's train station into a mobile mediascape powerful enough to modulate the walker's sense of time in space and space in time. What Cardiff and Miller, in the tradition of 1960s concepts of expanded cinema, call "physical cinema" displaces the most basic foundation of classical film viewing, namely the organizing power, spatial stability, and relative invisibility of the frame, only to redefine our experience of moving images as a performative practice that literalizes the architectural metaphor Benjamin had used to understand film as the most modern and political of all art forms. The video of *Alter Bahnhof*, as we see it on screen, may not have been entirely shot in one continuous long take; the

photographic footage from the Nazi period clearly interrupts the take and embraces editing as a means to call forth forgotten pasts and allegorize the Holocaust's catastrophic break of tradition. When understood as a much larger sculptural and architectural environment, however, *Alter Bahnhof* engages the viewer—his or her moving body as much as his or her eyes—as a long-take camera so as to reshape our very sensing of time, of history's present. Our eyes may wander from iPod touch to physical space and back in an effort to map screen space against "real" space. Our attention to what is around us and to what may suddenly appear on screen may be fundamentally hybrid and distracted—void of visual focus, of contemplative stillness, of pensive concentration. Yet as we wander through, partake of, and produce the physical cinema of Kassel's train station, what we come to experience is nothing other than a long take's durational qualities, its ability to decenter perceptual haste by subjecting the viewer to a unique sense of presentness in all its temporal complexity.

Cardiff and Miller's *Alter Bahnhof* provides a site to observe, sense, and reflect on movement and time in space. It bootstraps perceiver and perceived, mediated and felt space; it explores the durational as a means to allow repressed pasts to reenter the present, not in the form of the monstrous but as something that makes us shudder and wonder about architecture's unconscious. The slow long take of walking, of experiencing film as an architectural and mobile medium, here provides a prism that dispels any sense that we could ever master the world through acts of looking. *Alter Bahnhof* thus asks us to climb on the ladder of the operative image beyond it, to embrace the interface of the iPod touch as a window toward the aesthetic. Our sense of wonder about Young and Millwood's glacial dance on screen may at first be muted. What will strike the viewer as truly wondrous, however, is the fact that we admire the dance at all, in spite of the past that subtends this space in the first place. Cardiff and Miller's *Alter Bahnhof* embraces and expands the cinematic long take not to come to terms with a murderous past at the level of representation and thereby pretend to be done

with it, but in order to incorporate this past into the present and attune the present's rhythms to this past's often invisible afterlife. What Cardiff and Miller's expanded long take aspires is nothing less than for us to learn how to recall the dead and forgotten without arresting them and us melancholically in time—how to move, move with, and move in face of this past so as to truly inhabit the present. That someone here dares and succeeds to dance at all is the wonder.

First-Person Shooter

Extended subjective takes, as we witness them in *Alter Bahnhof,* are perhaps most familiar today from the operative images of video games and game artists who use so-called first-person shooter (FPS) perspectives. As indicated by the name, FPS games are not only often associated with a great deal of (virtual) violence to be administered to ever-new challenges, but also seem to privilege ludic over narrative aspects—that is to say, they privilege the immersive experience of designed worlds over the extended temporality of a good story. The pace of FPS games displaces the long breath of cinematic storytelling and critical reading, yet in featuring breathless spectacle at the cost of narrative cohesion, they—if we followed a critical commonplace—galvanize minds no longer capable of drawing necessary lines between the movements of an embodied subject and those of a diegetic avatar, between discontinuous stimuli and the rationalizing power of context, and between symbolic and material strategies of venting one's anger, angst, and aggression. Whenever fatal school shootings come to pass, media pundits are quick to identify the shooter's previous playing of FPS games as a perfect training ground for the death of innocent children and teachers. In their view, FPS games are no different from what hunters do on shooting ranges to perfect their kill shots in the wild. Further, the FPS perspective is as inherently predatory and violent as—in Susan Sontag's reading—a photographer's effort to capture an image of passing realities as if it were a trophy.[8]

Yet far from providing a direct channel from virtual to material violence, the ubiquity of FPS interfaces in the twenty-first century rests on historical developments much older than the history of gaming design: the legacy of subjective takes and point-of-view shots as used in cinema since the emergence of the classical codes of cinematic storytelling.[9] Point-of-view shots have been and continue to be a main staple of stitching the viewer into the fabric of diegetic space, be it in the form of the classical shot/countershot scenario or of takes framing the world as if seen from the general direction of a protagonist. Much rarer in cinema are subjective shots that suggest that we are literally seeing a protagonist's seeing. Think of F. W. Murnau's innovative use of mobile cameras to capture the perception of a drunken hotel doorman in his 1924 *The Last Laugh*; think of the (admittedly stale) 1947 noir thriller *Lady in the Lake*, making us witness an entire detection process through the eyes of Philip Marlowe; think of Hitchcock's famous implementation of a retro zoom to immerse us into Scottie's acrophobia in *Vertigo* (1958). Unlike the merely symbolic perspectivalism of the point-of-view shot, subjective camera work enables the possibility of inscribing the phenomenology of perception into the filmic process itself. Nothing in its technical setup, however, has predetermined its dominant encoding in mainstream cinema today as an index of subjective derangement, potential violence, and perversion, most forcefully articulated in the horror genre in which subjective camera work time and again draws us into the perceiving body of the killer, the stalker, and the vicious voyeur. Though pundits love to hate video games' FPS perspective as an inherently violent way of seeing the world, in truth FPS games simply rework cinematic traditions that largely refused to develop the full phenomenological potential of subjective camera perspectives and instead reduced this technique to a signifying strategy expressing latent violence, threat, and fear. What may strike some gamers as seemingly unmediated and utterly unique to the medium of gaming has its origin in the long history of cinematic storytelling and remediation.

To be sure, as much as FPS games pick up codes that stretch from popular to experimental and art cinema, so do they add important elements to what we might understand as image and perspective in the first place. Video games are about doing rather than viewing.[10] Their images are operational from the get-go as they invite us to act on what we see and to readjust our actions according to the shifting worlds we encounter. Moreover, they require fully rendered actionable spaces to anticipate a player's impulse to enter what in cinema would be the off frame or space off. In Alexander Galloway's words, "Game design explicitly requires the construction of a complete space in advance that is then exhaustively explorable without montage. In a shooter, because the game designer cannot restrict the movement of the gamer, the complete play space must be rendered three-dimensionally in advance. The camera position in many games is not restricted. The player is the one who controls the camera position, by looking, by moving, by scrolling, and so on."[11] Though movements may be much more restricted than game theorists often suggest, most video games expand the logic of first-person subjective perspectives to such a degree that viewers will barely notice the fact that gaming not only drastically changes the function of the cinematic frame but also uses the long take—the absence of real or virtual cuts, of montage and decoupage—as the most basic principle of structuring the passing of time. To play (and study) a video game is not to primarily focus on the game's representational qualities but to negotiate a continuous and montage-free space-time in which we deal with real rules while interacting with fictional worlds,[12] and in which gaming time emerges as a curious hybrid between ludic and narrative elements, between certain temporalities prescribed by the game and others adopted and produced by the gamer. Game time is at once more and less sealed off than the time of narrative feature films—more because most serious gamers encounter gaming as a variant of that utter sense of absorption that athletes consider as being in the zone, and less because games ask their users to inhabit half-real worlds to begin with as they invent imaginary universes in

which the ongoing possibility of loss—the failure to live up to the stakes of the game—is no doubt a real event for the gamer. As a result, games are much more charged with narrative temporalities and durational experiences than hard-core ludologists are willing to admit, though they follow different models of storytelling than other media and subscribe to what Henry Jenkins has importantly theorized as spatialized modes of narrativity.[13] Reminiscent of epic sagas or the genre of the road movie, games offer narrative architectures that are structured around a character's movement through space while they invite the gamer to accelerate or retard certain plot elements, and to follow certain clues charged with mnemonic power, by navigating fully rendered spaces through continuous and often contingent actions. To argue, therefore, that video games per se desensitize and stimulate violence because they—in contrast to cinema—deflate our sense of time and memory misses the point. A much more viable question to ask is what we can learn from the peculiar architecture of game time about the temporalities of contemporary cinema, and how gaming's continuous hovering in between the real and the imaginary, rule and narrative, can further illuminate our understanding of the long take's aesthetic of the wondrous.

Consider *Journey* and *The Unfinished Swan*, the first developed by Thatgamecompany, the second by Giant Sparrow for Sony's PlayStation 3, both financed somewhat outside of the dominant gaming market, both initially released in 2012 and able to gain traction with millions of gamers worldwide within a short period of time. Both can be considered "art games" according to the taxonomy developed by Astrid Ensslin—that is, works that, unlike representatives of "game art," want and need to be played to reflect on the medium of the game itself. Whereas the concept of game art—think of Hito Steyerl's *Factory of the Sun* (2015) or Omer Fast's *5000 Feet Is the Best* (2011)—"refers to works of art that are inspired by videogame aesthetics and technologies but aren't games as such," art games such as *Journey* and *The Unfinished Swan* are driven by ludic dynamics—that is to say, "the digitally programmed and

analog mechanisms that afford gameplay."[14] If game art is typically displayed similar to other works of art in museums and galleries, and if it addresses the aesthetics of video games at the level of representation alone, then art games explore the art of gaming within the medium of the game itself, pressing us to recognize the extent to which we find moving image art beyond the realms film critics and art historians once claimed as theirs alone.

Journey takes the player on a surprisingly eventless voyage through a desert landscape (Figure 40). The point is not to battle

Figure 40. *Journey* by Thatgamecompany, 2012. Screenshots.

monsters or pick up hidden clues, but simply to explore stunningly beautiful landscapes and a number of seemingly deserted ruins, ponder about what may have led past generations to abandon the project of their civilization, and at times allow one's avatar simply to go with the flow of sand, wind, and elevation changes. Most controller buttons do not really produce any effects on screen whatsoever, except that we can make our avatar sing for brief moments, and by gathering hovering pieces of fabric, we can entice this avatar to jump into and even glide through the air in ecstatic celebrations of movement. Floating much more than walking through space, we after several hours of astonished wandering will finally be able to ascend a wintry mountain, only to be enveloped at the very end by what appears to be a dazzling light of transcendence. If *Journey* grants us ample time—without cut and discontinuity—to marvel at the wonders of mysterious spaces, in *The Unfinished Swan* the production of space through continuous movement itself becomes an object of wonder (Figure 41). After a brief narrative introduction, we find ourselves in front of an entirely white screen, and as we are soon to realize, by casting black inkblots around us, we can not only render visible the contours of the game's diegetic space but also mark out possible pathways for navigation and further discovery. The longer we play, and the longer we follow the traces of an ever-evasive swan, the more we come to fill this world's negative spaces, generate the world as a site of visibility, and uncover the extent to which in this (game) world perception and action, seeing and being seen, movement and architecture all roll into one durational experience. Shooting inkblots as we move forward, sideward, and at times backward, we end up painting a wondrous moving picture that transcends its frame and is as much part of the perceiving body as it relies on this body to come into being.

Roger Ebert once famously denounced any effort to think of video games as a legitimate art form: "To my knowledge, no one in or out of the field has ever been able to cite a game worthy of comparison with the great dramatists, poets, filmmakers, novelists and composers. That a game can aspire to

The End

Figure 41. *The Unfinished Swan* by Giant Sparrow, 2012. Screenshots.

artistic importance as a visual experience, I accept. But for most gamers, video games represent a loss of those precious hours we have available to make ourselves more cultured, civilized, and empathetic."[15] While one may take issue with Ebert's assumption about what good art should do in order to touch on the deepest recesses of the human soul, art games such as *Journey* and *The Unfinished Swan* certainly ask their users to spend precious hours in spaces not governed by the mandates

of self-management and instrumental reason—spaces whose absence of scripted time, potential for fearless discovery and drift, and cleansing of the perceptual clutter of the present no doubt have the power to make us pause and explore often forgotten affects. What makes video games art is not their ability to dazzle viewers with beautiful imagery and well-designed story worlds. Instead it is their ability to enable logics of action, of doing things with still and moving images, of inhabiting image spaces and allowing images to inhabit us, that categorically differ from how our ubiquitous screenscapes today mandate ongoing attention and response, a ceaseless waking to anticipate, calculate, catalog, and further communicate visual input. *Journey* and *The Unfinished Swan* exemplify video games' ability to inaugurate alternative aesthetic logics of action and temporality. They define time not as a discontinuous series of events requiring the users to parry shocks and challenges but as a durational experience well able to probe our attentional habits and allow us to discover what exceeds prior anticipation and categorization: the magic of forgotten places and unexpected companionship in *Journey*, the riddles of what resists visual sovereignty and masterly presence in *The Unfinished Swan*. Like all great art (at least in Ebert's sense), the spatial narratives and traveling long takes of video games such as *Journey* and *The Unfinished Swan*, in the form of a reminder or promise, invite us to rescue from rational and cognitive oblivion an ecology of time in whose context we may encounter the unknown and mysterious without fear, no matter how suddenly it may enter our sensory field.

But does it really make sense to speak of these art games' first-person perspective and how they make us navigate space as a variant of the long take? Is it really meaningful and possible to square on the one hand the animation schemes, imaginary landscapes, and virtual camera work of game designers such as Thatgamecompany and Giant Sparrow with the delicate camera movements of Tarr, the observational tenacity of Tsai, the enchanted lyricism of Weerasethakul, and the moralism of Kiarostami, and on the other hand the role of extended

time-images in the installation work and video art of Calle, Hubbard and Birchler, Manglano-Ovalle, Dean, and Alÿs? These questions, I suggest, are falsely asked. The point of this entire book is to wrest the long take away from a standing tradition of criticism and practice in whose horizon extended shot durations were either solely associated with a certain language of observational realism or simply were utilized to absorb a certain postwar conception of European art cinema into contemporary cinephilia. Long takes today wander across different media platforms—digital and nondigital, stationary and mobile—and attach themselves to a whole variety of aesthetic projects, realistic or not. The most important question to ask is not whether gamers should have a say in contemporary screen studies to discuss moving image works that may eschew montage yet do not abandon narrative impulses. The true question is how video games may, among other mediums, redefine what critics consider a long take in the first place, and how the exploratory temporalities of games such as *Journey* and *The Unfinished Swan*, similar to the itinerant video art of Cardiff and Miller, add to and illuminate the long takes' role in contemporary international screen art as a medium of the wondrous—as a medium challenging and recalibrating the ubiquity of operative images in today's 24/7 economy of attention.

Expanded Cinema and Art Cinema Redux

Recent writings on slow cinema by authors such as Ira Jaffe, Matthew Flanagan, Todd McGowan, and Justin Remes envision the long take as a primary tool of decelerating narrative so as to challenge the hyperactivity of commercial cinema. Always at the brink of collapsing film back into photography, slow or static movies, according to this writing, feature continuous silence, impassivity, absence, and emptiness. They privilege waiting and minimalist designs over action and splendor. Their narrative structures are marked by a lack of emotion and a restrained sense of communicability—"by deadpan facial expressions, extended pauses, sparse dialogue, minimal plot,

barren spaces, a static camera and unusually long takes."[16] Instead of communicating optimistic concepts of progress, slow movie culture foregrounds the desolation and cheerlessness that underlie our busy present. Similar to other efforts to slow down the pace of contemporary life, it urges us to rediscover the gravity of decelerated time as such in an effort to expose the catastrophic underpinnings of modern existence. Slow cinema's affectlessness and stillness, by stressing the extent to which the lifelike motion of cinema historically derived from still photography, pays tribute to modes of nondigital filmmaking whose days appear increasingly numbered in the face of the mindless speed and progressivism of digital culture.

One of the forefathers of today's slow cinema advocates, Robert Bresson, once noted, "Be sure of having used to the full all that is communicated by immobility and silence."[17] Produce emotion, he continued, by resisting the representation of emotion on screen; offer viewers as little as possible to activate the audience, and have them graft their own stories onto what they encounter on screen. Some of the films and filmmakers discussed in the pages of this book no doubt echo the minimalist codes of slow cinema. Tsai's characters certainly cannot but strike the viewer as deadpan, inviting us to read narratives into his films the director's static images themselves seem to refuse. Scarce dialogue and desolate landscapes are surely also central features of Tarr's cinema, designed to provide a potent alternative to the hyperkineticism of today's mainstream cinema. And the austere moralism of Haneke's work indubitably seeks to trap the viewer's desire for narrative again and again, thereby making us think of a cinema of silence and stillness that would oppose today's euphoria of technological progress. Yet even though the work of each of these directors might easily be seen as a contribution to slow and static filmmaking today, their particular use of the long take certainly does not define extended shot durations as an exclusive medium of deflating desire, emotion, and mobility altogether, of resuscitating a lost language of cinephilic contemplation, and of embracing—as McGowan would argue[18]—the atemporal as

a means of recalling the traumatic ensnarement of human existence. To think of the long take as a tool whose primary aim is to reduce emotion, mobility, and movement to a near minimum not only ignores its intricate and varied uses in the work of a Tsai, Tarr, Kiarostami, and Weerasethakul, its reflexive probing of our durational commitments as much as its coupling to a return of the wondrous, it also misses the extent to which long takes today play a central role in moving film beyond its traditional medium and institutional setup and redefine it as a feature of the perceiving body in motion—a body that navigates the architectures of contemporary screen culture as spaces that embed perceiver and perceived into dynamic ecologies and therefore no longer allow us to think of spectatorship in cherished terms of contemplative stillness or critical detachment in the first place. Far from wanting to mobilize death—the stillness of the photographic image—against the frenzy and ideological progressivism of contemporary mainstream cinema, the twenty-first-century long take plays a crucial role in moving cinema and spectatorship beyond their twentieth-century paradigms. Equally present in the work of nondigital filmmakers such as Tsai, Tarr, and Dean as in digitally based examples of contemporary installation art or gaming culture, the long take's slowness today explores present and future spaces of perceiving something extraordinary as extraordinary, of experiencing that fresh and unscripted sense of attention that Plato and Descartes considered to be the wondrous. The long take breaks the mindless logic of 24/7, not merely by decelerating time but also by setting a stage on which we can retrain our attentional dynamics to encounter something unseen, unheard, or forgotten with passion and without fear—and thereby to witness no less than a rupture in the very fabric of self-managed time.

Classical long takes, it has been argued, slowed down cinematic time because they withheld shot/reverse shot patterns, reactions shots, and occasional point-of-view frames and precisely thus refused to stitch the viewer into a film's dynamic fabric of affects. Long takes, as we have come to know them from postwar auteurs such as Antonioni and Jancsó, decelerated

the viewer's perceptual processes and emotional energies as they no longer attached the viewer's viewing to the impression of a film protagonist's narrative agency and subjectivity. As a strategy that migrates across different media platforms today, the long take in fact does not need to be inherently slow; nor does it need to evacuate subjectivity and emotion from the act of engaging with moving images. It may assimilate the apparatus's presentation of real or fictional worlds to the scales of human perception, but it does not automatically—as slow and static cinema advocates would argue—produce contemplative modes of seeing, that is, open-ended forms of looking in which viewers peruse an image in all its detail and totality over time, linger and caress various parts at their own pace, only to then experience a certain dissolution of initial boundaries between subject and object, mind and materiality. As redefined in contemporary media practice, the long take figures as a central moment in featuring the architectural aspects of moving image spectatorship—our looking at rather than looking through, our moving with and our being moved by the ubiquity of screens in contemporary culture. Just as important, as it moves us through and beyond the classical auditorium's black box, the long take today challenges concepts of viewing that presume a preexisting viewing subject that will either be activated and transformed or condemned to mindless passivity by objects of art. The majority of existing categories of viewing such as absorptive, contemplative, pensive, possessive, and critical looking all operate under the assumption that viewers initially enter a viewing situation as fully formed, self-contained, and autonomous viewing subjects, only to then experience images on screen as stimuli to redraw, expand, contract, or liquefy the borders of subjectivity. At its most ambitious and innovative, the long take today instead draws our attention to the reciprocal relations between viewer and viewed; the fact that today's architectures of mediated vision produce subjects of viewing as much as these spaces requires subjects to be counted as objects in return. The long take's promise of the wondrous offers a model or training ground, not simply to develop nonhierarchical relations between subjects and objects but also to explore

the extent to which our own perceiving is coconstituted by the temporalities of the perceived. Wonder promises a rupture in the fabric of time, not to free subjects from the pressures of objectivity or to reconfigure our power to manage the world more effectively but to make us experience what it means to become and be a subject in the first place. Wonder dramatically expands the visible and sensory world as much as it expands cinema itself.

Austrian video and performance artist Valerie Export once theorized 1960s projects of expanded cinema as efforts to approach film as sculpture. Much more than a stylistic concept, the notion of expanded cinema envisioned film as a material formation in time and space; its principal purpose was to emancipate moving images from how ordinary cinema played tricks on the eyes of the viewer to pass flat surfaces as three-dimensional realities. Expanded cinema included "multiple projections, mixed media, film projects, and action films, including the utopia of 'pill' films and cloud films. 'Expanded cinema' also refers to any attempts that activate, in addition to sight and hearing, the senses of smell, taste and touch. . . . In the mid-1920s, Moholy-Nagy had suggested rippling screens in the form of landscapes of hills and valleys, movable projectors, and apparatuses that made it possible 'to project illuminated visions into the air, to simultaneously create light sculptures on fog or clouds of gas or on giant screens.'"[19] As they recalibrated 1920s experiments within the volatile context of the 1960s, practitioners of expanded cinema aspired to challenge hegemonic art practices of the postwar period—the transformation of modernism into a canonical and marketable item. Just as important, expanded cinema wanted to provide a critical alternative to how European new wave cinemas of the 1960s renewed the language of cinema without really questioning the technological setup of film projection and spectatorship; to how the Antonionis, Truffauts, and Bergmans of the time may have created new stylistic accents but refused to unleash the full experimental power of contemporary moving image technologies and cultures. Often seen as peripheral to the histories of both art and cinema, the 1960s vision of expanded

cinema aspired to fold both into one in order to move our engagement with moving images—whether projected on screens or not; whether seen with eyes, ears, skins, or minds—into new and uncharted landscapes that were able to cause in viewers accustomed to modern media wonder about their seeing and sensing again.

As it migrates across different media platforms, the long take today is often deeply, though often unknowingly, indebted to this tradition. Its principal desire is to install physical spaces to sense, observe, and reflect on the passing of time, and to enable durational experiences that rub against the restless logic of time and self-management associated with neoliberal media societies. Contrary to what today's advocates of slow cinema argue, the long take may not pursue a deceleration of contemporary speeds to approximate moments of photographic standstill; nor does it automatically endorse preservative agendas seeking to protect cinema from possible contaminations through commercial culture and digital media. It does not need to be a standard-bearer of the indexical; it does not necessarily promote the flat and affectless as a defense against the present's process of mediatization and virtualization. The twenty-first-century long take instead can serve as a medium to expand cinema beyond its twentieth-century boundaries and situate art as a space of experience in whose context we can probe durational commitments, explore and recalibrate the workings of attention, and partake of alternative rhythms and regimes of perception, including wonder's promise of profound newness and first sight. In Cardiff and Bures's physical cinema, the long take allows forgotten pasts to reenter a mobile present and map layers of history often hidden underneath architectural structures. FPS games such as *Journey* and *The Unfinished Swan* engage the long take to make users travel across contiguous spaces and continuous time, not simply to entertain our senses but also to draw attention to what it means to be, live in, and drift through time in the first place. And various screen-based installations discussed in this book reconfigure the viewer's roaming body itself into a long take camera, thus offering ecologies of perception that have little to do with the

pensive viewer of slow movie culture. Moreover, even though for each feature film discussed in this book another could be named that uses extended shot durations simply to showcase the acrobatic prowess of its director, what the long takes of Kiarostami, Tarr, Tsai, and Weerasethakul aspire to is not the embracing of representations of stillness and death as antidotes to contemporary speed, but rather the redefining of the physical space of the movie theater and its screen as a site to rework the temporalities of sensory perception. Rather than merely offer slow images of slow life, long-take cinematography here wants to actively modulate the rhythms, reroute the itineraries, and serve as an echo chamber of the perceiving body; it wants us to play through models of navigating space in time that at once reckon with and differ from how electronic media today regiment everyday movements, memories, and anticipations. Here, as in other arenas of contemporary moving image culture, the long take's principal goal is to retune the body's sense of temporality, not by hitting viewers on the head and shocking their perceptual systems but by constructing alternative media spaces—rooms for play—that constitute the body as a perceiving body and enable this body to apprehend media technologies as if they indeed were liberated from the strategic willfulness of media culture. At times the long take might certainly slow down physical and virtual movements; at other times it might accelerate them. At heart, however, the long take aspires to provide ecologies of technology, media, and sensory perception that viewers may inhabit without fear and pressure—architectures of time in which we can experience drift, delay, and the durational as habit and partake of moving image culture as a quasi-natural habitat powerful enough to challenge and displace the imperatives of ceaseless self-management issued by 24/7 media societies today.

Sleep is play's and aesthetic experience's sibling as much as it is the long take's secret ally—not in the sense that long takes put viewers to sleep, as certainly some argue, and as even hard-core cinephiles know only too well. On the one hand, sleep, unless it generates unbearable nightmares, is a breeding ground for dreams and the wondrous, understood as

both something that happens to us spontaneously and without our doing, that strikes us with something not common to our everyday and situates us in a visual space in the mode of surprise and the sudden, that holds our attention without our intention, and that produces curiosity and thought upon awakening, our eagerness to make sense of the unexpected visual worlds that just engulfed our entire perceptual system. On the other hand, sleep—as Jonathan Crary argues—provides a time that cannot entirely be functionalized by the protocols of 24/7, that withstands the neoliberal call for continuous activity and self-realization, and that displaces today's regimes of operative images while, at least in theory, clearing the ground for encountering the world afresh and anew every morning.[20] Whether they hang on to the vestiges of the indexical or not, whether they animate theatrical screens or are being animated by roaming spectators, long takes today invite us to sleep with our eyes wide open and inhabit screenscapes *as if* we were navigating the world of our dreams like a resilient wrinkle of time amid the fabrics of contemporary task management. Though long takes today may at times seem void of aspiration, they often promise to offer rooms for play in which viewers can perceive things *as if* seeing and sensing them for the first time, *as if* no categories or expectations for classifying the new existed, *as if* no anxiety was necessary to suddenly be in the present of what we do not know or comprehend at first. As it reconciles the disparate trajectories of expanded cinema and the art film, the twenty-first-century long take redefines art cinema as an effort to explore the temporality of moving images and spectatorship and to unleash the productivity of sleep against the ceaseless imperatives of categorization and self-management.

In Descartes's view, wonder suspended the cognitive filters, defensive shields, and selfish stratagems humans project onto the world. Wonder moved the individual beyond the willful and the operative; it allowed her or him to encounter the world without concept and judgment, and even though its effects could not but quickly diminish over time, it provided transformative experiences of novelty, pleasure, excitement, and curiosity. What defined wonder, as the first of all passions,

as different from blind awe and mind-numbing passivity was the fact that it produced forms of receptivity linked to generosity and the charge to use novel knowledge well. Wonder reminded the modern subject "that there is nothing that really belongs to us but the free disposition of our volitions,"[21] as much as it implored this subject not to embrace the thrill of novelty for its own sake. Descartes's link between wonder and generosity is instructive. Designed for viewers not afraid of extended durations, today's long take—when toying with the possibility of the wondrous—reminds us of the fact that we own neither time nor our own bodies, but borrow the latter from the former, or receive it like a gift that defies predetermined economies of giving. German filmmaker Alexander Kluge defines generosity as "the ability to engage in free exchange. The permeability of empathy. The ability to give gifts as well as 'oneself as a gift.' 'Opposite of forgetting' (Adorno)."[22] Magnanimity, in Kluge's perspective, liquefies the boundaries between self and other, the familiar and the foreign. It involves what his teacher Adorno envisioned as the anthropological root of aesthetic experience: mimetic behavior, a subject's ability to be and become other, to enact noninstrumental forms of subjectivity that incorporate the world as much as they allow the world to incorporate the self. Like hospitality, true generosity belongs to a world in which subjects no longer need to fear being subjects and engage the present as a space of uninhibited reciprocity. In our world of 24/7 distractions, stimulation, and strategic self-management, wonder has become as rare as gestures of true magnanimity. The long take, one of the central armatures of contemporary screen art, holds on to the promise of a world in which humans can experience the wondrous and act with generosity precisely because they experience time and perception as something they don't and can never own, as something that makes and unmakes our fragile position as subjects in the first place, and as something whose substance cannot be measured by the clocks, spreadsheets, news tickers, and bandwidth rates of our agitated present.

Figure 42. Sophie Calle, *Voir la mer. Old Man,* 2011. 3 hours, 11 minutes, digital film with color and sound, TV screen, framed color photograph. 20¾ × 35¾ × 5¼ inches (screen) + 13¼ × 20¾ × 1 inches (photograph). Copyright 2015 Artists Rights Society (ARS), New York/ADAGP, Paris. Courtesy of Galerie Perrotin, New York.

NOTES

Introduction

1. "Plane Songs: Lauren Sedofsky Talks with Alexander Sokurov," *Artforum International* 40, no. 3 (November 2001): 126.
2. Justin Remes, *Motion(less) Pictures: The Cinema of Stasis* (New York: Columbia University Press, 2015).
3. Lutz Koepnick, *On Slowness: Toward an Aesthetic of the Contemporary* (New York: Columbia University Press, 2014).
4. Harun Farocki, *Weiche Montagen/Soft Montages* (Bregenz: Kunsthaus Bregenz, 2011). The concept was initially developed in Kaja Silverman and Harun Farocki, *Speaking about Godard* (New York: NYU Press, 1998).
5. René Descartes, "The Passions of the Soul," in *The Philosophical Works*, trans. Elizabeth S. Haldane and G. R. T. Ross (Cambridge: Cambridge University Press, 1975), 1:358.
6. Philip Fisher, *Wonder, the Rainbow, and the Aesthetics of Rare Experiences* (Cambridge, Mass.: Harvard University Press, 1998), 17.
7. For more about modernity's assault on wonder, see Ekkehard Martens, *Vom Staunen oder die Rückkehr der Neugier* (Leipzig: Reclam, 2003), 9–19.
8. Richard Holmes, *The Age of Wonder: How the Romantic Generation Discovered the Beauty and Terror of Science* (New York: Vintage, 2010).
9. Max Horkheimer and Theodor W. Adorno, *Dialectic of Enlightenment: Philosophical Fragments*, trans. Edmund Jephcott (Stanford, Calif.: Stanford University Press, 2002), 94–136.
10. Walter Benjamin, "On Some Motifs in Baudelaire," in *Selected Writings*, ed. Howard Eiland and Michael W. Jennings (Cambridge, Mass.: Belknap Press of Harvard University Press, 2003), 4:313–55.

11. Todd McGowan, *Out of Time: Desire in Atemporal Cinema* (Minneapolis: University of Minnesota Press, 2011).

12. Jacques Rancière, *Béla Tarr: The Time After*, trans. Erik Beranek (Minneapolis, Minn.: Univocal, 2013).

13. Paul Virilio, *Aesthetics of Disappearance*, trans. Philip Beitchman (New York: Semiotext(e), 1991); Paul Virilio, *Negative Horizon: An Essay in Dromoscopy*, trans. Michael Degener (New York: Continuum, 2008).

14. Fredric Jameson, "The End of Temporality," *Critical Inquiry* 29, no. 4 (Summer 2003): 695–718.

15. Qtd. in Holmes, *Age of Wonder*, xx.

16. John Armstrong, *Move Closer: An Intimate Philosophy of Art* (New York: Farrar, Straus and Giroux, 2000), 101.

17. Walter Benjamin, "The Work of Art in the Age of Its Technological Reproducibility," in *Selected Writings*, 3:104–5.

18. Qtd. in Michael Fried, *Absorption and Theatricality: Painting and Beholder in the Age of Diderot* (Chicago: University of Chicago Press, 1980), 184.

19. Michael Fried, *Why Photography Matters as Art as Never Before* (New Haven, Conn.: Yale University Press, 2008).

20. Raymond Bellour, "The Pensive Spectator," *Wide Angle* 9, no. 1 (1987): 6.

21. Laura Mulvey, *Death 24× a Second: Stillness and the Moving Image* (London: Reaktion Books, 2006), 184.

22. Ibid., 171.

23. Ibid., 176.

24. Tom Gunning, "The Cinema of Attractions: Early Film, Its Spectator and the Avant-Garde," in *Early Cinema: Space, Frame, Narrative*, ed. Thomas Elsaesser and Adam Barker (London: BFI, 1990), 56–62; and Tom Gunning, "An Aesthetic of Astonishment: Early Film and the (In)credulous Spectator," in *Viewing Positions: Ways of Seeing Film*, ed. Linda Williams (New Brunswick, N.J.: Rutgers University Press, 1995), 114–33.

25. Daniel Yacavone, *Film Worlds: A Philosophical Aesthetics of Cinema* (New York: Columbia University Press, 2015), Kindle edition.

26. Tom Gunning, "Moving Away from the Index: Cinema and the Impression of Reality," in *Screen Dynamics: Mapping the Borders of Cinema*, ed. Gertrud Koch, Volker Pantenburg, and Simon Rothöhler (Vienna: Synema, 2012), 50. See also Karen Beckman, ed., *Animating Film Theory* (Durham, N.C.: Duke University Press, 2014).

27. Gunning, "Moving Away from the Index," 57.

28. Theodor W. Adorno, *In Search of Wagner*, trans. Rodney Livingstone (London: Verso, 1981), 156.
29. Mulvey, *Death 24× a Second*, 31.

1. To Cut or Not to Cut

1. Andrew V. Uroskie, *Between the Black Box and the White Cube: Expanded Cinema and Postwar Art* (Chicago: Chicago University Press, 2014), 47–48.
2. Harry Tuttle, "Average Shot Length," *Unspoken Cinema*, January 16, 2007, http://unspokencinema.blogspot.com/.
3. See chap. 5 of Gabriele Pedulla, *In Broad Daylight: Movies and Spectators After the Cinema*, trans. Patricia Gaborik (London: Verso, 2012), Kindle edition.
4. Mary Ann Doane, *The Emergence of Cinematic Time: Modernity, Contingency, the Archive* (Cambridge, Mass.: Harvard University Press, 2002).
5. For a useful overview, see Uroskie, *Between the Black Box and the White Cube*; and A. L. Rees, Duncan White, Steven Ball, and David Curtis, *Expanded Cinema: Art, Performance, Film* (London: Tate, 2011).
6. Allan Kaprow, "The Shape of the Art Environment (1968)," in *Essays on the Blurring of Art and Life*, by Allan Kaprow, ed. Jeff Kelley, expanded ed. (Berkley: University of California Press, 2003), 94.
7. André Bazin, "The Myth of Total Cinema," in *What Is Cinema? Volume 1*, trans. Hugh Gray (Berkeley: University of California Press, 1967), 21.
8. André Bazin, "An Aesthetic Reality: Cinematic Realism and the Italian School of Liberation," in *What Is Cinema? Volume 2*, trans. Hugh Gray (Berkeley: University of California Press, 1971), 28.
9. André Bazin, "The Ontology of the Photographic Image," in *What Is Cinema?*, 1:15.
10. Monica Dall'Asta, "Beyond the Image in Benjamin and Bazin: The Aura of the Event," in *Opening Bazin: Postwar Film Theory and Its Afterlife*, ed. Dudley Andrew with Hevré Joubert-Laurencin (Oxford: Oxford University Press, 2011), 62.
11. Pier Paolo Pasolini, "Observations on the Long Take," in *The Cinematic*, ed. David Campany, trans. Norman Macafee and Craig Owens (Cambridge, Mass.: MIT Press, 2007), 84–87.
12. Ibid., 86.
13. Ibid., 87.

14. Gilles Deleuze, *Cinema 2: The Time-Image*, trans. High Tomlinson and Robert Galeta (Minneapolis: University of Minnesota Press, 1989).

15. David Bordwell, *The Way Hollywood Tells It: Story and Style in Modern Movies* (Berkeley: University of California Press, 2006).

16. Maeve Connolly, *The Place of Artists' Cinema: Space, Site and Screen* (Bristol, U.K.: Intellect, 2009), 9. For pathbreaking essays on the transactions between art and cinema during the last two decades, as well as the need to reconceptualize seasoned notions of spectatorship, see Raymond Bellour, "D'un autre cinéma," *Trafic* 24 (June 2000): 5–21; Dominique Païni, "The Return of the Flâneur," *Art Press* 255 (March 2000): 33–41; Peter Osborne, "Distracted Reception: Time, Art and Technology," in *Time Zones: Recent Film and Video* (London: Tate, 2004), 66–83; Daniel Birnbaum, *Chronology* (New York: Lukas and Sternberg, 2005); Campany, *Cinematic*; Kate Mondloch, *Screens: Viewing Media Installation Art* (Minneapolis: University of Minnesota Press, 2010); Tamara Trodd, *Screen/Space: The Projected Image in Contemporary Art* (Manchester: Manchester University Press, 2011); Ursula Frohne and Lilian Haberer, eds., *Kinematographische Räume: Installationsästhetik in Film und Kunst* (Munich: Fink, 2012); *Screen Dynamics: Mapping the Borders of Cinema*, ed. Gertrud Koch, Volker Pantenburg, and Simon Rothöhler (Vienna: Synema, 2012); and Uroskie, *Between the Black Box and the White Cube*.

17. Don DeLillo, *Point Omega* (New York: Scribner, 2010), 5.

18. Ibid., 6.

19. Siegfried Kracauer, "Those Who Wait," in *The Mass Ornament: Weimar Essays*, trans. and ed. Thomas Y. Levin (Cambridge, Mass.: Harvard University Press, 1995), 129–40.

20. Qtd. in Mondloch, *Screens,* 40.

21. In Mondloch's words: "While the audience's expected time commitment is putatively preordained in the case of viewing non-installation variants of film or video . . . , viewers routinely enjoy what one might call an exploratory duration in observing gallery-based media installations: that is, spectators autonomously determine the length of time they spend with the work. Largely unburdened by externally imposed timetables, museum visitors of film and video installations appear to be free to walk in or out at any time." Ibid., 41.

22. Ibid., 54.

23. Benjamin, "Work of Art," 3:117.

24. Malcolm McCullough, *Ambient Commons: Attention in the Age of Embodied Information* (Cambridge, Mass.: MIT Press, 2013), Kindle edition.
25. Ibid.
26. Jonathan Crary, *24/7: Late Capitalism and the Ends of Sleep* (London: Verso Books, 2013), 47.
27. Ibid., 53.
28. Ira Jaffe, *Slow Movies: Countering the Cinema of Action* (London: Wallflower Press, 2014). See also Matthew Flanagan, "Towards an Aesthetic of Slow in Contemporary Cinema," *16:9: filmtidskrift* 6, no. 29 (November 2008), http://www.16-9.dk.
29. Brittney Gilbert, "David Lynch on iPhone," *YouTube*, January 4, 2008, https://www.youtube.com/.
30. Theodor W. Adorno, *Aesthetic Theory*, trans. Robert Hullot-Kentor (New York: Continuum, 2002), 1.
31. Crary, *24/7*, 125–26.
32. Marco Abel, *The Counter-Cinema of the Berlin School* (Rochester: Camden House, 2013); and *Berlin School Glossary: An ABC of the New Wave in German Cinema*, ed. Roger Cook, Lutz Koepnick, Kirstin Kopp, and Brad Prager (Bristol, U.K.: Intellect, 2013).

2. Images of/as Promise

1. Kenya Hara, *White*, trans. Jooyeon Rhee (Baden: Lars Müller, 2010), 39.
2. Philipp Lachenmann, "Space/Surrogate I (Dubai), 2000," http://www.lachenmann.net/.
3. Hara, *White*, 61.

3. "It's Still Not Over"

1. Byung-Chul Han, *Der Duft der Zeit: Ein philosophischer Essay zur Kunst des Verweilens* (Bielefeld: Transcript, 2009), 41–45; see also Frederic Gros, *A Philosophy of Walking* (London: Verso Books, 2014).
2. Rudolf Arnheim, *Film as Art* (Berkeley: University of California Press, 1957), 73–74.
3. Thomas Elsaesser and Malte Hagener, *Film Theory: An Introduction Through the Senses* (New York: Routledge, 2010), 14.
4. Jared Rapfogel, "Taiwan's Poet of Solitude: An Interview with Tsai Ming-liang," *Cineaste* 29, no. 4 (Fall 2004): 28.
5. Jean Ma, "Tsai Ming-liang's Haunted Movie Theater," in *Global*

Art Cinema: New Theories and Histories, ed. Rosallind Galt and Karl Schoonover (Oxford: Oxford University Press, 2010), 334–50; Jean Ma, *Melancholy Drift: Marking Time in Chinese Cinema* (Hong Kong: University of Hong Kong Press, 2010); Sheldon Hsiao-peng Lu, ed., *Transnational Chinese Cinemas: Identity, Nationhood, Gender* (Honolulu: University of Hawai'i Press, 1997); and Rey Chow, *Sentimental Fabulations: Contemporary Chinese Films* (New York: Columbia University Press, 2007).

6. Rancière, *Béla Tarr*. For a useful introduction to Tarr's overall work, see András Bálint Kovács, *The Cinema of Béla Tarr: The Circle Closes* (New York: Wallflower, 2013).

7. Elsaesser and Hagener, *Film Theory*, 39.

8. Eric Schlosser, "Interview with Béla Tarr: About Werckmeister Harmonies (Cannes 2000, Director's Fortnight)," October 1, 2000, http://brightlightsfilm.com/.

9. See Wim Wenders's short film *Silver City Revisited* (1968) and various entries in his book, *The Logic of Images: Essays and Conversations*, trans. Michael Hoffman (London: Faber & Faber, 1991).

10. Siegfried Kracauer, *Theory of Film: The Redemption of Physical Reality* (Princeton, N.J.: Princeton University Press, 1997).

11. For more on the role of the body and the everyday in Tsai's work, see Tiago de Luca, "Sensory Everyday: Space, Materiality and the Body in the Films of Tsai Ming-liang," *Journal of Chinese Cinemas* 5, no. 2 (2011): 157–79; Corrado Neri, "Tsai Ming-liang and the Lost Emotions of the Flesh," *East Asia Cultures Critique* 16, no. 2 (2008): 389–407; and Jean-Pierre Rehm, Olivier Joyard, and Danièle Rivière, *Tsai Ming-liang* (Paris: Dis Voir, 1999).

12. Fionn Mead, "Béla Tarr," *Bomb* 100 (Summer 2007): 36.

13. Bellour, "Pensive Spectator," 6–7.

14. Theodor W. Adorno, *Minima Moralia: Reflections from Damaged Life*, trans. E. F. N. Jephcott (London: Verso, 2005), 89–90.

15. Ian Bogost, *Alien Phenomenology, or What It's Like to Be a Thing* (Minneapolis: University of Minnesota Press, 2012), 239.

16. Maurice Blanchot, "The Essential Solitude," in *The Gaze of Orpheus*, trans. Lydia Davis (New York: Station Hill, 1981), 75.

17. For more on the formation of German empathy theory, see Juliet Koss, *Modernism after Wagner* (Minneapolis: University of Minnesota Press, 2010); and Harry Francis Mallgrave and Eleftherios Ikonomou, ed. and trans., *Empathy, Form, and Space: Problems in German Aesthetics, 1873–1893* (Santa Monica, Calif.: Getty Foundation, 1994).

18. For more on how recent film theory has embraced the notion of

haptic seeing in order to develop various concepts of embodied looking, see, among others, Laura S. Marks, *The Skin of Film: Intercultural Cinema, Embodiment, and the Senses* (Durham, N.C.: Duke University Press, 2000); Guiliana Bruno, *Atlas of Emotion: Journeys in Art, Architecture, and Film* (London: Verso, 2002); and David Trotter, *Cinema and Modernism* (Malden, Mass.: Blackwell, 2007), 17–48.

19. Erwin Panofsky, "Style and Medium in the Motion Pictures," in *Film Theory and Criticism*, ed. Gerald Mast and Marshall Cohen (New York: Oxford University Press, 1984), 215–33, originally published as "On Movies," *Bulletin of the Department of Art and Archaeology of Princeton University*, June 1936, 5–15. Hugo Münsterberg, *The Photoplay: A Psychological Study and Other Writings*, ed. Allan Langdale (1916; reprint, New York: Routledge, 2002).

4. The Long Goodbye

1. Pedulla, *In Broad Daylight*.
2. Osborne, "Distracted Reception," 72.
3. Qtd. in Mondloch, *Screens*, 54–55.
4. For an extended discussion of medium specificity as a stand-in for nature amid a world of increasing dematerialization, see J. M. Bernstein, *Against Voluptuous Bodies: Late Modernism and the Meaning of Painting* (Stanford, Calif.: Stanford University Press, 2006).
5. Zarahayes, "Film: Portrait of Tacita Dean," *Vimeo*, February 23, 2012, https://vimeo.com/.
6. Tacita Dean, *Film*, ed. Nicholas Cullinan (London: Tate, 2011), 143.
7. Charles Baudelaire, *Prose and Poetry*, trans. Arthur Symons (New York: Albert and Charles Boni, 1926), 63.
8. Nigel Thrift, "Beyond Mediation: Three New Material Registers and Their Consequences," in *Materiality*, ed. Daniel Miller (Durham, N.C.: Duke University Press, 2005), 237.
9. For an extended discussion of *Le Basier/The Kiss* and its relation to other media art featuring windows, see my contribution to Sabine Eckmann and Lutz Koepnick, *Window | Interface: Screen Arts and New Media Aesthetics 2* (St. Louis, Mo.: Mildred Lane Kemper Art Museum, 2007).
10. Panofsky, "Style and Medium," 155.
11. Osborne, "Distracted Reception," 72.
12. Benjamin, "Work of Art," 3:101–33.

5. Funny Takes?

1. See, among many others, Carl Honoré, *In Praise of Slowness: How a Worldwide Movement Is Challenging the Cult of Speed* (San Francisco, Calif.: HarperCollins, 2004); and Christian McEwen, *World Enough and Time: On Creativity and Slowing Down* (Dublin: Bauhan, 2011). For a challenge of the contemporary rhetoric of slowness, see Koepnick, *On Slowness*.
2. Flanagan, "Towards an Aesthetic of Slow." See also Jaffe, *Slow Movies*.
3. Crary, *24/7*, 53.
4. For the most insightful recent writing on Haneke, see Ben McCann and David Sorfa, eds., *The Cinema of Michael Haneke: Europe Utopia* (London: Wallflower, 2011); Brian Price and John David Rhodes, eds., *On Michael Haneke* (Detroit, Mich.: Wayne State University Press, 2010); Peter Brunette, *Michael Haneke* (Champaign: University of Illinois Press, 2010); Roy Grundmann, ed., *A Companion to Michael Haneke* (New York: Wiley-Blackwell, 2010); Fatima Naqvi, *Trügerische Vertrautheit: Filme von Michael Haneke* (Vienna: Synema, 2010); and Catherine Wheatley, *Michael Haneke's Cinema: The Ethic of the Image* (New York: Berghahn Books, 2009).
5. John David Rhodes, "Haneke, the Long Take, Realism," *Framework: The Journal of Cinema and Media* 47, no. 2 (2006): 19.
6. Qtd. in Catherine Wheatley, "Domestic Invasion: Michael Haneke and Home Audiences," in McCann and Sorfa, *Cinema of Michael Haneke*, 12.
7. Susan Sontag, *Regarding the Pain of Others* (New York: Farrar, Straus and Giroux, 2003), 41.
8. Giorgio Agamben, *Homo Sacer: Power and Bare Life*, trans. Daniel Heller-Roazen (Stanford, Calif.: Stanford University Press, 1998); Eric Santner, *On Creaturely Life: Rilke, Benjamin, Sebald* (Chicago: University of Chicago Press, 2006).
9. For a polemical version of this argument, see Moira Weigel, "Sadomodernism," *n+1* 16 (March 2013), http://www.nplusonemag .com/.
10. Fisher, *Wonder*, 59.
11. Immanuel Kant, *Grundlegung zur Metaphysik der Sitten*, in *Immanuel Kants Schriften: Ausgabe der königlich-preussischen Akademie der Wissenschaften* (Berlin: de Gruyter, 1902–), 4:426.
12. Theodor W. Adorno, *Aesthetic Theory*, trans. C. Lenhardt (London: Routledge & Kegan Paul, 1984), 58.

13. Qtd. in Amos Vogel, "Of Nonexisting Continents: The Cinema of Michael Haneke," *Film Comment* 32, no. 4 (1996): 75.

14. Wheatley, "Domestic Invasion," 10–23.

15. Mulvey, *Death 24× a Second*, 28.

16. Andrey Tarkovsky, *Sculpting in Time: Reflections on the Cinema*, trans. Kitty Hunter-Blair (Austin: University of Texas Press, 1987).

17. Mulvey, *Death 24× a Second*, 178.

18. André Bazin, "The Ontology of the Photographic Image," trans. High Gray, *Film Quarterly* 13, no. 4 (Summer 1960): 8; Philip Rosen, *Change Mummified: Cinema, Historicity, Theory* (Minneapolis: University of Minnesota Press, 2001).

19. Lesley Stern, *Dead and Alive: The Body as Cinematic Thing* (Montreal: Caboose, 2012).

6. The Wonders of Being Stuck

1. Enda Duffy, *The Speed Handbook: Velocity, Pleasure, Modernism* (Durham, N.C.: Duke University Press, 2009); Koepnick, *On Slowness*, chap. 1.

2. Michel Chion, *Film: A Sound Art*, trans. Claudia Gorbman (New York: Columbia University Press, 2009).

3. Cuauhtémoc Medina, Russell Ferguson, and Jean Fisher, *Francis Alÿs* (London: Phaidon, 2007), 48.

4. Barbara A. MacAdam, "Francis Alÿs: Architect of the Absurd," *ARTnews*, Summer 2013, http://www.artnews.com/.

5. Rancière, *Béla Tarr*, 26.

6. André Bazin, "Cinema and Theology," in *Bazin at Work: Major Essays and Reviews from the Forties and Fifties*, trans. Alain Piette and Bert Cardullo, ed. Bert Cardullo (New York: Routledge, 1997), 61.

7. Dall'Asta, "Beyond the Image," 61.

7. (Un)Timely Meditations

1. James Quandt, ed., *Apichatpong Weerasethakul* (Vienna: Synema, 2009), 189.

2. "A Debate with Abbas Kiarostami," *Film International* 3, no. 1 (Winter 1995): 47.

3. Christian Metz, "Photography and Fetish," *October* 34 (Autumn 1985): 81–90.

4. André Bazin, "The Virtues and Limitations of Montage," in *What Is Cinema?*, 1:48.

5. David Campany, "When to Be Fast? When to Be Slow?," in Campany, *Cinematic*, 11.

6. Daniele Dell'Agli, "Die rhapsodische Kamera," *perlentaucher.de: Das Kulturmagazin*, February 2014, http://www.perlentauche r.de/.

7. Ma, "Tsai Ming-liang's Haunted Movie Theater"; Ma, *Melancholy Drift*; Lu, *Transnational Chinese Cinemas*; and Chow, *Sentimental Fabulations*.

8. Devin Fore, *Realism after Modernism: The Rehumanization of Art and Literature* (Cambridge, Mass.: MIT Press, 2012), 75–132.

9. Acousmatic sounds, for Chion, are sounds whose sources are hidden from the viewer's view. They can reside in or emanate from what lies beyond the frame of the image; or they can resound from nondiegetic spaces, a film's musical soundtrack and the voice-over of a disembodied filmic narrator being the most common examples. Michel Chion, *The Voice in Cinema*, trans. Claudia Gorbman (New York: Columbia University Press, 1999), 18–23.

10. Ibid., 22.

11. Qtd. in Alberto Elena, *The Cinema of Abbas Kiarostami* (London: SAQI, 2005), 182.

12. See, e.g., Abbas Kiarostami's collection *Walking with the Wind: Poems by Abbas Kiarostami*, trans. Ahmad Karimi-Hakkak and Michael Beard (Cambridge, Mass.: Harvard University Press, 2001).

13. Qtd. in Remes, *Motion(less) Pictures*, 42.

14. Susan Sontag, *Against Interpretation and Other Essays* (New York: Picador, 2011), 14.

15. Abbas Kiarostami, "Notes on Photography," in *Abbas Kiarostami: Stille und bewegte Bilder/Images, Still and Moving*, ed. Silke von Berswordt-Wallrabe, Alexander Klar, and Ingrid Mössinger (Ostfildern, Germany: Hatje Cantz, 2012), 15.

16. Catherine Zuromskis, *Snapshot Photography: The Lives of Images* (Cambridge, Mass.: MIT Press, 2013).

17. Silke von Berswordt-Wallrabe, "Between Stasis and Motion: Reflections of Abbas Kiarostami's Photographs and Videos," in von Berswordt-Wallrabe, Klar, and Mössinger, *Abbas Kiarostami*, 113.

18. Roland Barthes, *The Rustle of Language*, trans. Richard Howard (Berkeley: University of California Press, 1989), 348.

19. Aldous Huxley, "Wanted, a New Pleasure," *Aldous Huxley: Complete Essays*, ed. Robert S. Baker and James Sexton (Chicago:

Ivan R. Dee, 2001), 3:263. For an insightful discussion and apology of Huxley's text, see Duffy, *Speed Handbook*, 17–57.

20. Uroskie, *Between the Black Box and the White Cube*, 81.
21. For an extended version of this discussion of the contemporary, see Koepnick, *On Slowness*.
22. Giorgio Agamben, "What Is the Contemporary?," in *What Is an Apparatus? and Other Essays*, trans. David Kishik and Stefan Pedatella (Stanford, Calif.: Stanford University Press, 2009), 41.
23. Victor Burgin, *In/Different Spaces: Place and Memory in Visual Culture* (Berkeley: University of California Press, 1996), 184.
24. Rikrit Tiravanija, "Ghosts in the Projector," in *Apichatpong Weerasethakul*, ed. Gary Carrion-Murayari and Massimiliano Gioni (New York: New Museum, 2011), 32.
25. *Kino-Solaris* (blog), http://kino-solaris.blogspot.no/.
26. Carrion-Murayari and Gioni, *Apichatpong Weerasethakul*, 14.
27. Qtd. in Jordan Hruska, "The Architecture of Apichatpong," *Art in America*, http://www.artinamericamagazine.com/.
28. Quoted from assistant curator's Dena Beard's press release, "Apichatpong Weerasethakul/Matrix 247," BAM/PFA, February 15–April 21, 2013, http://bampfa.berkeley.edu/.

Conclusion

1. Uroskie, *Between the Black Box and the White Cube*, 48.
2. Remes, *Motion(less) Pictures*, 51.
3. Harun Farocki, "Phantom Images," *Public* 29 (2004): 17.
4. Ibid., 18.
5. Christian Ulrik Andersen and Søren Pold, "Manifesto for a Post-Digital Interface Criticism," *the new everyday: a media commons project,* http://mediacommons.futureofthebook.org/.
6. Koepnick, *On Slowness*, 217–48.
7. Benjamin, "Work of Art," 3:120.
8. Susan Sontag, *On Photography* (New York: Farrar, Straus and Giroux, 1977).
9. For a brilliant and exhaustive reconstruction of how the FPS genre mainstreamed much older cinematic traditions, see Alexander R. Galloway, *Gaming: Essays on Algorithmic Culture* (Minneapolis: University of Minnesota Press, 2006), 39–69.
10. Ian Bogost, *How to Do Things with Videogames* (Minneapolis: University of Minnesota Press, 2011).
11. Galloway, *Gaming*, 64.

12. Jesper Juul, *Half-Real: Video Games between Real Rules and Fictional Worlds* (Cambridge, Mass.: MIT Press, 2011).

13. Henry Jenkins, "Game Design as Narrative Architecture," in *First Person: New Media as Story, Performance, and Game*, ed. Noah Wardrip-Fruin and Pat Harrigan (Cambridge, Mass.: MIT Press, 2004), 118–30.

14. Astrid Ensslin, *Literary Gaming* (Cambridge, Mass.: MIT Press, 2014), 4.

15. Roger Ebert, "Why Did the Chicken Cross the Genders?," *Chicago Sun-Times*, November 27, 2005.

16. Jaffe, *Slow Movies*, 10.

17. Robert Bresson, *Notes on Cinematography*, trans. Jonathan Griffin (New York: Urizen, 1977), 17.

18. McGowan, *Out of Time.*

19. Valie Export, "Expanded Cinema: Expanded Reality," in Rees et al., *Expanded Cinema*, 290.

20. Crary, *24/7.*

21. Descartes, *Philosophical Works*, 1:401 (modified translation).

22. Alexander Kluge, *Wer sich traut, reißt die Kälte vom Pferd* (Frankfurt am Main: Suhrkamp, 2010), 79.

INDEX

Lutz Koepnick is Gertrude Conaway Vanderbilt Professor of German, Cinema, and Media Arts at Vanderbilt University in Nashville. He is the author of *On Slowness: Toward an Aesthetic of the Contemporary*, *Framing Attention: Windows on Modern German Culture*, *The Dark Mirror: German Cinema between Hitler and Hollywood*, *Walter Benjamin and the Aesthetics of Power*, and *Nothungs Modernität: Wagners Ring und die Poesie der Politik im neunzehnten Jahrhundert*; coauthor of *Windows | Interface* and *[Grid ‹ › Matrix]*; and coeditor of anthologies on German cinema, sound art and culture, new media aesthetics, aesthetic theory, and questions of exile.

Lightning Source UK Ltd.
Milton Keynes UK
UKHW020632090220
358415UK00007B/249